Bengal to B

Re-creating Historic Fas the Muslin Trade

Foreword by

Dr. Sharif Uddin Ahmed

Edited by

Heritage Fashion Recreators

Designed by

Saif Osmani

STEPNEY
COMMUNITY TRUST

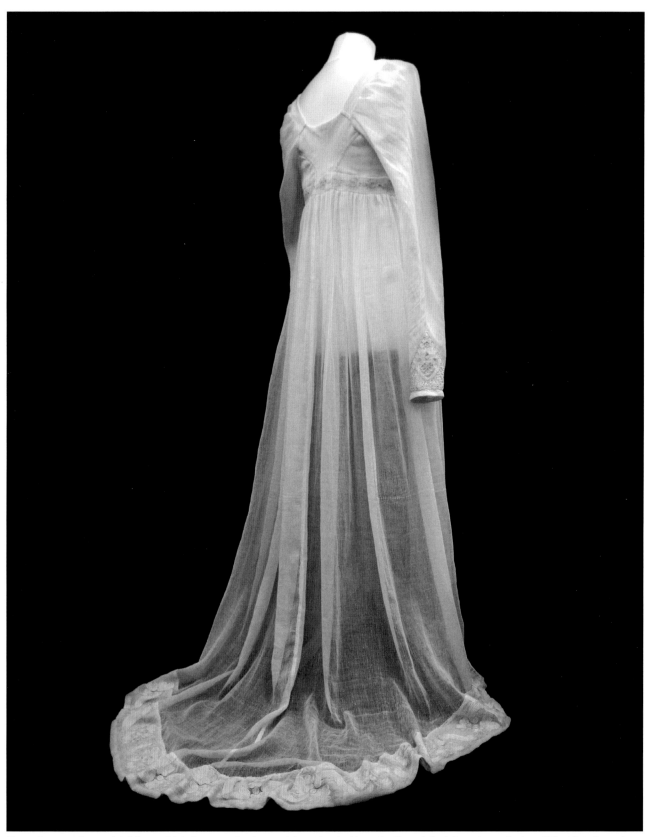

Cover image: sleeve detail from a historic recreation by participant Lucky Hossain. The original dress is on display at The Victoria and Albert Museum, London

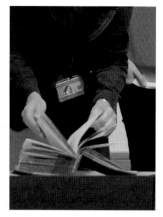
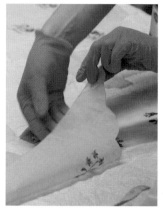
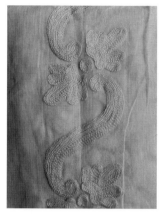
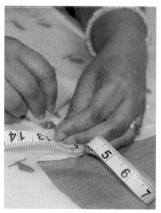

Published by Stepney Community Trust

Copyright © Stepney Community Trust

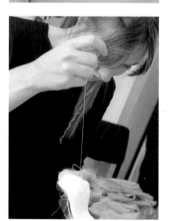

Every effort has been made to ensure that the information in this book was correct at the time of going to press, should any errors or omissions be found please contact the publisher and we will undertake to make sure corrections, if appropriate, but without prejudice.

The authors have asserted their right under the Copyright, Designs and Patent Act 1988 to be identified as the Authors of this Work.

ISBN: 978-0-9926810-0-5

Publishing Director: Bodrul Alom, Stepney Community Trust
Designer: Saif Osmani
Printed in the United Kingdom by Stephen Austin & Sons Ltd.

Contents

Acknowledgements

In the shared memory of Bengali people's past the muslin fabrics have a special place, even though, along with this material, a number of other textiles and raw silks were produced in Bengal and exported around the world. There is a real pride involved in this as the legendary reputation of the fabrics generates a deep feeling in Bengalis, of a special achievement of their ancestors that was really valued and highly appreciated by people from around the world.

However, the true story of muslin is not very well known. This is because within the wider society there has been more imagination at play, often generated by social or political movements, rather than fact-based construction of the story of muslin, the famous textile of Bengal. This book and the project, 'How Villages and Towns in Bengal Dressed London Ladies in the 17th, 18th and Early 19th Centuries', on which it is based, is an attempt to bring out into the wider arena factual information about the special muslin fabrics and, through creativity, generate more interest on the real significance and history of Bengal textiles. In this regard many institutions and individuals have supported the project in various

ways, without which it would have been an impossible undertaking. The Stepney Community Trust's interest on the subject matter and the project idea emerged from a London seminar in 2010 arranged by Brick Lane Circle on 'Muslin: the famous textiles of Bengal', delivered by Dr. Sharif Uddin Ahmed, who was visiting London from Bangladesh at that time. Bodrul Alom, secretary of the Trust , inspired by the story of muslin, dedicated a great deal of his personal time and organisational resources towards developing the initiative. The project idea was further developed with encouragement, new ideas and practical support from many people, including Andrea Cunningham (Head of Informal Learning and Access, National Maritime Museum), Rosemary Crill (Senior Curator, Victoria and Albert Museum), Hilary Davidson (former Curator, Fashion & Decorative Arts, Museum of London), Dr Lynne Hammond (Manager of International Educational Consultancy office, London College of Fashion). Aysha Ahmad (Globe Bengali Mohila Shamity) was an early enthusiast and worked with the Trust to develop ideas and details of the project. In addition to these individuals and institutions, Penny Brooks and Dr. Margaret Makepeace from the British Library also provided letters of support for the Trust's funding application to the Heritage Lottery Fund (HLF). Anne Wilding (Heba Women's Project in Brick Lane) and Oliver Carruthers (Rich Mix Centre in Shoreditch) showed early interest with the initiative and offered the use of their premises. Several women from Heba also joined the project as Heritage Fashion Recreators.

A number of other people have made contributions, in a variety of ways, towards the success of the project. Dr John McAleer (former curator) and Amy Miller (curator of decorative arts and material culture), both from National Maritime Museum, delivered a workshop / guided tour of the 'Traders Gallery' for the project participants. Sonia Ashmore (author of Muslin), Professor Mushtak Khan (School of Oriental and African Studies), Dipak Basu (a retired gentleman) and Dr. Sharif Uddin Ahmed (Supernumerary Professor of History, University of Dhaka) participated in the production of two video documentaries on the story of muslin, produced to promote the project and generate further interest. Rezia Wahid (Woven Air) delivered a presentation and practical workshop, sharing her experience of how she developed her handloom and the complex and time consuming process involved in hand weaving.

In Bangladesh Imtiazul Haque (freelance photographer / cinematographer) was the key person who helped organise the fabric production, weaving designs and undertaking embroidery work. He was assisted by Saddam Hussain and together they interpreted the design specifications sent from London, including drawing designs on trace papers, to help weavers and embroiderers understand the precise requirements of the order. They also monitored and ensured that the products were produced at the highest quality. Abdul Wasey Khan Hashu (TV artist) helped identify a quality embroidery company and liaised with them regularly to guarantee a good quality finish. Above all the credit for producing the high quality white fabrics and white

fabrics with woven coloured and white designs goes to Mohammed Abu Mia Jamdani (Jamdani Palli). Idea Boutiques and Taylors, based in Taltola Market in the Khilgaon area of Dhaka, undertook the impressive embroidery work .

During visits to the Museum of London, V&A, British Library and National Maritime Museum they allowed the trust to take photographs of their collections, archival materials and workshops proceedings. An additional visit was made by the project co-ordinator to Worthing Museum and Art Gallery to look at and photograph their muslin collections, shown by Gerry Connolly (Curator of Historic Collections). Many such photographs have been used in this publication with their kind permission.

The Trust was lucky to have access to the expertise of Alice Gordon and Lewis Westing. Between them they guided the Heritage Fashion Recreators with all their needs, ranging from deciding which garments to recreate to developing order specifications, pattern cutting, hand sewing and quality finishing.

There are many individuals and groups who supported the project in many different ways and the Trust is very appreciative of their contributions. Special thanks go to Heritage Fashion Recreators who worked incredibly hard, many evenings and weekends, to complete their costumes and chapters of the book. They are: Anjum Ishtiaq, Lindsay Dupler, Rehana Latif, Eppie Evans, Hilda Pollet, Lucky Hossain, Sima Huang-Rahman, Momtaz Begum-Hossain, Rifat Wahhab, Fathema Wahid and Saif Osmani.

The Trust is also grateful to the Heritage Lottery Fund for awarding a grant to finance the project.

Finally, the enthusiasm of the Stepney Community Trust Management Committee and Trustees towards the initiative was key to the success of the project. Under the leadership of Bodrul Alom the entire management committee took a continuous and active interest on the initiative since the project's inception in 2010/2011. They are: Abdul Malik, Muktar Hussain, Sheraj Uddin, Ameena Begum, Enam Uddin, Steve Mallaghan, Abdur Rahman, Hafiz Ahmad Hassan, Kamal Ahmed and Dewan Nurul Islam.

Foreward

I have been requested to write a forward to the book
'Bengal to Britain: Re-Creating Historic Fashions of
the Muslin Trade'. I am very pleased to undertake
this task not only because Bengal muslin, particularly
Dhaka muslin, has been subject of my research for
the last few decades but also because this important
project brings out to light the deep centuries old
historical and cultural connections between the
United Kingdom and Bengal (current day Bangladesh
and West Bengal in India). The efforts made by the
project have already borne fruits in encouraging
new generations of British Bangladeshis and others
to explore and discover the hidden roots and
connections between the diverse communities who
live in the UK. This initiative is also likely to help
develop a wider appreciation of the rich culture and
unique history of Bengal.

This particular book consists of a short history of
Bengal textiles, specially focusing on muslin, and
a report on the project. The authors and organizers
of the project have touched on one of the greatest
cultural heritages of the world. Bengal muslin had

been one of the wonders of the world in the past, attracting Europeans and other merchants to come to this distant land to procure muslin in its various forms for their aristocratic customers. As the Dhaka muslin was extremely fine and delicate some people could not believed that these had been woven by human hand.

Direct entry of Europeans into the Indian Ocean trade in textiles, including muslin, from the early 16th century, lead to the development of the continent's connections with Bengal and helped increase the demands for its produce. This caused the already popular Bengal textiles to flourish further. In Europe many fashionable dresses were made from muslin, which included woven designs and embroidery works of different motifs and designs. It became a craze of the fashionable and fashion-loving people of Europe. From kings and queens, princes and princesses to upper middle class people, muslin became the most sought after and desired fabric. Private merchants and organized companies, such as the English East India Company, the French East India Company and the Dutch East India Company, made a brisk business and derived huge profits from the trade. For more than a century from the mid - sixteenth to early nineteenth centuries the European muslin trade was at its peak. Sadly however, the British conquest of Bengal led to its decline and finally its extinction in the nineteenth century, partly through the promotion of the growing textile industry of Britain.

With the passage of time muslin went out of most people's minds in the United Kingdom and very few individuals were aware of its significant history until a group of British Bangladeshis in London turned their attention to discovering and sharing this wonderful world heritage. They have also been successful in generating interest in muslin dresses in western / British fashion among dressmakers, fashion designers and people with other non fashion backgrounds.

I am rather amused to learn that my lecture on 'Muslin: The famous textiles of Bengal' in 2010 held at the Whitechapel Idea Store, East London, organised by Brick Lane Circle, has something to do with the adoption of the project. This has naturally pleased me very much. However, undoubtedly, without the utter dedication and efforts of a number of people this project would not have seen the light of the day.

The introduction of the book provides details of how the project was started and how the volunteers, experts and institutions became interested and provided support. It is an amazing story. It shows how research and practical actions, based on historical information can contribute to today's economic, social and cultural activities. It also highlights the critical importance of museums, archives and libraries in discovering heritage and historical treasures.

The project seems to have achieved two main outcomes. First, it traced the history of the muslin fabrics (and Bengal textiles in general), particularly its

trade and use in the United Kingdom during the 17th, 18th and early 19th centuries. Second, nearly a dozen volunteers worked with dedication in 'recreating heritage fashions' of muslin dresses worn by ladies during that time. One of the participants worked on recreating a historical male waistcoat. All these have been achieved through voluntary participation.

The most interesting aspect of the project is the participation of dedicated volunteers from different backgrounds and communities, who became known as 'Heritage Fashion Re-creators'. Indeed their participation in the project and hard work in recreating dresses were the most revealing. Each of the Heritage Fashion Recreators wrote their own chapters in the book, detailing their own stories of how they became involved with the project and the process they went through in recreating historical dresses.

Heritage Fashion Re-creators were helped by several museums and relevant institutions, particularly The British Library, The Victoria and Albert Museum and Museum of London, for their sources and information. While recreating the heritage fashions they were surprised to learn how much the European people of the past centuries coveted muslin clothes and how much ingenuity and expertise the Bengal weavers and embroiderers had shown in their works.

I am sure the publication of the book would cause a breakthrough in helping to revive, use and trade in the muslin fabrics again, both in Britain and in Bangladesh. Let me express my regards and appreciation to all those who were involved in the project and the publication of the book, especially the volunteers. I am sure this project will help develop stronger bonds between Britain and Bangladesh.

Dr. Sharif Uddin Ahmed
Supernumerary Professor of History
University of Dhaka

Former Director of the National Archives of Bangladesh

President of Bangladesh Archives and Records Management Society (BARMS)

Introduction

'How Villages and Towns in Bengal Dressed London Ladies in the 17th, 18th and early 19th centuries' was a unique project recently delivered by the Stepney Community Trust. It involved recruiting volunteers from London's diverse communities to research and recreate historical costumes worn by ladies in the UK that were made from Bengal textiles. The project was based on the idea that there was a hidden but very important and deeply connected shared heritage that links Bengal and Britain for nearly four centuries that needed to be revealed. The recreation ideas was considered to be a uniquely effective way of engaging individuals from London's diverse communities who would find the story of that deep connection interesting and enjoy recreating historical costumes. It was envisaged that the process of the project and the end product would help generate further interest for similar process of learning of history through new and creative ways.

Bengal supplied a range of textiles to the world until the late 18th Century and continued to be an important source of Indian textiles for Britain for several decades of the 19th Century. Bangladeshi

and other Bengali people in the UK and in the Indian sub-continent are to some extent familiar with the names of a group of hand woven fabrics that came to be known as muslin, the famous textiles of Bengal. Except the Jamdani fabric, which was also imported from Bengal as a luxury fashion item by the East India Company, not much is known about the other varieties of muslin except their names, such as *Malmal* (the finest sort), *Jhuna* (used by native dancers), *Rang* (of transparent and net-like texture), *Abirawan* (fancifully compared with running water), *Khassa* (special quality, fine or elegant), *Shabnam* (morning dew), *Alaballee* (very fine), *Tanzib* (adorning the body), *Nayansukh* (pleasing to the eye), *Buddankhas* (a special sort of cloth), *Seerbund* (used for turbans), *Kumees* (used for making shirts), *Doorea* (striped),

Charkona (chequered cloth) and Jamdanee (figured cloth)'.

There exist many mythical and legendary stories about the famous muslin textiles and how they were valued around the world. The name of this historical textile is also known within certain groups in the UK and around the world but as far as the general population is concerned very few people are aware of its historical significance. Knowledge and interest in historical muslin seem to be mostly confined within certain sections of the population with family history of imperial connections with India, academic research and associations with heritage institutions, such as museums and stately homes.

The weaving of the muslin textiles has been long dead and currently no one is known to have the necessary skills and knowledge capable of producing these fabrics again. The particular cotton variety of the Dhaka region which provided the raw materials for producing the finest varieties of muslins is also not available now as it is not cultivated anywhere in the region anymore. It is believed that the particular cotton plant that produced the superfine and strong muslin threads may have become extinct, at least, no one currently knows where it may be found. However, as this was a native plant of the region there still exist a strong possibility that somewhere in the wild it is still alive and thriving.

(1): Publicity flyer used to promote the project
(2): Seminar at Idea Store Whitechapel

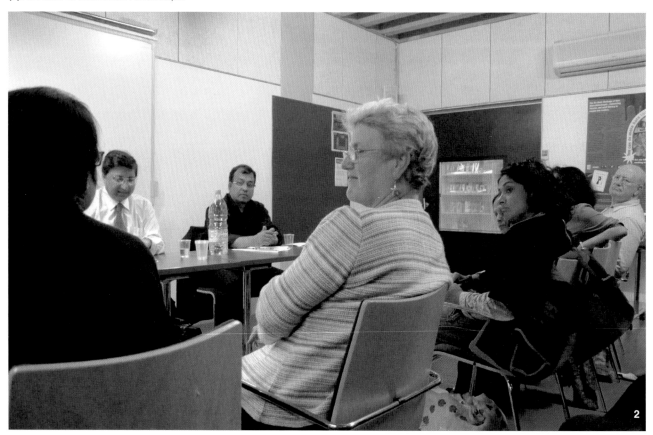

For many generations of people in Bengal, perhaps since the mid to late 19th Century, no one has seen, touched or worn these fabrics. Its legendary stories and reports range from how a certain large amount of muslin could be placed very easily in a small match box to the 'cutting off of Bengal weavers' hands and tongues' by the British, in order to destroy this important indigenous industry of Bengal. The memory, right or wrong, of how this indigenous industry clothed people around the world which brought associated economic benefits to the region, is still very much alive in the consciousness of the people of Bengal (Bangladesh, parts of India and the Bengali Diaspora). This memory has acted both as a symbol of pride and from time to time provided nationalistic fuel against British rule in India during the colonial period.

Legend aside there is very little accurate and factual information in circulation on muslin or other historical Bengal textiles. The Bangladeshi and Bengali Diaspora in the UK are relatively more disadvantaged than people in the India subcontinent regarding knowledge and familiarity with the textiles. The schooling and the education system in the UK provides very little scope for young people to learn about this important heritage that links Bengal with Britain for nearly four centuries. There are experts in the field and many archives and museums around the world have important records, samples and travellers accounts. These sources can be utilised to develop a good picture of what the muslin textiles were, their historical significance, the reasons for their enduring reputation, etc.

Origin of the project

In 2010 Dr. Sharif Uddin Ahmed from Bangladesh visited London, who runs the Centre for Dhaka Studies and President of Bangladesh Archives and Records Management Society (BARMS). He has written several books, including 'Dhaka – A Study in Urban History and Development, 1840-192'. During his visit he delivered a seminar on 'Muslin: The Famous Textiles of Bengal', organized by Brick Lane Circle.

The packed seminar, held at the Whitechapel Idea Store, prompted the Stepney Community Trust to look into the subject matter further. From the research that Brick Lane Circle carried out on East India Company with a group of young people it emerged that the British and other European trading companies exported a large quantity of textiles from Bengal. According to records of the East India Company's import figures from the Indian subcontinent, during most of the 18th century, Bengal's share was more than the total amount of textiles imported from the whole of India. This fact led the Trust to ask many searching questions, such as what happened to those textiles that came from Bengal and India into the UK, what kind of dresses were made from such textiles, etc.

Internet searches and other enquiries produced very

little information on these questions except for a small period covering the late 18th to early 19th centuries. This was also the span of time that has become known as the Empire and Regency in the fashion field, when Jane Austen was living and writing her novels. Internet searches on 'Bengal muslin textiles in 18th century fashion' and 'Regency fashion', for example, produced a range of useful results. Articles and information found from internet searches were very good introductory sources of information on Bengal and Indian textiles in western and British fashion of the period. The majority of the information and images relating to muslins in western fashion found on the internet and on museum websites were in relation to women's fashion. Although men also wore the fabrics very little information was found on the topic from the research that the Trust carried out prior to the start of the project.

The Trust, for a period, continued to make further enquiries in general and on specific museum sites, which started to reveal more about the significance of the historical Bengal textiles. At the Victoria and Albert Museum there are a few muslin items on public display and their website contains details of more items from Bengal. Searches on other museum sites also produced information about other muslin collections at various heritage institutions in the UK. A number of museums were contacted to explore the nature and extent of their collection of Bengal textiles, including Museum of London in Barbican, Victoria & Albert and National Maritime Museums.

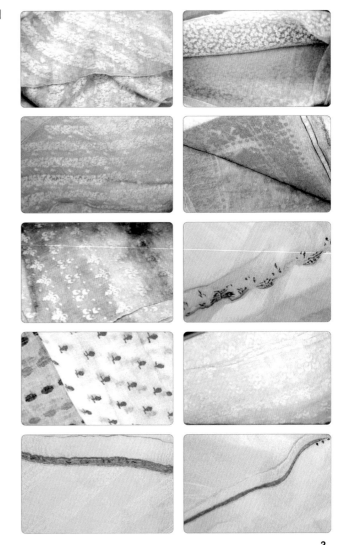

3

The idea of the project 'How Villages and Towns in Bengal Dressed London Ladies in the 17th, 18th and early 19th centuries' slowly began to emerge. It was thought that a very exciting and creative project, if developed, could enthuse people from the London's diverse communities to take part. Enquiries with Museums were followed by face to face meetings with Rosemary Crill (V&A) and Hilary Davidson (Museum of London) to explore what they have in their respective collections and how they may be able to assist the Trust in developing and

delivering this unique project. While The Victoria and Albert Museum had a few items - a complete dress, handkerchief, etc. made from Bengal muslins on public display they had a large archival collection of muslin fabrics. The Trust was invited by Rosemary Crill to visit the museum to discuss the project idea. Subsequently, the museum had agreed to support the Trust's application to the Heritage Lottery Fund and invited representatives of the Trust to visit the museum again to look at some of the muslin items in their collection. Several items seen from the V&A's muslin textiles collection was really astonishing, however, not all were from Bengal. Some of them have originated from various other parts of India. A common misunderstanding amongst Bangladeshis is that only Bengal, and no other place in the undivided India, produced muslin.

Before visiting the Museum of London in Barbican for a meeting with Hilary Davidson, it was not known what a treasure house of muslin dress collection was archived in that institution. There were no original muslin items on public display at the museum, except a recreated dress. During discussions with Hilary Davidson she revealed that the Museum of London had quite a large collection of Indian muslin items in their archive. Subsequently, the museum agreed to support the project by providing advice and running a number of workshops for the participants.

During the project development phase the research that the Trust carried found no traces of muslin dresses surviving or paintings depicting British and Western people wearing them except for around the Regency period. The British Library however has comprehensive records of East India Company's orders sent to India, including Bengal, items that came back and how they were sold in the UK. Also it emerged that approximately between thirty to forty percent of East India Company's textiles imports from India, most of which came from Bengal, were re-exported to Africa, in some cases to purchase African slaves. Although it is known that the majority of re-export of Indian textile to Africa were from western India, namely Gujarat, a sizeable amount must have also originated from Bengal. This conclusion is based on the sheer volume, varieties and proportion of British textile imports that came from Bengal (see chapter on History of Bengal Textiles).

The project ideas was discussed with Penny Brooks and Dr Margaret Makepeace from the British Library. Subsequently, they agreed to support the project by running workshops for the participants and showing how to access records and archives of the British Library. The National Maritime Museum, which in 2011 opened a new East India Company section called 'Traders Gallery' also enthusiastically agreed to support the project and provide a range of help, including to host the end of project celebration.

The rational for the project was based on a number of elements. First, it was thought that there was a very important heritage and story to tell. Second, there

was an opportunity to engage members of the UK diverse communities, through using creative means, to bring out the story of Bengal textiles, particularly the heritage of the muslin fabrics. Third, a number of British heritage institutions contained a vast amount of information, data and items which could be worked on to reveal a very important and deep historical connection between UK and Bengal. Based on these reasons an application to the Heritage Lottery Fund was made in 2011. A successful outcome during the same year led to the initiative starting in October 2011. The delivery of the project consisted of a number of stages.

Open Day / Evening and recruitment

An open evening launch was organised on 8th February 2012 to promote the project and attract potential volunteers to participate in recreating historical dresses. The event consisted of an exhibition on Bengal muslins in history, presentations from several experts from the V&A (Sonia Ashmore) and National Maritime Museum (Dr John McAleer, former curator), Rezia Wahid (weaver), Mia Walden (illustrator and costumier) and two short videos on muslin textiles. Professor Sharif Uddin Ahmed from Bangladesh, Professor Mushtak Ahmed from (School of Oriental and African Studies) in London, Dipak Basu and Sonia Ashmore featured in the video

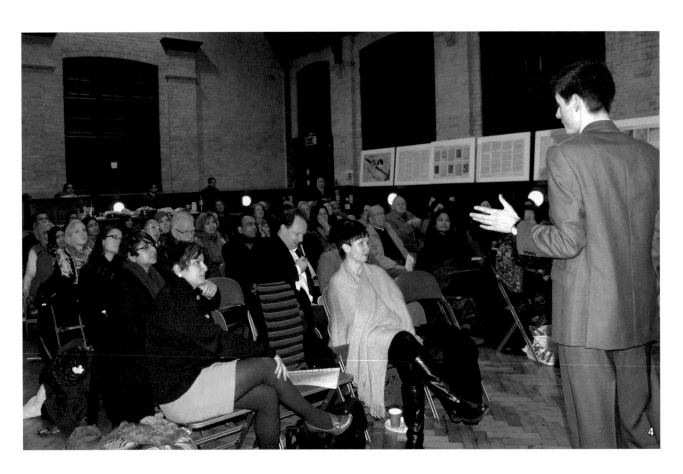

4

and spoke about the famous textiles. The event was well attended, made up of people from the London's diverse communities. Many participants asked questions and sought clarifications, in terms of commitment, involvement, time, etc., with an application deadline set for 9th March 2012. The Trust continued to undertake further outreach and promotional work to raise awareness of the project to generate more interest.

In total the project recruited twelve individual volunteers and they were called Heritage Fashion Recreators. A number of distinct phases were involved in the delivery of the project, and each phase was broken down into several separate parts. The steps in the first phase were designed to enable the participants to feel more confident about fashion designing and learn about the multi-dimensional story of Bengal textiles in British fashion history. This was considered as necessary and valuable preparatory steps before embarking on the complex tasks involved in actual recreations and creations. Every participant was required to produce two items, one a recreation of an actual dress and another a creative item based on the knowledge gained of fashion of the period.

Training with London College of Fashion (LCF)

The first part of the learning process involved attending a three day training course by the London College of Fashion (LCF) called Contemporary Fashion Design Workshop. This was delivered by Zarida Zaman, fashion design lecturer at LCF.

It covered how to start from a concept and then go through a process of getting inspiration, sketching, using calicos to learn draping and ending with producing and completing the fashion garment. The idea behind the course was to provide the volunteer fashion recreators with training from one of the best institutions in the field, who could then use the knowledge and skills gained to work on recreating historical dresses.

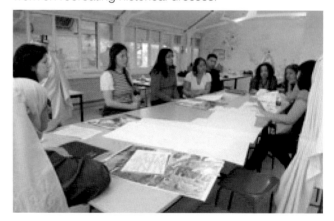

(3): Examples of some muslin fabrics (Source: V&A)
(4): Presentation by Dr John McAleer (former curator of National Maritime Museum) at the Open Evening of the project
(5): Training session at London College of Fashion (LCF)

Visits to Museums and the British Library

The training course with the London College of Fashion was followed by visits to three museums and the British Library. At the Museum of London in Barbican Hilary Davidson provided two workshops, where about twenty five complete dresses and other items were brought out from their store to show the group and provide explanations of how they were constructed. Most of the items seen covered the period from late 1700s to early 1800s. The museum seems to have one of the largest collection of muslin dresses worn by British ladies.

When the group visited the The Victoria and Albert Museum they were able to see many items of actual muslin fabrics in the their collection and discuss with Rosemary Crill and Sonia Ashmore to gain a better understanding of Indian and Bengal textiles stored at the museum and about the muslin fabrics collection at the institution.

The visit to the National Maritime Museum consisted of a tour of a new section on East India Company called 'Traders Gallery', where Dr John McAleer (former curator) provided valuable information about how Indian / Bengal and Asian textiles transformed British fashion and clothing scene from the 17th century onwards. He also explained how textiles goods were transported by the East India Company ships and their evolution during the long periods of contact with Asia as a result of improvements in navigational and ship technology. Amy Miller, another curator at the museum gave a workshop on how and why muslin became very popular in the 18th Century. She pointed out that it was the love of everything classical Greek that developed in the UK during the 18th century that explains the popularity of muslin fabrics.

According to Amy, many British travellers to Italy and Greece during the 18th Century developed a fascination for everything classical which was a very important factor in muslin's popularity. This was because the fabrics were very soft and could drape

(6): Workshop at Museum of London. By Kind permission of the Museum of London
(7): Workshop at The Victoria and Albert Museum archives
(8): Guided tour of the 'Traders Gallery', National Maritime Museum
(9-11): Workshop at the British Library. © The British Library Board

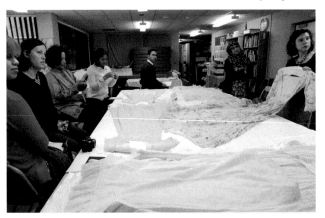

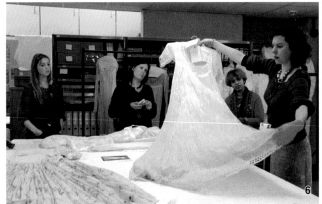

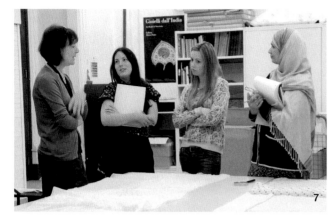

easily around bodies just like images of Greek figures found in white dresses on white sculptures. Another advantage of the muslin fabrics as mentioned was that it took paint very easily. This meant that elaborate designs could be printed on them with ease and speed unlike silk and linen which were also available at that time and worn widely. Ability to incorporate new designs very easily meant that the muslin fabrics allowed merchants to respond more quickly to consumer demands and changes in tastes.

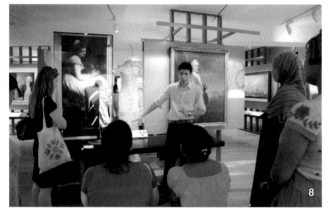

The visit to British Library was designed to provide the participants with knowledge of the sources of information. By looking at East India Company records of orders and the delivery of Indian textiles to England, including Bengal muslin fabrics, the participants would develop a better appreciation of the project's significance. They would be able to see for themselves the true scale of the textiles imported from Bengal by the East India Company. In addition, if they wanted, they could undertake further studies into the subject area, knowing where to go for information and how to access them.

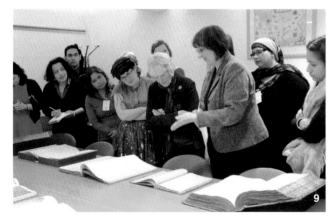

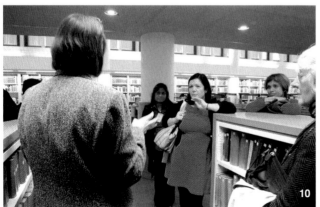

The workshop at British Library was run by Penny Brooks and Dr Margaret Makepeace. They showed the group examples of various types of records kept at the library, which included on orders that were sent out from London, items that came back from India, how they were then sold to merchants and buyers in the UK, etc. Old newspaper cutting with reports and merchants publicising the arrival of new muslin stocks, inviting potential buyers to come to such a place and such a time were also displayed for the project participants. The second part of the workshop consisted of a tour of the Asia reading room to show where the records are kept, how to cross reference and access records. Details of the process of ordering handwritten records which are kept in separate stores and how to become a member of the library were also explained.

Rezia's Handloom

Rezia Wahid is a textile expert, who has developed and built a handloom at her home. She hand weaves textiles and is working on creating something very near the legendary historical Bengal muslin. With this in mind she named her endeavour 'woven air' in the spirit of the reputation of the superfine fabrics.

The Heritage Fashion Recreators were taken on a visit to Rezia's loom to see how actually the hand weaving takes place. This was to give the participants a sense of the method of hand weaving, how much time it takes and the difficulties involved. At the workshop Rezia provided a demonstration and wove a small

(12): Rezia Wahid demonstrating hand weaving to the project participants
(13): The group developing their designs / order specifications for weaving and embroidery work in Bangladesh

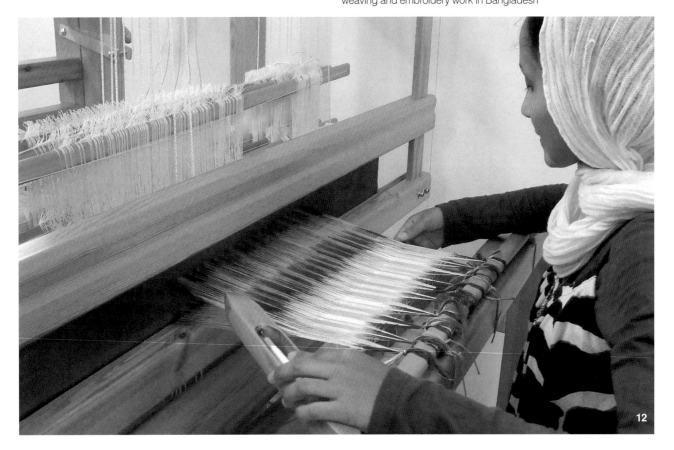

12

amount of textile, with explanations of the process. She also shared her own story of involvement in textiles and the development of the loom.

Appointment of facilitators and regular workshops

After the completion of the training course with the London College of Fashion and the visits to museums and the British Library the group developed sufficient knowledge and motivation to start the process of choosing the garment to recreate. They could choose one that they have seen at the museums, or one from a painting or from their own independent research into dresses located at any other heritage institutions.

Stepney Community Trust hired two experts on historical fashion, Alice Gordon and Lewis Westing, to support the participants to deliver the project. They helped the group to go through a process of understanding what it involves in garment creation, choosing the dresses to recreate and deciding on new creations. They supported the group collectively and individually to determine how much material they needed, to sketch patterns of designs to be woven and embroidered. This process took several months and each participant produced a specification for their design, materials, woven design and embroidery requirements.

According to the Heritage Lottery Fund application all the fabrics for the project were to be sourced

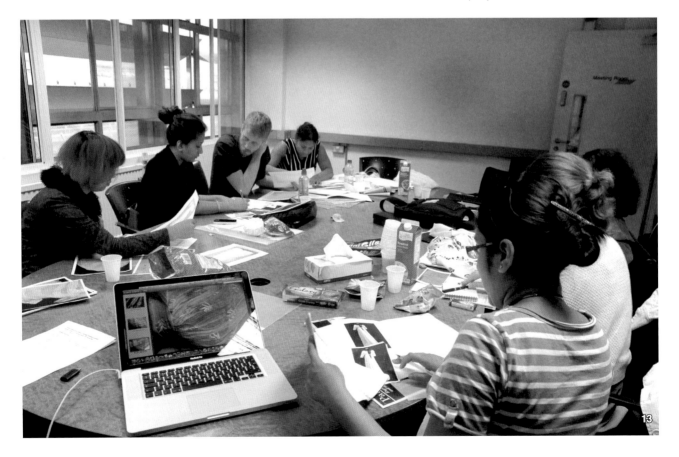

from the UK. However, this was changed for several reasons. First, the partners at The Victoria and Albert Museum and Museum of London thought that it would be better and more interesting if the fabrics were produced by handlooms in Bangladesh using historical methods, which would be closer in looks and structure to the original muslin fabrics that came from Bengal in earlier centuries. Second, the fabrics sourced in the UK would look very different and would not generate the quality and appreciation of the recreated dresses. Third, many of the relevant dresses in museums and other places had woven designs and intricate embroideries incorporated. Finding fabrics in the UK with the right kind of design woven would be an impossible undertaking and commissioning embroidery work in this country would be very costly. The participants also did not have the skills and ability to undertake any intricate embroidery work themselves. Fourth, handlooms in Bangladesh are able to incorporate intricate woven design while weaving the fabrics. Fifth, many handloom weavers in Bangladesh were the descendents of muslin and other Bengal textiles producers of earlier centuries. This meant that this project would help add this very important heritage dimension to the project.

The orders and specifications were taken to Bangladesh for the work to be undertaken entirely by hand, using traditional methods. One of the important requirement was to hand weave a large amount of plane white materials, some with a variety of woven designs, using thinner cotton threads than currently

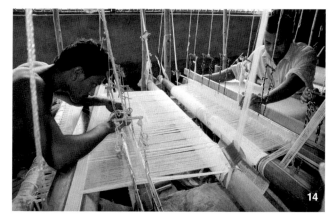

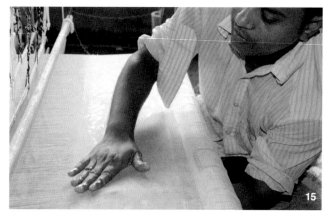

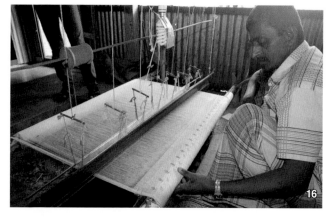

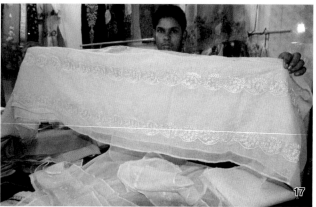

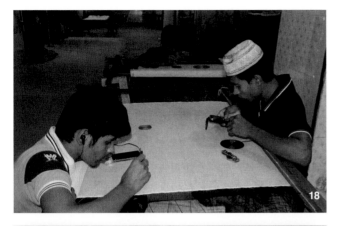

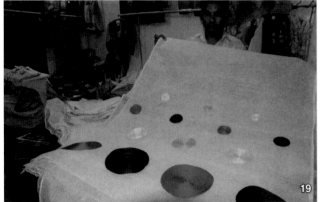

village in the location, created by the government of Bangladesh. It acts as a cluster designed to help the important traditional hand weaving skills and Jamdani textiles survive and become sustainable. Some of the plain fabrics, after being woven, were then taken to 'Idea Boutiques and Taylors', based in Taltola Market in the Khilgaon area of Dhaka, to undertake the embroidery work entirely by hand, mostly using the tambour method.

The end products brought back from Bangladesh were very high quality, which took just over one month to complete. When the finished items were handed over to the group they were positively surprised and very impressed by the outcome.

in use to achieve as near as historical muslin as possible. Some of the designs included coloured threads. Although historical Bengal weavers used very fine cotton threads to work on producing a range of muslin fabrics, currently, as today's cotton lacks the strength of the past, the weavers use thicker threads and work mostly on producing mixed silk and cotton textiles. The width of the fabrics currently produced is just over forty inches so the weaver in Bangladesh had to adapt their looms to produce a one yard width fabrics to meet the requirements of the past.

The weaving work was carried out by a family of Jamdani weavers, headed by Mohammed Abu Mia, situated in Rupganj, about twenty miles from Dhaka City in Bangladesh. There exists a Jamdani

Working with the fabrics

The time that it took to produce the chosen garments was longer than originally anticipated. The volunteer fashion recreators were required to undertake the entire process of recreating historical items by hand sewing. No one in the group had much, if any, previous experience of hand sewing and on historical pattern cutting / dress making. The expert facilitators were required to provide more support than originally anticipated. The group met regularly sometimes once every week at the Rich Mix Centre in Shoreditch and Heba Women's Centre in Brick Lane. The participants were from diverse backgrounds, who possessed a variety of different skills, talents and previous experiences. They worked extremely hard,

giving many weekends and evenings to the project, to complete the amazing project.

During the delivery phase of the project, Fathema Wahid, one of the participants, became pregnant and therefore had to take time off from attending workshops which caused a slight delay in her progress towards the dress completion. Later, after having the baby, she restarted participation in the workshops by bringing her new born son to introduce to the group. A few months later, Alice Gordon, one of our expert facilitator also became pregnant which mean that she also could not provide the levels of support originally anticipated. Third in the number, another participant, Sima Rahman-Huang, also became pregnant. This makes one wonder, perhaps, some of the historical legends and myths behind the muslin textile perhaps were true after all.

Conclusion

The rest of the book consists of the story of Bengal textiles and the place of muslin fabrics within that history; the story of muslin in the UK and chapters by each of the Heritage Fashion Recreators.

(14-19): Weavers in Bangladesh working on the specifications
(20): Fortnightly sewing workshops
(21, 22): Completed orders from Bangladesh being presented to the group

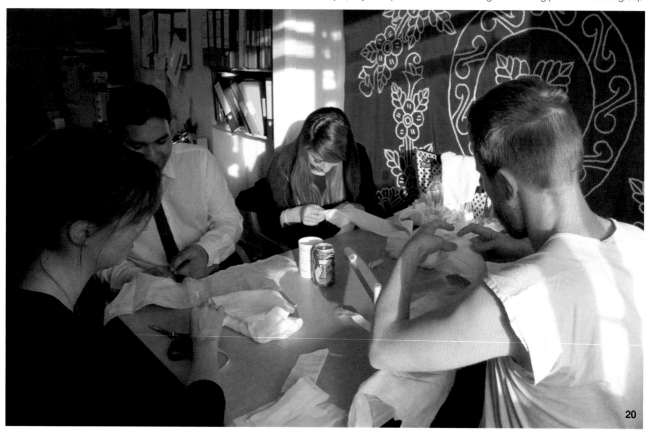

20

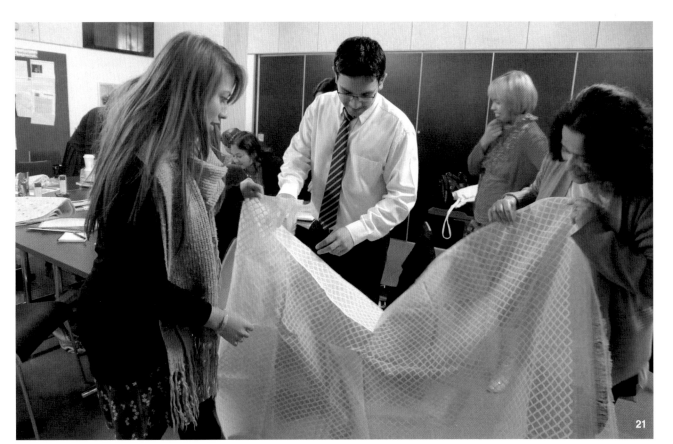

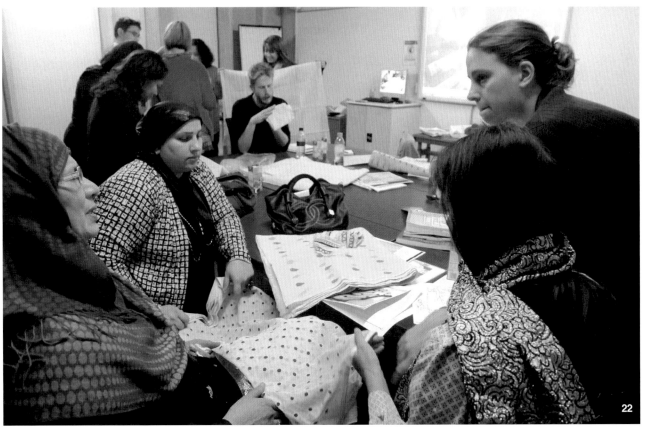

History of Bengal Textiles

Present day Bangladesh, particularly the Dhaka region, stretching from Mymensingh in the north to Barisal in the south, was for centuries the centre of the most prized and superfine hand woven cotton textiles in the world. Traders came from many places around world to purchase the highly regarded cotton textiles and silk that ordinary people in the region produced. Many outside travellers to the region and buyers of textiles talked about the quality and reputation of Bengal textiles wherever they went and wrote about their experiences, often imagining mythical descriptions. Through various reports and writings one knows how the textile products of Bengal villages in past history were highly valued, sought after and enjoyed by people around the world. An example of how far in history the reputation of Bengal stretches to can be seen from the following quotation from Campus:

"There was a time when the muslins of Dacca shipped from Satgaon clad Roman ladies and when spices and other goods of Bengal that used to find their way to Rome through Egypt were very much appreciated there and fetched fabulous prices..."

History of the Portuguese in Bengal, (J. J. A. Campos)

Textile Map of Bengal, Early 18th Century

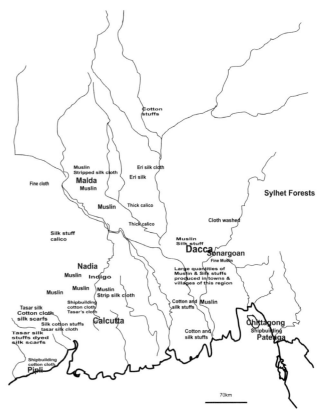

The Bay of Bengal

Map 1: Based on map by KN Chaudhuri (The Trading World of Asia and the English East India Company: 1660-1760).

There were many types and varieties of textiles produced in the Bengal region, both for internal consumption and export purposes, based on cotton,

silk and mixed threads. In addition, raw silk was an important export item of Bengal and at times constituted about a fifth of the total. Each type of the woven textile had a wonderful name, often describing beauty or aesthetic feelings generated from human interaction with nature. The types of items produced ran into hundreds but a number of woven cotton fabrics were grouped together due to a number of common characteristics and called muslin. The main characteristics shared by textiles called muslin were that they were made from very fine cotton threads, loosely woven and looked a bit transparent. Bengal was one of several textile export centres in India, each one with its own unique specialisations, supplying fabrics to the world.

The first Europeans to directly bring back textiles from Bengal and elsewhere in India were the Portuguese, from the early 1500s. The Dutch and the English joined the Indian Ocean trade from early 1600s but their textile trade mainly consisted, at first, of inter-Asia trade where they bought Indian textiles to exchange for Indonesian spices and other Asian goods.

Until around the middle of the 17th Century Britain was quite an uneventful place regarding clothing, textiles and fashion. This situation began to change however from the latter half of the century and did so quite rapidly and dramatically. India as a whole was the main source of that transformation, the first place being Gujarat, followed by Madras and then finally

Bengal. The sea voyages by the English East India Company to Asia brought back spices, textiles and other useful items to Britain and helped transform the country from a relatively dull place to something increasingly exciting. An indication of how that change was viewed at that time can be seen from Defoe's Everybody's Business is Nobody's Business, where he observed that a

...plain country Joan is now turned into a fine London madam, can drink tea, take snuff, and carry herself as high as best. She must have a hoop too, as well as her mistress; and her poor scanty linsey-woolsey petticoat is changed into a good silk one, four or five yards wide as the least.

According to Niall Furguson, 'In the seventeenth century, however, there was only one outlet the discerning English shopper would buy her clothes from. For sheer quality, Indian fabrics, designs, workmanship and technology were in a league of their own. When English merchants began to buy Indian silks and calicoes and bring them back home, the result was nothing less than a national make over'. Every aspect of British life became entangled with things Indian. 'In 1663 Pepys took his wife Elizabeth shopping in Cornhill, one of the most fashionable shopping districts of London, where, according to his words, 'after many tryalls bought my wife a Chinke (chintz); that is, a paynted Indian Calico to line her new Study, which is very pretty'. When Pepy's himself sat for the artist John Hayls he went to the

trouble of hiring a fashionable Indian silk morning gown, or banyan. In 1664 over a quarter of a million pieces of calico were imported into England. There was almost as big a demand for Bengal silk, silk cloth tafetta and plain white cotton muslin. As Defoe recalled in the Weekly Review of 31 January 1708: 'It crept into our houses, our closers, our bedchambers; curtains, cushion, chairs, and at last beds themselves were nothing but Calicoes or Indian stuffs.' (Empires: How Britain made the modern world, Niall Furguson).

The first place that the East India Company visited in the Indian subcontinent was Gujarat in 1607, primarily to buy Indian textiles to exchange for spices from the Indonesian spice islands. For about three decades this was the main source from where the Company purchased most of its Indian textiles. Then from 1640, when the Company established a base in Madras in South India another important centre was added to its sources of textiles. The third centre, which subsequently became the most important was Bengal, where the company started to purchase textiles from around 1660s. At first the Bengal element was very low but gradually increased to become the main provider of the East India Company's textile needs. By 1725 Bengal's contribution to East India Company's textile export was bigger than the other two centres combined and this continued throughout the 18th century. This means that a significant amount of Indian textiles to Britain came from Bengal.

Although the British imported large quantities of textiles from Bengal between the late 17th century and throughout the 18th century there exist very little physical evidence of how they were used in fashion. However, many fashionable ladies items from the later Regency period (1790-1820), made from Indian muslins, still survive in museums and collections around the UK and beyond. This was also the period when Jane Austen was writing her now famous novels and enjoying fashion items made from muslins, which means there is an additional heritage interest with respect to the historical Bengal textiles. 'By the late 18th Century Indian textiles were the height of fashion. In 1814 alone over 1.25 million Indian cloths were exported to Britain. The Dictionary of Traded Goods and Commodities explains how they were put to use. For example, we are told that Indian Muslin, a lightweight cotton, was used for "ruffles, cravats and handkerchiefs but also gowns and ladies dresses ". This shows that both men and women wore Indian muslin, although women in larger quantities. Muslin is also detailed in the newspapers, like on 3rd August 1821 The Guardian describes a dress constructed from four different types of muslin. It is therefore clear that Indian fabrics, like muslin, were highly fashionable.' (HIST2530 Indian Influences in Regency British Dress, Leeds WIKI).

Besides the consumption of large quantities of Indian fabrics in UK fashion and in many other every day usages, the varieties of textiles imported by the East India Company also became a valuable trade

currency. Some of the textiles items brought to the UK were for consumption, while others were re-exported to many places around the world including for the purchase of African slaves. Although it is clear that most of the re-export textiles to Africa originated in Gujarat or some from Madras, however, the sheer volume and percentage of the total textiles imported from Bengal alone means that British re-export of Indian textiles to Africa must have included an element that also originated in Bengal. For example, it is known that between 30-40% of Indian textiles imported by the East India company was re-exported to Africa during 1720-1740.

From figures provided by Bhishnupriya Gupta on the number of textile piece goods from India and by KN Chaudhury on the total value of exports from Asia by the East India Company, it is clear that the vast majority of the textiles were from Bengal. According to Bhishnupriya Gupta, of the 3,130,000 pieces of Indian textiles imported by Britain from India, during the twenty years period in question, 2,066,000 (66%) came from Bengal. In terms of value, during the same period, KN Chaudhuri put Bengal's share of East India Company's exports from India to be around 70%. Further, according to Prasannan Parthasarathi, during that time, 'Indian textiles accounted for about a third of British exports to Africa. From the 1740s, Indian cloth represented a smaller fraction of British exports, but the quantity of Indian textiles sold in west Africa exploded because of the tremendous expansion in the slave trade in the second half of the eighteenth

century' (The European Response to India Cottons). This means that there is a slave connection to textiles produced by Bengal weavers, although the proportion of textiles that came from western India that were re-exported to Africa were probably far higher than Bengal textiles.

Bengals' legendary reputation

Britain became increasingly familiar with Bengal from the late 17th Centuries primarily through the imports of its textile. However, the region was already a well known place around the world for its fine weaving, particularly cotton, and rich textile history. The tradition of high quality fabrics making goes back to ancient times and there are records of textiles of this regions being exported to Rome before Christ was even born, especially muslin fabrics. This story is not known very well or appreciated now, either in Bengal / Bangladesh or outside the Indian subcontinent. According to Campus, 'There were times when the muslins of Dacca shipped from Satgaon clad Roman ladies and when spices and other goods of Bengal that used to find their way to Rome through Egypt were very much appreciated there and fetched fabulous prices.'(History of the Portuguese in Bengal, by JJA Campus). Many ancient and past travellers to the land had written accounts of the quality, variety and fame of Bengal and its textiles. Following are some examples of historical reports of Bengal textiles, particularly of the fine muslin varieties:

"The Provinces of Bengala are very extensive and are much frequented by foreigners, owing to the trade there, both in food-stuffs, as I have remarked above, as also in fine cloth. So extensive is the trade that over one hundred vassals are yearly loaded up in ports of Bengala with only rice, sugar, fats, oils, wax, and other similar articles.

Most of the cloth is made of cotton and manufactured with delicacy and propriety not met with elsewhere. The finest and richest muslins are produced in this country, from fifty to sixty yards long and seven to eight handbreadths (22/2) wide, with borders of gold and silver or coloured silks. So fine, indeed, are these muslins that merchants place them in hollow bambus, about two spans long, and, thus secured, carry them through Corazane, Persia, Turkey, and many other countries."

Travels of Fray Sebastian Manrique (1629-1643)

"It was also about this time (Dharmapala) (775-812 AD), too, that a regional economy began to emerge in Bengal. In 851 the Arab Geographer Ibn Khurdadhbih wrote that he had personally seen samples of the cotton textiles produced in Pala domains, which he praised for their unparalleled beauty and fineness.

As early as 1415 we hear of Chinese trade missions bringing gold and silver into the delta, addition

to satins, silks, and porcelain. A decade later another Chinese visitor remarked that long-distance merchants in Bengal settle their accounts with tankas. The pattern continued throughout the next century. "Silver and Gold", wrote the Venetian traveller Cesare Fedeci in 1569, "from Pegu (Burma) they carried to Bengala, and no other kind of Merchandize." The monetization of Bengal's economy and its integration with markets throughout the Indian Ocean greatly stimulated the region's export-manufacturing sector.

Although textiles were already prominent among locally manufactured goods at the dawn of the Muslim encounter in the tenth century, the volume and variety of textiles produced and exported increased dramatically after the conquest. In the late thirteenth century, Marco Polo noted the commercial importance of Bengali cotton, and in 1345 Ibn Battuta admired the fine muslin cloth he found there. Between 1415 and 1432 Chinese diplomats wrote of Bengal's production of fine cotton cloths (muslins), rugs, veils of various colors, gauzes (pers., chana-baf), material for turbans, embroidered silk, and brocaded taffetas.

A century later Ludovico di Verthema, who was in Gaur between 1503 and 1508, noted: "Fifty ships are laden every year in this place with cotton and silk stuffs… These same stuffs go through all Turkey, through Syria, through Persia, through Arabia Felix, through Ethiopia, and through all India". A few years later Tome Pires described the export of Bengali textiles to ports in eastern half of the Indian Ocean.

Clearly, Bengal had become a major centre of Asian trade and manufacture."

The Rise of Islam and the Bengal Frontier, Richard M. Eaton

"There was a time when the muslins of Dacca shipped from Satgaon clad Roman ladies and when spices and other goods of Bengal that used to find their way to Rome through Egypt were very much appreciated there and fetched fabulous prices...

Regarding the trade and wealth of Bengal, the Portuguese had the most sanguine expectations which did not, indeed, prove to be far from true. Vasco de Gama had already in 1498 taken to Portugal the following information: "Bengala has a Moorish King and a mixed population of Christians and Moors. Its army may be about twenty-four thousand strong, ten thousand being cavalry, and the rest infantry, with four hundred war elephants. The country could export quantities of wheat and very valuable cotton goods. Cloths which sell on the spot for twenty-two shillings and six pence fetch ninety shillings in Calicut. It abounds in silver".

From time to time Albuquerque had written to King Manoel about the vast possibilities of trade and commerce in Bengal. When the Portuguese actually established commercial relations in Bengal, they realised to their satisfaction what a mine of wealth they had found. Very appropriately, indeed, did the

Mughuls style Bengal, "the Paradise of India"...

The Portuguese shipped various things from Bengal, seat as it was of a great many industries and manufactures. Pyrard de Laval who travelled to Bengal in the beginning of the 17th century says, "The inhabitants (of Bengal), both men and women, are wonderously adroit in all such manufactures such as of cotton, cloth and silks and in needlework, such as embroideries which are worked so skilfully, down to the smallest stitches that nothing prettier is to be seen anywhere." The natural products of Bengal were also abundant, and various are the travellers who have dwelt on the fertility of the soil of Bengal watered as it is by the holy Ganges...

Dacca was then the Gangetic Emporium of trade. It was there that those priceless muslins were made even as early as the Roman days. Its thread was so delicate that it could hardly be discerned by the eye. Tavernier mentions, "Muhammad Ali Beg when returning to Persia from his embassy to India presented Cha Shafi III with a cocoanut of the size of an ostrich egg, enriched with precious stones, and when it was opened a turban was drawn from it 60 cubits in length, and of muslin so fine that you would scarcely know what it was had in your hand."

These muslins were made fifty and sixty yards in length and two yards in breadth and the extremities were embroidered in gold, silver and coloured silk. The (Moghul) Emperor appointed a supervisor in

Dhaka to see that the richest muslins and other varieties of cloth did not find their way anywhere else except to the Court of Delhi. Strain on the weavers' eye was so great that only sixteen and thirty years old people were engaged to weave. There are the men who with their simple instruments produced those far-famed muslins that no scientific appliances of civilized times could have turned out."

History of the Portuguese in Bengal (J. J. A. Campos)

Key players, routes and products of Bengal trade

India as a whole has a very long and rich history of producing and trading in amazing varieties of textiles, including cotton and silk, both plain and with designs. Plain fabrics were of many varieties also, ranging from highly fine and transparent muslin to coarse materials for ships' sails. The designed items were made from design woven during the weaving process to painting and block printing. Although all regions and areas in India produced a variety of textiles, cotton based fabrics were its most prized items and the Indian subcontinent was the dominant producer in this regards for centuries. According to Prasannan Parthasarathi and Giorgio Riello, during 1200-1800 AD, 'the bulk of the cottons that crisscrossed the globe had their orgins in the Indian subcontinent, which was the pre-eminent centre for cotton manufacturing in the world until the nineteenth century' (The Spinning World: A Global History of Cotton Textiles, 1200-1850, Giorgio Riello and Prasannan Parthasarathi).

All places in India, especially urbanised locations, had centres of textile production. Most producing areas catered for the needs of ordinary people, rulers, elite groups, business people, government officials, army, etc. However, certain, locations and regions within the Indian sub-continent developed many types of specialisations in textile production and over time evolved into large exporting areas (Bengal, Gujarat, Masulipatam and Punjab). Most of Punjab's textiles exports went to western and central Asia through land routes while a large proportion of the other three regions' textiles were exported by sea to various locations in the Middle East, Africa and South East Asia. Further, from the Middle East many Indian textiles were taken to various locations in Europe. However, after the arrival of the Portuguese to India in the late 15th century a small amount of textiles from there started to travel directly to Europe, which rapidly increased after the Dutch and the British joined in the Indian Ocean trade from early 17th Century. Some aspects of Bengal's international trade can be seen from the following:

"It is well-known... that so far as Bengal's International trade was concerned, the huge demand for its commodities in the global markets, especially its textiles and raw silk, attracted buyers from various parts of the world. As Bengal during this period (1650-1757) was self-sufficient and as the market for

import commodities was strictly limited, almost all these traders, whether Europeans or Asians, had to bring in precious metals, mostly silver, to Bengal for the procurement of the export commodities. Thus the influx of silver to Bengal in the seventeenth and the early half of the eighteenth century was because of Bengal's favourable balance of trade with the rest of the world.

European Trade, Influx of Silver and Prices in Bengal (1650 - 1757), Sushil Chaudhury

In addition to exporting Indian textiles abroad the Indian subcontinent had thriving inter-regional and mutually dependent trade. For example, Gujarat had a thriving silk manufacturing industry, producing beautiful varieties of silk textiles, but most of the raw silk for this came from Bengal. On the other hand, demand for Bengal's cotton textiles were so great that the local production of raw cotton was insufficient to meet the amount needed so a large quantity of Gujarat raw cotton were imported each year. Gujarat cotton was however not very fine and could not be used to produce the top quality muslins. They were instead used to manufacture more coarser materials. The high quality fine textiles that came to be known as muslin were primarily manufactured by raw cotton grown in East Bengal within a narrow strip of land along the Brahmaputra river from Meymansingh to Barisal. The fine textiles produced by this cotton became known as Dhakaya Muslin. It was Dhaka

region's own native cotton that was said to be both soft and strong at the same time, which produced muslins: the famous textiles of Bengal. The quality of the soil, high levels of rain and the local environmental factors all contributed to help evolve the legendary muslin cotton plant and the local people developed specialised skills to produce superfine threads from which beautiful textiles were woven with their hands.

For a very long time Bengal had a thriving direct sea-borne and land routes based trade with many parts of the world and its manufactured textiles also reached near and far away places through indirect routes and second hand trade. The Indian Ocean was very busy with ships and boats taking goods to and from many locations, along long established trading routes. When the Portuguese first arrived in the Indian Ocean on the eve of the 16th Century they began to destroy and change the old trading networks and the operations of the long established trading systems involving Africa, Middle East, India, South East Asian and China. The process got speeded up after the Dutch and English established their trade in the India Ocean from early 17th century onwards. Information about the ancient trade of India, including that of Bengal) have been written by many past travellers.

According to Tom Pires, a Portughese traveller during the early 16th Century, 'A junk (four or five ships) goes from Bengal to Malacca once a year and sometimes twice. Each of these carries from eighty to ninety thousand cruzados worth. They bring fine cloths,

seven kinds of sinbafos, three kinds of chautares, beatilhas, beirames and other rich materials... cut-cloth work in all colours and very beautiful... Bengal cloth fetches as high price in Malacca, because it is a merchandise all over the East' (Pires, Suma Oriental). Sanjay Subramanyan recently wrote on Bengal's sea-born trade during the 16th Century. In the 'Notes on 16th Century Bay of Bengal Trade' he provides information and details of Bengal's trade with Burma, Malaka, Sri Lanka, Maltives, Gujarat and the Middle East. A variety of goods were imported and exported, and textiles of Bengal were a very important element of its total exports. '... by the early sixteenth century, the Bengal region was a major exporter of textiles to many regions in Asia, a distinction it shared with two other parts of India: namely, Coromandel and Gujarat... Bengal was celebrated, however, not merely for its textiles... the region was a considerable exporter of grain (particularly rice)... which were carried to a diversity of destinations. Bengal was also known for its production and export of sugar...'

According to Sanjay Subramanyam, Bengal's seaborne trade mainly consisted of four routes. Table 1 below provides details of Bengal's exports to a number of locations, which includes textiles.

After the Europeans entered direct trade with India and Asia Europe became another destination for Bengal's exports, particularly textiles. In this regard, the Dutch and English were the biggest trading

Table 1: Bengal's seaborne trade mainly consisted of four routes

From Bengal	Export
Maleka	'The first set were the eastward routes, dominated by the trade to the great entrepot of Melaka- supplied from Bengal with textiles, rice, sugar and conserves.'
Middle India Ocean	'To Sri Lanka, Malabar and the Maldives. To all these areas, Bengal again exported textiles and foodstuff, and the rice export to the Maldives was in fact one of the constant features of Bengal trade in the sixteenth and seventeenth centuries.'
Trade with Burma	'there come each year four or five naus of Bengalla [to Cosmin],and the goods that these naus bring are sinabafo textiles and every other cloth which is consumed in the kingdom.'
Western Indian Ocean	'Direct links between the Bengal ports and the Red Sea and the ports of Gujarat - included textiles, sugar and Bengal long pepper. In the case of Gujarat, strong links between Bengal and the ports of Chaul, Dabhol and Cambay.'

partners. At first, the Dutch imports from Bengal were larger but from around the first quarter the of the 18th Century the English established a position of dominance which remained and continued to grow until they finally took control over Bengal after the Battle of Plassey in 1757. From then on the British virtually monopolised Bengal's textile trade and squeezed other traders, both Europeans and Asians, out of the region.

Tables 2/3 and Graphs 1-3 show the scale of British imports of goods from Asia and India, and Bengal's share. The first is on the total value, based on five yearly intervals, between 1665 and 1760, developed from annual figures generated by KN Chaudhuri. Textiles were about 71-81% of the total value of goods imported from Bengal to the UK by the East India Company. The second, based on the work of Bhishnupriya Gupta, show the number of items of textiles imported by the British from the Indian subcontinent during 1665-1849 and Bengal's total share. Both the tables and associated graphs show that from around the end of the first quarter of the 18th Century Bengal's share of total exports of textiles from Asia by the British was higher than all other locations combined.

From various others sources it has been established that around 71-81% of the total imports were textiles in the case of Bengal.

Bengal

Various locations within Bengal developed their own specialisations in the production of textiles. The Dhaka region in present day Bangladesh became famous for its fine muslins, although the area also produced a range of other textiles. In West Bengal the main locations for textile production were Hugli, Kasimbazar and Malda, where they also produced muslins. Most of the fine and luxury quality muslins exported by the East India company to Europe were from the Dhaka region. According to East India Company records they were in their Anglicised names: Addadies, Cossaes, Dimitties, Jamdanees, Mulmuls, Nainsooks, Seerbands, Seerbettes, Shalbafts, Tanjeebs and Terrindams. The table below lists the most frequently exported textiles by the East India Company from different locations within Bengal.

Total East India Company exports from the Indian sub-continent in value (£) (1665 - 1760)						
	Bombay	Madras	Bengal	SE Asia	China	Total
1665	63130	53100	23867	17903	0	158755
1670	74181	70182	25358	47206	0	216927
1675	35471	58568	29732	43845	807	169172
1680	97416	131532	77951	30932	13899	356465
1685	183469	171240	211900	1650	4869	584019
1690	65034	19376	3970	9124	13646	120971
1695	228	0	28212	158	351	28949
1700	192341	53932	237121	634	5511	501501
1705	5562	73489	65893	6571	51150	204010
1710	94168	81840	173819	6789	0	370547
1715	15860	85475	163859	5034	0	282837
1720	59302	94544	332792	10026	37005	580510
1725	109192	80803	191117	0	20885	450665
1730	18753	37205	431581	0	124807	612346
1735	97287	164372	400988	6290	377777	751541
1740	11346	54257	401163	0	90444	578861
1745	80691	155626	449152	6960	60036	786869
1750	53549	165433	511177	5857	239199	1013641
1755	93923	70257	411505	12788	310029	933158
1760	20369	0	366872	0	324099	711340
Total	1371272	1621231	4538029	211767	1674514	9413084

Table 2: Based on data provided by KN Chaudhuri *(The Trading World of Asia and the English East India Company: 1660-1760).*

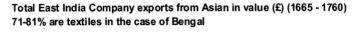

Total East India Company exports from Asian in value (£) (1665 - 1760)
71-81% are textiles in the case of Bengal

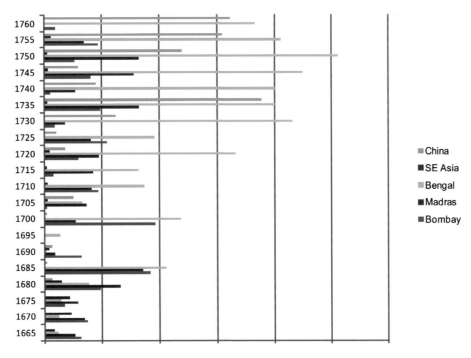

Graph 1

Total East India Company exports from the Indian sub-continent in value (£) (1665 - 1760), 71-81% are textiles in the case of Bengal

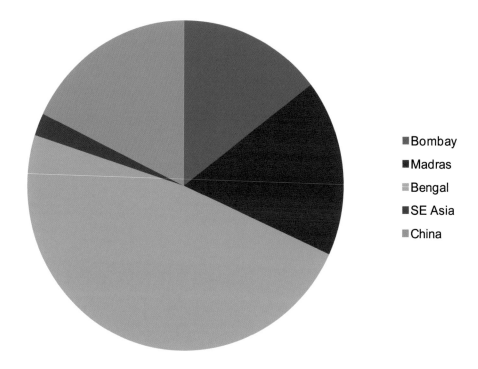

- Bombay
- Madras
- Bengal
- SE Asia
- China

Graph 2

Total East India Company exports from the Indian sub-continent in value (£) (1665 - 1760), 71-81% are textiles in the case of Bengal

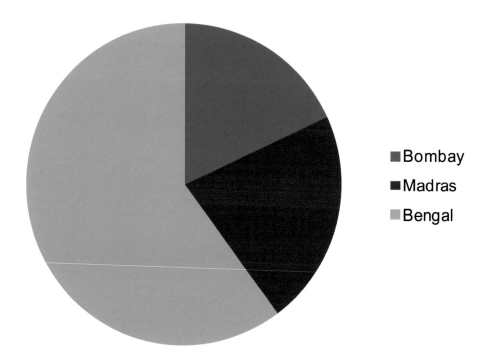

- Bombay
- Madras
- Bengal

Graph 3

#	Name	Origin	Quality/Use	Dimensions	Period
1	Addaties - plain white muslin	Bengal - Dacca district	Medium to fine quality. Fashionwear and re-export trade		17th-18th
2	Allibannies - mixed cotton and silk, probably striped	Bengal - Malda-Kasimbazar area	Medium to superior quality - fashionwear and re-export trade		17th-18th
3	Atchabannies - plain white	Bengal	Course quality - domestic and general use		18th
4	Bandannoes - silk handerchief, dyed in the thread	Bengal - Kasimbazar	Superior to fine quality - fashionwear and re-export trade		17th-18th
5	Bafta - plain white	Bengal and Bihar - Dacca, Jugdea, Patna	Medium to superior quality - clothing and block printing in England	13-18 yards * 1 yard	18th
6	Carridarries - mixed cotton and silk striped	Bengal	Medium to superior quality - clothing and re-export trade		18th
7	Cherconnaes - mixed cotton and silk, striped and checks	Bengal	Fine quality - Fashionwear and re-export trade		17th-18th
8	Chillaes - striped cotton in blue and white	Bengal	Medium quality - clothing and re-export trade		18th
9	Chintz, block printed	Bengal and Bihar - Kasimbazar, Patna and Calcutta	Medium to superior quality - Domestic and general use, re-export and colonial trade		17th-18th
10	Chowtars - plain white	Bengal and Bihar	Medium to superior quality - clothing and re-export trade	13 yards * 1 yards	17th-18th
11	Coopees - plain white	Bengal	Medium to superior quality - clothing and re-export trade		18th
12	Cushtaes - striped blue and white	Bengal - Nadia district	Medium to superior quality - clothing and re-export trade		18th
13	Chucklaes - mixed cotton and silk, striped	Bengal	Fine quality - fashionwear and re-export trade		17th-18th
14	Cuttanees - plain white and striped	Bengal	Superior to fine quality - fashionwear and re-export trade		17th-18th
15	Cossaes - plain white muslin	Bengal - Santipur and Dacca district	Fine quality - Fashionwear and re-export trade	20 yards * 1-1.5 yards	17th-18th
16	Dysooksies - plain white muslin	Bengal	Fine quality - fashionwear and re-export trade		18th
17	Doreas - mixed cotton and silk	Bengal, Malda-Kasimbazar area	Fine to superfine - fashionwear and re-export trade		17th-18th
18	Dimitties - plain white muslin	Bengal and Orissa - Dacca and Balasore	Fine quality - fashionwear and re-export trade		17th-18th
19	Dosooties - plain white muslin	Bengal	Medium, fine and superfine quality - fashionwear and re-export		18th
20	Elatches - mixed cotton and silk, striped	Bengal - Malda, Bihar - Patna	Fine quality - fashionwear and re-export trade		18th
21	Emerties - plain white,	Bihar - Patna	Medium quality - general use and block printing in England and re-export trade	13-18 yards * 0.75 yards	17th-18th
22	Ginghams - mixed cotton and silk, striped	Bengal - Kasimbazar	Medium quality - fashionwear and re-export trade		17th-18th
23	Gurrahs, plain white	Bengal - Kasimbazar-Malda area	Medium quality - Domestic and general use, block printing in England and re-export trade	15-33 yards * 1 yard	17th-18th
24	Handkerchief - cotton and silk mixed	Bengal	Medium to fine quality - clothing		17th-18th
25	Hummums - plain white muslin	Bengal	Superior to fine quality - clothing and re-export trade		17th-18th
26	Jamdanees - brocaded white or coloured silk	Bengal - Dacca district	Luxury quality - fashionwear		17th-18th
27	Jamwars - silk brocade	Bengal - Kasimbazar	Luxury quality - fashionwear	10-18 yards * 0.75 yards	17th-18th
28	Lacowries - plain white	Bihar - Patna and Lakhowar	Course to medium quality - Domestic and general use, re-export trade		17th-18th
29	Mulmuls - white plain, base cloth for fine embroidery or flowering on the loom	Bengal - Santipur and Dacca district	Fine to superfine quality - fashionwear and re-export	20 yards * 1 yard	17th-18th
30	Nainsooks - plain white muslin	Bengal - Dacca district	Superfine to luxury quality - fashionwear		18th
31	Nillaes - mixed cotton and silk, striped	Bengal	Medium to superior quality - clothing and re-export trade		17th-18th
32	Photaes - dyed calico	Bengal	Coarse to medium quality - domestic and general use, re-export trade		17th-18th
33	Peniascoes - mixed cotton and silk, striped	Bengal	Medium quality - clothing and re-export trade		17th-18th
34	Romalls, handkerchief	Bengal	Medium quality - clothing		17th-18th
35	Silk lungees - silk handerchief used in India as a sarong	Bengal - Kasimbazar	Clothing		17th-18th
36	Sannoes - plain white	Orissa - Balasore	Medium quality - domestic and general use, re-export trade		17th-18th
37	Shalbafts - plain white muslin	Bengal	Fine quality - fashionwear and re-export trade		17th-18th
38	Seerhaudconnaes - plain white muslin	Bengal - Dacca district	Luxury quality - fashionwear		18th
39	Seerbettes - plain white muslin	Bengal - Dacca district	Fine to superfine quality - fashionwear and re-export		18th
40	Seerbands - plain white muslin	Bengal - Dacca district	Medium to fine quality - clothing and re-export trade		17th-18th
41	Seersuckers - mixed cotton and silk, striped	Bengal - Kasimbazar	Medium to superior quality - clothing and re-export		18th
42	Sooseys - mixed cotton and silk, striped	Bengal - Kasimbazar	Fine quality - fashionwear and re-export trade		17th-18th
43	Taffetas - silk piece goods	Bengal - Kasimbazar	Fine quality - fashionwear and re-export trade		17th-18th
44	Tanjeebs - plain white muslin	Bengal - Dacca district	Fine quality - fashionwear and re-export trade		17th-18th
45	Terrindams - plain white muslin	Bengal - Dacca district	Fine to superfine quality - fasionwear and re-export		17th-18th
46	Tepoy - mixed cotton and silk	Bengal	Fine quality - clothing and re-export trade		18th

Table 3: East India Company's Textile Imports from India to Britain (1665-1760)
Above table based on information from *The Trading World of Asia and the English East India Company: 1660-1760* by KN Chaudhuri

During the Ottoman empire large quantities of Dhaka muslins were exported to Turkey and Persia. Besides the Moghuls in Delhi and Agra, there were other very important Asian regions for the consumption of the luxurious textiles of Bengal. During Moghul rule muslins were among the top quality Indian textiles consumed by the rulers, their families, noblemen, etc. Moghuls also helped to expand and develop deeper connections between different Indian regions under their rule and beyond to expand trade and increase government revenue.

The arrival of the Europeans injected new demands and creativity within the various textile exporting regions in India, perhaps increasing Bengal's own production by around 33%, which generated additional economic development and created many local jobs. This percentage is based on Sushil Chaudhury's calculation of the total share of Bengal textile exports carried out by the Europeans.

"The textile export by Asian merchants can be computed at around Rs 9 million to Rs 10 million a year, while the total exports of Bengal textiles by the Europeans did not exceed Rs 5 or 6 million. While the total value of silk exported by the Asian merchants is estimated at around Rs 5.5 million on an average during the period from 1749 to 1753, and Rs 4.1 million from 1754 to 1758, the average annual value of the European export of silk was only around Rs 0.98 million over the same period. In other words, the Asian share of silk exports from Bengal was 4 to 5 times more than the European share in the pre-Plassey period."

The Prelude to Empire, Sushil Chaudhury

Map 2, based on a map in 'The Trading World of Asia and the English East India Company: 1660-1760' by KN Chaudhuri, shows the Asian trading routes and how the Indian subcontinent was connected with the outside world during the early 18th century. Bengal was connected with many places in India, Asia and Europe, by land and sea, including with the inland trading world of the Great Silk Road, Persia, Ottoman Empire and Arabia.

Decline of trade and technique

During its long history a number of factors, including changing political and dynastic situations, caused the demand and taste for Bengal textiles to vary from time to time. New markets and new geographical locations around the world were added and sometimes lost. For example, during the 16th, 17th and 18th centuries Europeans directly shipped Bengal textiles to Europe and elsewhere, although this trade was relatively small during the 16th Century, which was primarily undertaken by the Portuguese. The main destinations for the Portuguese export of Bengal goods, including textiles, were the various ports in Asia, some of which they controlled directly, such as Maleka and Goa, and others like Sumatra, Borneo, Maldives, China and Japan with which they were engaged in trade. On the other

hand, after the British took over of Bengal in 1757, the new power in charge slowly squeezed out most of the foreign buyers of Bengal textiles from the region and significantly reduced Bengal's trading links with the outside world. By the end of the 18th century there were very little direct exports of Bengal textiles by parties other than the British (East India Company and private traders) and their local partners.

Soon after the British conquest of Bengal the East India Company stopped paying for their textile purchases using cash brought in from Britain. Instead they switched to utilising from elements of the revenues they got from Bengal taxes to purchase Bengal textiles. They also made life difficult and near impossible for other countries to trade with Bengal. In effect they cut off or reduced Bengal's independent trading links with traditional trading partners and monopolised the buying of textiles, imposed conditions and forcibly lowered prices that they paid to weavers for textiles purchased.

"From the final decade of the eighteenth century cloth exports from South Asia had already begun to decline for a variety of reasons, including the monopsony that the English East India Company had built in Bengal and South India, which blocked manybuyers from obtaining cloth."

Cotton Textile Exports from the Indian Subcontinent, 1680-1780, Prasannan Parthasarathi

ASIAN TRADE ROUTES, EARLY 18TH CENTURY

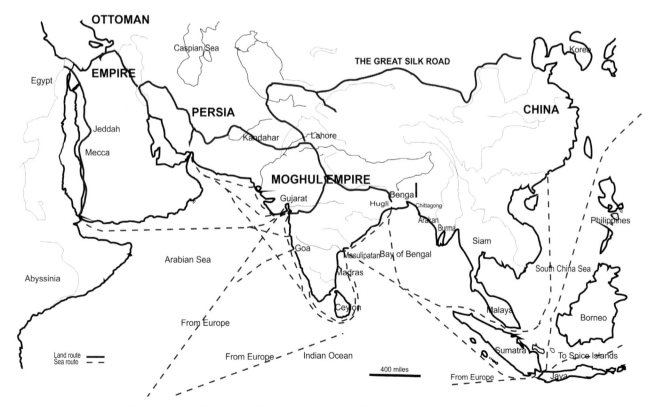

Map 2: Based on map by KN Chaudhuri (The Trading World of Asia and the English East India Company: 1660-1760)

Table 4 shows what happened to Dhaka cotton trade during the first forty years of British rule after the East India Company's conquest of Bengal. In 1747, ten years before the Battle of Plassey in 1757, there were about thirteen main destinations for cotton exports, which generated 285,000,000 in Arcot Rupees. Fifty years later in 1797, there were only three types of buyers left and the total value of Dhaka cotton exports reduced to 140,154,500 in Arcot Rupees. This is less than half of what it was fifty years earlier. Evidence suggests that as the East India Company squeezed more out of the weavers, more textiles for less money, through their monopoly and domination of the market, the reduction of the monetary value into half does not mean that the quantify was also reduced proportionately.

Soon afterward the declining state of Bengal textiles manufacturing experienced another massive shock which ultimately brought the extra ordinary history of the region's fabric manufacturing to something quite insignificant. This was caused by the industrial revolution that started in England and the East India Company's flooding of the captured Bengal market with cheaper machine made cotton goods from Britain. The Bengal textile industry then declined rapidly and by around the 1850s there were hardly anything left of its past glory. These factors caused

Dhaka cotton goods trade	Value in Arcot Rupees	
Buyers	**1747**	**1797**
The Emperor of Delhi	10,000,000	
The Nawab of Murshidabad	30,000,000	
Jagath Seth at Murshidabad	15,000,000	
Turani Merchants for sale in North West India	10,000,000	
Pathan Merchants	10,000,000	
Armenians for Basra, Mocha and Jidda Markets	50,000,000	
Mughal merchants for external and internal markets	40,000,000	
Hindu merchants for home market	20,000,000	63,702,500
English Company for Europe	35,000,000	50,738,800
Individual (English) merchants for exports	20,000,000	25,713,600
French company for Europe	25,000,000	
French individuals	5,000,000	
Dutch company	10,000,000	
Total	**285.000.000**	**140.154.500**

Table 4: *Mohsin, K.M., Commercial and Industrial Aspects of Dhaka in the Eighteenth Century, Dhaka: Past Present Future, edited by Sharif Uddin Ahmed*

the once famous textiles industry of Bengal to demise, causing the death of the legendary fine muslin textiles. Muslin was Bengal's finest heritage that made the region famous and attracted visitors and riches to its shores for millennia.

The fine muslin textiles were produced by a special cotton variety, native to region around Dhaka, but now no known trace of that plant exist. What makes the situation even worse is the thought that the cotton plant / tree that produced the soft and strong threads for hand weaving the amazingly fine and beautiful muslin fabrics may have become extinct.

Revival

After a long period of decline the situation is now experiencing a slow positive change and there seems to be an increasing interest on the history of Bengal textiles. This is due to the efforts being made by dedicated individuals and groups involved in research and practical work. These attempts are helping to revive and promote many lost techniques and traditional methods of textile production. They are trying to help make visible the rich history of the once famous textile industry of Bengal. The aim is to achieve wider appreciation of this textile heritage and, through an increase in interest, help bring back its many lost traditions and prevent knowledge and skills currently under threat from disappearing.

Through theoretical and practical efforts the rich history of Bengal textiles is slowly finding its way to the wider consciousness of people around the world, particularly in Bangladesh and West Bengal in India. This trend is set to grow as a result of current interest and also spurred by new discoveries. An example of a chance discovery is the recent unearthing of several publications on costumes. According to Madhumita Bose, 'two series of volumes... dating back to 1866, titled, Textile Manufactures and Costumes of the People of India', which are 'rare volumes of intricate designs and weaving techniques', were stumbled upon 'while breaking open a locked cupboard'. The volume was produced by the British who used British locks to shut the cupboard, which is situated at the Industrial section of the Indian Museum in Calcutta. 'Together, the volumes present nearly 2000 fabric designs, complete with their length, breadth, weight, place and price specifications, as well as detailed archival material on weaving patterns, techniques and processes, with a companion volume on natural dyes. The whole project reflects the British zeal for detailed study'. (Himal Southasian, May 2009).

During the last few decades, especially after the partition of India in 1947 and the creation of Bangladesh in 1971, there has been a growing interest in learning about the history of Bengal textiles and the use of traditional handloom based production. In Bangladesh for example the government, soon after the birth of the country in 1971, set up a Jamdani cluster, in Rupganj, about 20 miles from Dhaka City.

This place is situated in Dhemrai in Dhaka District in Bangladesh, one of the historically famous centres of textile production in Bengal. The place is also known as Jamdani Palli (Jamdani village) where the clustering process has brought together a large number of Jamdani weavers at one dedicated place. This allows interactions, cooperation, skills and experience sharing / learning and also where buyers can come to one place to order their Jamdani sarees. The clustering policy has already had some success in helping to develop a thriving community of Jamdani weavers producing traditional style hand woven cotton and cotton/silk mix sarees. They range from very simple to highly intricate and elaborately designed items. Today the village has about 450 units, each of which consists of living quarters and several looms. A family lives in one unit and the total number of looms per unit varies from two to four. This means that in total there are about 1000-1200 handlooms in this particular village. There are other centres of production of traditional textiles throughout Bangladesh and in West Bengal in India. To the right are some images from the Rupganj Jamdani Palli.

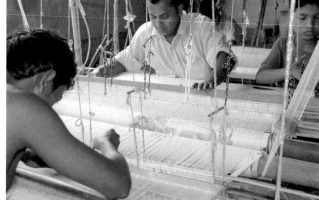

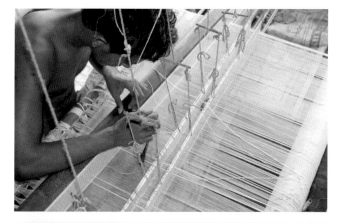

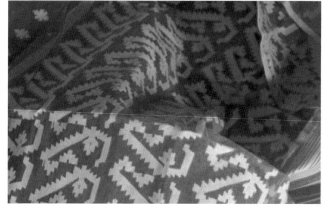

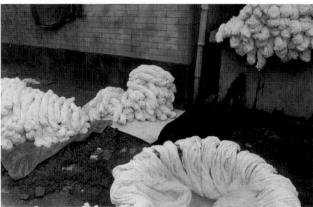
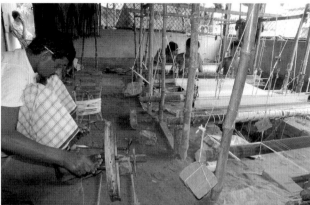
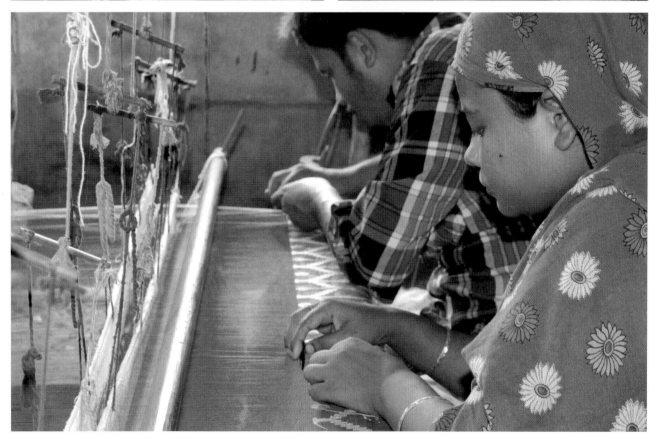

Bengal Textiles in Britain

The English East India Company started to visit Bengal from the early 1660s to directly purchase textiles from this historically important region, as well as other items such as saltpetre, turmeric and cowries. Bengal was by then already a well established place for producing a range of cotton, silk and mix textiles, including the finest cotton textiles in the world, collectively known as muslin. Earlier Gujarat and Madras were the main sources of the Company's textile procurement, some of which were utilised to purchase spices from the Indonesian islands. Although Bengal was the last major region within the Indian subcontinent to be added for British textile imports, it soon emerged as the biggest, which continued throughout the 18th and early 19th centuries.

The textiles that the East India Company imported into England from India had a significant impact quite early on in British life, initiating major changes in fashion. According to Defoe, in his book Everybody's Business is Nobody's Business, a '... plain country Joan is turned into a fine London madam'. John Blanch, a pamphleteer, wrote in 1696 that, 'thanks to the efforts of the East India Company, Indian muslin and silk are becoming the general wear in England.' Muslin textiles were utilised in a variety of ways. According to one account 'Indian Muslin, a lightweight cotton, was used for ruffles, cravats and handkerchiefs but also gowns and ladies dresses.'

In an article in The Guardian in 1821, called *Novel And Tasteful Fashion For August* several usages of muslins were identified. For example, one type consisted of an 'English Dinner Party Dress where plain Indian muslin was placed over pink satin; 'Three rows of clear muslin round the border; between which rows are broad spaces, richly embroidered in raised spots, or filled up by letting in broad lacy spotted muslin or lace sleeves to correspond, wreathed round with puffings of muslin'.

The Import and Export of Muslin

When in the 1790s the English imitation muslin was being produced in greater and greater numbers and

available more cheaply in the UK the manufacturers of this fabric still faced stiff competition due to the existence of high levels of demand for genuine Indian textiles. In order to compete with Indian muslins, which were regarded more highly, the English manufacturers often added spice scents and sometimes even sent imitation muslin items to India to be repackaged and returned to England as products of India, authenticated by adding fragrance similar to what was found on genuine Indian textiles.

From the records kept by the East India Company, in terms of orders sent, what came back to England and then how they were sold to buyers, it is possible to develop an overall picture of trends over several centuries. KN Chaudhuri's work is quite helpful in this regard (*The Trading World of Asia and the English East India Company: 1660-1760*). On an annual basis, covering 1665-1760, he produced a list of the total value of imports by the East India Company from Asia, broken down into five regions (Bombay, Madras, Bengal, SE Asia and China). His research showed that Bengal was the main source of Indian textiles imported to England, some of which were re-exported to other parts of the world.

Another list produced by KN Chaudhuri contains the number and anglicised names of the most frequently ordered textiles from western India; southern India; and Bengal, Bihar and Orissa. He provided details of the various types of textiles purchased in each of the three regions and in the sub locations from where they were procured. For example, some of the finest Muslin varieties came from the Dhaka region within Bengal while coarser items were sourced at Malda and Kasimbazar. This work is complimented by Bhishnupriya Gupta's study (*Competition and control in the market for textiles: The weavers and the East India Company*) which produced several lists, based on a number of sources, of the total number of textile items imported by the East India company from the three different regions within India, covering the period 1665–1849. Together they provide valuable details of the variety, quality and value of textiles imported into Britain from India and Bengal's share of the total.

From these two studies it is clear that the Bengal element represented the majority of Indian textiles imported by the East India Company, some for home consumption while others were re-exported. Various other sources provide additional and complementary information on the variety of Indian textiles that entered the UK fashion scene and how that caused important changes in society. A section of local merchants in England were very hostile towards the importation of foreign textiles by the East India Company.

Although textiles imported from Bengal have certainly played a significant role in British fashion trends for several centuries, there are very few garments / dresses that have been found preserved from the 17th and 18th centuries. In general, therefore, very

little is known about the usages of such historical textiles in the UK. Further painstaking research on the subject matter and wider dissemination of findings would, no doubt, help improve the situation. However, some garments and dresses that were made from Bengal muslin textiles, during the last quarter of the 18th and first quarter of the 19th century, have survived. Many such items have been stored at various museums and in private collections around the world, including London.

The imports of Bengal textiles into the UK virtually came to an end by around mid 1800s. Although nearly all the muslin textiles imported from India by the English East India Company originated in Bengal, by the late 18 century British imitation muslin started

to compete for a slice of the cake, with respect to both the home market and export trade. Many surviving muslin dresses from the late 18th and early 19th centuries were also made from machine made imitation fabrics. At first the amount of British imitation was relatively small but they grew and grew and eventually replaced muslin textiles that were previously imported from the Indian subcontinent.

(1-4): Dispatches from England, 1680-82. List of Goods to be provided at Yr Coast + Bay / Att Forte St George (Reproduced from British Library records)

ATT THE BAY.

Ginghams coulored of ye finest Sort and not too Stiff.			15000
Cossaes	13000
Mullmulls	10000
Silk Romalls 5000 of which are to be provided at			
Decca	20000
Nillaes	18000
Hummums fine of Decca	8000
Taffaties 1/2 Sad Cloth coulors & 1/2 Light Coulours			47000
where 1/3 french yellows	47000
Ditto Raw	2000
Sannoes	25000
Arund Cloth Blew 1 $^{1/8}$ yard broad & 16: yd . Long		...	1000
Ditto Brown of Ye same Length and Breadth	3000
Arund yarn	tonns		10
Raw Silk head and Belly	Bales		900
Ditto Ordinary D.N$^{o.}$ 4	600
White Silk G.H.I.	360
Ditto No. 2:3	100
Floretta yarn	150
Cotton yarn not hard Spun or Crosse reeled	100
Salt Petre (what more can be got)	tons		1000
Turmerick	250
Sticklack	50
Cowrees	100

1

CASSAMBUZAR MUSTERS.

farrendine Black	600
Sattins -- 150: Pinck	
150: french yellow	
150: Skies	
150: Crimson	
	600
Taffaties Black	7500
Ditto Green	750
Ditto Skies	750
Adathaes of each sort	300

HUGHLY MUSTERS.

Mahmood Bannies		1500
Alabanes		300
Photaes		300
Chareannees fine		600
Ditto ordinary		900
Elatches of each sort		300
Amarees		300
White silk No. 1 what quantity they can.		
Ditto No. 2	Bales	50
Ditto No. 3		50
Ditto No. 4:5:6: what quantity they can.		

More to be provided at ye Bay according to patters now sent

No. 1 Peniascoes		1000
2 Phoolganies flowered 1 yd wide: 10: yds Lond and of severall Collours as reds green Purple and Philamot Skie		3000
3 Cherklies double peices each 10 yds & one yd wide & variety of coulors		3000
4 Silk and Cotton Striped Stuffs Mundille of Malda 18 yds Long and 1 yard wide to be of variety of mixtures 100 ps. of each work & colour		1000
5 Striped Chain Taffaties 10: yds Long 1 yd: wide and to be of severall Coulors green Purpole Cornation Black Philamot yellow and Skie, the ground & Chain to be of different Coulours		3000
6 Sousaes of severall Coulors 10 yds Long 1 yd wide..		2000
7 Strip'd Taffaties or Rastees of 10 yds Long & 1 yd Broad of severall Coulors 1/2 to be Cloth : & ye other Light coulor to be done on plain without curling ...		6000
8 Strip'd Muzlings fine (Doreas) 21 yds Long 1$^{1/8}$ yd or ell wide better made at Hughly Santapore and Maulda some to be ye Strype a Little broader and Some ye Stripe a little narrower than ye Pattern ...		2000

Atlasses according to ye Inclosed Samples for Coulors
and Stripes to be made 81/2 yds Long and full 1/2 ell wide,
ye yard Broad and ye Large Stripe are not desirable
here this being a fit Length and Bread, also ye
fuller of Silk & Stronger the Better they will turn to
account though they cost somewhat more 4000

Ditto flowerd white of ye same Length and Breadth ... 500

Silk Neckcloths 10 in a piece and 1/2 yd wide 200

Girdles 2/$^{1/2}$ yards Long and 3/8 wide Gird 500

Mullmulls with fine needle work flowers wrought with
white ye flowers to be about 3 or 4 Inches asunder
and neate ye peices to be 1/18 wide at least and
Better if ell, and 21 yards Long 500

Taffities either white or Light ash to be died here into
Blacks to be 1/2 ell & naille wide and little better
and if they can be died into Black there, send non
but blacks to be double pieces or 20 yards 500

4

East India Company's purchase and distribution of Bengal textiles

The East India Company kept meticulous records of its orders of textiles sent to India, where to purchase them from - western coast (primarily Gujarat), Metchlepatam (near Madras) and The Bay (Bengal) - fabrics name, quantity, quality, designs, sizes, etc. Below are some examples.

Often not all the items requested by the East India Company from India were sent back and sometimes items not requested were also sent because agents

LONDON, the 27th of August, 1734.

CARGOES of the PRINCESS OF WALES from Bombay, and NORMANTON from Fort St. George and Bengal: Arrived on Account of the United Company of Merchants of England, Trading to the East-Indies: Viz.

	Pieces		Pieces
Anjengo Piece Goods	9240	Sannoes	1200
Baftaes	4548	Soofeys	849
Bombay Stuffs	300	Tanjeebs	867
Chelloes Blue	1700	Tapseils	600
Ditto Red	800	Ditto Large	3400
Chints Bengal	10165	Terrindams	95
Coopees	517		
Cossaes	2757	**lb.**	
Doosooties	293	1000 Aloes Socatrina	
Emerties	4000	17100 Carmenia Wool.	
Gurrahs	16805	2800 Cardemons	
Ditto Long	2765	11000 Cotton Yarn	
Humhums	862	510000 Pepper	
Lacowries	4600	28700 Raw Silk, gr. lb.	
Longcloth	21440	67000 Redwood	
Ditto Brown	2160	209000 Saltpetre	
Ditto Blue	4050	11000 Shellack	
Neganepauts	100	5100 Sticklack.	
Ditto Silk	100		
Niccannees	10320		
Ditto Large	6100	Besides several Parcels of	
Photaes	410	Goods, the Particulars	
Romals	9516	whereof are not yet	
Sallampores	17680	known.	
Ditto Bombay	3400		

"Wee have viewed the Patterns of the Maulda Musters you sent us from the Bay, and we would have you provide f them the Severall Sorts & quantities following, but take care they be exact according to Pattern

		rup	ann		
Mullmulls - No G. cost		4	. 8-two thousand	- 2000 peeces.	
Ditto	F. cost	7	. 9-two thousand	-2000	
Ditto	E. cost	16	. 11-two thousand	-2000	
Cossaes	D. cost	4	. 12-two thousand	-2000	
Ditto	No C. cost	9	. 5-one thousand	-1000	
Ditto	B. cost	9	. 0-five hundred	-500	
Ditto	A. cost	14	. 5-five hundred	-500	

all ye Cossaes to be thinner & cleerer yn. Ye Samples

As for the Elatches and other Stuffs, we shall write by our shipping, & returne Samples of them back, and then advise what quantities wee would have of each Sort.

Upon Opening and viewing our Callicoes (in order to their sale) which were brought home by these Ships, we find as followes.

That the Brown Cloth is thin and worse than formerly and therefore would have no Brownes sent but such as are thick and well made.

The Sallampores No: 18.19.20 are much too dear as formerly advised.

The Parcallaes No 13.14.15 are very much too dear

Ginghams No 33..36.37 are very much too dear."

(Company Generall to the Agent and Councill at Fort St George, 7th September 1677 / Received 7th March 1678 / 9.)

in India made their own judgments, based on delegation, experience and availability of different types of items. Frequently, there were also disparities between volumes and quality of items requested and what came back to England. Below is an example in this regard.

It was not always possible to supply exactly according to orders due to a variety of reasons, one of which was the length of time that it took for the whole process to be completed. Sometimes orders took longer time to return from India than anticipated. Company servants in India were also on the lookout

(5): The following is an example of an East India Company Record that contains details of cargoes of two ships arriving from India on 27th August 1743: Princes of Wales from Bombay and Normanton from Fort St George (Madras) and Bengal.
(6): Reproduced from British Library records
(7): © The British Library Board ORB/587

for opportunities and, based on judgements and circumstances, they were allowed to purchase additional or different items. Sometimes local competition that the East India Company faced from other European companies (for example, the Dutch and the French) and Asian merchants in procuring Indian textiles meant that it was not always possible to respond to the exact request from the East India Company's headquarters in London.

When the ordered textiles items came back to England the East India Company sold their stocks primarily through regular auctions. Many merchants and buyers had accounts with the East India Company and through an agreed payment system goods brought back from India were sold. The

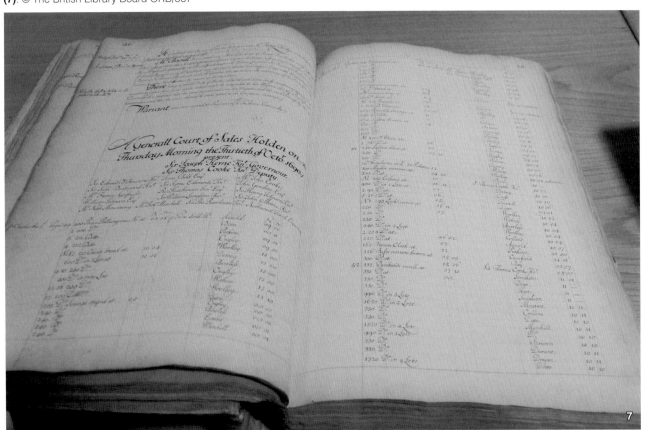

merchants then sold Indian textiles through a variety of channels.

The first image below is an example of an actual handwritten General Court of Sales of East India Company, held on 30 October 1690. The document contains details of the names of the people who bought items. The rest of the images are advertisements by merchants engaged in the buying and selling of muslin.

The process of ordering was a very complex and risky matter as it sometimes took several years for the ordered items to come back to England. Often the demand and fashion trend anticipated when orders were sent were no longer relevant when the items came back. However, due to a long period of East India Company's trading experience with India and Asia, good methods were develop about what and how much to order and flexibility of its agents on the ground, given the time period involved. There were regular correspondence and the time taken for communication, although still large, got smaller and smaller with new technological developments in shipping and navigation. Some of the difficulties involved in procuring exactly the items ordered were dealt with through more regular communications and explanations coming back from India about the causes of differences in prices, designs, etc. of the textiles purchased and shipped to England.

Regency Fashion Trends

The marketing of Indian textiles by the East India Company was a clear factor in generating demands for the eastern fabrics, causing major changes in English fashion. Although a variety of muslins were among the many Indian and Bengal textiles imported by the East India during the late 18th century, white muslin the fine high quality products of Dhaka region in Bengal became the most popular, especially in ladies fashion. Despite a large quantity of Bengal muslins being imported into England not much is known about what happened to them as hardly anything surviving can be found. The earliest items seen during this project are stored at Worthing Museum, consisting of several muslin hats and fichus from early 1760s. Most other items held by the Museum of London and the V&A date back to late 18th and early to mid 19th centuries.

"There is a good collection of what is believed to be Bengal / Indian muslin costume made for the European market in the Worthing Museum's collection dating back to the 1760s."

"The Museum of London's collection contains a small number of muslin objects from between 1780 and 1850 such as dresses, fichus, collars and an unusual muslin pelisse lined in sky blue silk. Most of the objects are embroidered in white linen, polychrome silk or wool, metal thread and spangles. A number of

COMET with such Caution and Address through the British Regions, that its Appearance may illumine Society, and be auspicious to the Porpoises of human Virtue.

Immediate Attention will be given to all Essays, Articles of Intelligence, Advertisements, &c. addressed to the Editor, No. 6, Newcastle-Street, Strand.

INDIA MUSLIN WAREHOUSE,
No. 173, Fleet-Street, London.

MESSRS. SMITH and Co. having made a large Purchase of every Kind of Plain and Fancy MUSLINS, upon the most reasonable Terms; beg Leave to inform Families, Country Drapers, Haberdashers and Milliners, who will do them the Favour to call, that in Addition to an elegant and fashionable Collection of the above Articles, they have also made a purchase of Irish Cloths, Damask, and other Table Linens, Sheetings, Cambrics and Dimities, to a considerable Amount, and which they are determined to sell on such Terms as cannot fail of giving Satisfaction. Some curious Moravian worked Aprons, Handkerchiefs and Gowns, not to be met with elsewhere, superfine 9-8th All-balli Muslins; also two Yard and three Yard-wide Ditto; some good Dimities, from 1s. 4d. per Yard, and upwards; some India Book Handkerchiefs at 1s. 10d. 2s. and upwards; great Variety of Shawls, from 1l. 1s. to 2l. 12s. 6d. equal in Beauty and Durability to those imported from the East Indies; good 7-8th Crape and Plain Gauze, at 6d. per Yard; 4-4th Crape Gauze, 8d. and 10d. a large Assortment of the French Muslins, in Plain and Figures—this last Article is likely to be scarce. Furs, Muffs, and other Winter Goods remaining on Hand, will be sold for little more than Half Price.

SMITH and Co. request to inform Ladies, that it is in Consequence of selling for Ready Money, that they are enabled to deal at the above low Prices: Bombazines, Crapes and black Silks for Mourning, rich black Modes for Cloaks, not to be matched in Town for Colour and Wear, and Ten per Cent. lower than last Year.

☞ Remark the Number is 173, as there are several of the same Name in the Neighbourhood.

N. B. Good Morning Caps to Milleners, at 40s. per Dozen, or 3s. 6d. each. Orders from the Country executed with Dispatch and Punctuality, on receiving the Money, or good Bills at short Date. Country Dealers are particularly requested to call and look at the Quality and Prices of our Goods, before they purchase elsewhere.

THE FULL MONEY,

Without the least Discount, or Deduction, will be paid on

and Edinbro' Royal Mail Coaches, which set out from York every Night.

The TADCASTER and YORK LIGHT COACH, every Afternoon about Five o'Clock, to the Black Swan, Coney-street, York; where it meets the Beverley, Hull, Northallerton, Darlington, Durham, Newcastle, and Edinbro' Mail Coaches, and the Pocklington and Whitby Diligences.

☞ The Proprietors will not be accountable for any Parcel, Box, or Truss, above the Value of Five Pounds, unless entered as such, and paid for accordingly.

ENGLISH STATE LOTTERY, 1789.
Began drawing the 22d of Feb. 1790.

WRIGHT's Old State-Lottery Office, No. 57, Charing Cross, appointed by Authority of Government for the Sale of

TICKETS and SHARES.

Tickets are divided into Halves, Quarters, Eighths and Sixteenths, in great Variety of Numbers, and on the very lowest Terms.—Every Share sold at this Office, is duly stamped, without which stamp all Shares or Chances, of whatever Denomination, are illegal and of no Value.—During the Period of Twenty-three Lotteries past, Tickets have been sold and shared, in Capital Prizes, at the above Office, to upwards of

Four Hundred and Fifty Thousand Pounds,
And paid immediately on Demand.

Country Correspondents by remitting good Bills at Sight, payable in London, or Cash sent in Parcels, by the Coaches, &c (Carriage or Post-paid) for Tickets or Shares, will be duly attended to, and their Commands executed with the same Integrity as if present.

Tickets and Shares registered at 6d. per Number, and the earliest Intelligence sent of their Success.

Mr WRIGHT begs Leave to acquaint his Friends and the Public, that he has no Connection or Concern whatever, with any Office which may be opened in his Name, (except at his old established Office as above) where his Customers are particularly requested to direct their Orders

TEN THOUSAND POUNDS.

THIS very extraordinary Advantage given to the Public by

HORNSBY and Co. *Stock Brokers,*

At their old established State-Lottery Office, (Licensed pursuant to Act of Parliament,) No. 26, Cornhill, opposite the Royal Exchange, London;

, impolitic, it to be re-hen he ob-nich gentle-ce,, without uct, and he f the noble e eloquence l it, would satisfy the anner was efent awful it to an ex-for going to emand that

"Money," says a celebrated numerical calculator, "bearing compound interest, increases slowly at first; but the rate of interest being continually accelerated, it becomes in time to rapid, as to mock all the powers of the imagination. One penny put out at our Saviour's birth to 5 per cent. compound interest, would, before this time, have increased to a greater sum than would be contained in a hundred and fifty millions of earths, all solid gold, but if put out on simple interest, it would, in the same time, have amounted to no more than seven shillings and four-pence halfpenny."

A Gentleman, who chuses to remain concealed, has given 12,000l. to the Society for propagating Christian knowledge in Scotland.

nst the re-and highly ts in favour rote already carrying on

in the habit ence of the his taking y. If ever ts own pro-nts, on the nothing op-ch a cause. ace of those was, to give m on which I venture to utter, while sullen and

tion, to the ster and his bers were, -nces, 253, the lobby, heir matter

SHIP-NEWS.

PORTSMOUTH, April 14th. Arrived. Maria, Clear; and Dart, Gray; from Havre. Friendship, Peterson; Ann, Ridley; from Plymouth. Nautilus, Groves, from Weymouth. Fly, Wright; Fanny, White; Two Sisters, Johnson; from London. Three Brothers, Berry; Tartar, Smith; from Guernsey. Oak, Gale, from London.

Sailed, Mary Anna, White; Sincerity, Gunner; Sincerity, Badcock; Providence, Parsons; for London. Klyn, Drakenstein, Anderson, for Leghorn. Thetis, Ryder; Portsmouth, Wilkinson; Bourdeaux, Brown; Mary, Timbeth; Friendship, Booth; for Sunderland. St. Vincent, Prior, for St. Ube's. William, Stephenson, for Alicant.

POOLE, April 14th. Arrived. Mary, Churchward, from Exeter. Briton, Grave, from Belfast. Fly, Wolland, from Dartmouth. Nancy, Barns, from Chichester. Esther, Poole, from Liverpool. Industry, Snelling, from Chester. Good Intent, Bagwell, from Lymr. Betsy, Miller, from Liverpool. Bell, Humble, from Christiana.

Sailed. Alive, Kemp; Lark, Spencer; Dove, Allen; and Thomas, Pudner; for Newfoundland. Polly, Rice, for America. Nancy, Whittle; Hope, Walters; for Liverpool. Blessing, Wills, from London. Concord, Galley; and Harmony, Sharp; for Sunderland.

SOUTHAMPTON, April 13th. Anna Maria, Nelson; and Carolina, Zachariason; from Fredrickstadt. Aasil and Anna, Pedersen, from Christiana. Lark, Neall; Anna, Bullmore; Pomona, Le Sueur; from Christiana.

Sailed. Harmony, Wright; Johanna, Ebden; for Jersey. Dispatch, Folaise, for Guernsey. Good Intent, Randall; and Surprize, Hancock; for Pool. Peggy, Ayling; and Duchess of Cumberland, Waterman; for Yarmouth. Cadland, Reed, for Chichester.

paper.

INDIA-MUSLIN AND LINEN-DRAPERY WAREHOUSE.

MESSRS. THOMAS SMITH and Co. at the THREE PIGEONS AND SCEPTRE, No. 173, FLEET-STREET, London, inform their friends, that they have lately purchased, for the Spring and Summer Trade, a large Assortment of India Muslins, cleared from the Company's last sale, several lots of which they are enabled to sell considerably lower than the same goods were sold for last year; with many Articles which are well worth the attention of Country Shopkeepers. They consist of the undermentioned Goods:

India Mulls, Seerbetts, and Book-muslins, from 1s. to 3 guineas per yard.

India Jacconet, and Alliballie Muslins, from 2s. to 3 guineas per yard.

Yard-and-half wide striped check Muslins, from 19d. to 12s. per yard.

India striped and check Muslins, from 2s. to 14s. per yard.

Tambour and Sattin worked muslins, from 2s. 6d. to three guineas per yard.

A very elegant assortment of Moravian worked Muslins, for Dresses, from 1 guinea to 4 guineas per yard.

Clear India Muslin Dresses for 7s. 6d. per dress, worth 12s.

India Callico and Long Cloth for Ladies Dresses, from 18d. to 10s. per yard.

Clear French Lawns, with elegant figures and spots, for Dresses, from 3s. to 6s. worth 9s. per yard.

Irish Cloths, 7-8, 7-4, and 4-4ths, from 6d. to 6s. per yard.

Stout Dimities and Muslinets, from 11d. to 3s. 6d.

Strong Sheetings, from 9d. to 7s. 6d. per yard.

A few curious 3-yard wide Holland Sheetings, at 10s. 6d. per yard.

Diaper and Damask Table-cloths, from 18d. to 5 guineas each.

Undressed French Cambrics, in Remnants of Four Pocket-handkerchiefs, for little more than half-price.

A large assortment of Canterbury Muslins and Seersuckers, from 13s. to 28s. per gown.

Norwich and other Shawls, equal in beauty and wear to those imported from the East Indies.

With many other goods in the Drapery Line equally cheap.

N. B. As many of the above articles will meet with a very rapid sale, they request their friends to call early, and to remark the Number of their house, (173,) as there are others of the name in Fleet-street.

number, exclusive of copper-plates, I shall my subscribers nearly as much in quantity others have formerly done, who charged d their numbers without copper-plate embellish cumstance will evidently render the present Family Bible of the kind ever published enabled to do this by types of a peculiar Notes and Reflections, being procured from of William Caston, Esq.—and, that readers may be accommodated to their wishes, the somely printed on a very large letter, agreea in the first number. With respect to the p sons advanced in years may have little re representations, yet they may be of great d and guardians who wish to have the hist ory impressed on the memories of you

Besides what has already been advanced ation had some weight with me in under namely, the many unsound and dangerous are already abroad, and which have in than those written on the side of truth.

In hopes that many who are yet unborn rusal of this my favourite work some riches of divine grace, and that it may now living; I commit the undertaking profit, and whose peculiar prerogative up his church in any way his sovereign

LONDON, March 26, 1791.

☞ A list of the subscriber's names delivered gratis with the last number.

⁎ That every reader may be enab judgment of the beautiful execution of ber, may be had as a specimen, and, money shall be immediately returned.

††† In order that the public may be perform every condition of his prope deliver with the first number a promi his Evangelical Family Bible shall without interruption, and that, if th bly exceed the 90 numbers proposed, overplus gratis to every subscriber, of hand.

N. B. As it is the author's wish have Bibles with Notes of an unsou them—it is requested, in order to av and particular orders may be given arriers for the Reverend Mr. PRI the BIBLE, with LARGE CO

pieces of exquisitely embroidered transparent muslin might have been form parts of dresses from Princess Charlotte's (1796-1817) trousseau. An unpicked gown of white muslin embroidered in silk floss and straw was worn by the Swedish opera singer Jenny Lind in 1850."

"The Victoria and Albert Museum in London has an outstanding and wide-ranging collection of South Asian textiles, from 'peasant' cloth to court dress. The core of the collection came from the East India Company's Museum. The collection illustrates a stunning range of textile techniques: dyeing and printing, painted and printed chintzes, embroidery, and a dazzling variety of weaving – from silks heavy with gold and silver wrapped thread to superb Kashmir shawls and the finest, almost weightless Bengali muslins and exceptionally fine nineteenth century jamdani. Besides a large range of muslins, the museum collection also contains examples of silks from Murshidabad, capital of Bengal for most of the eighteenth century, including some 'Baluchari' silks in distinctive deep colours figured with floral and pictorial motifs - one example depicts Europeans riding on a paddle steamer."

The majority of the surviving fashionable dresses seen in the above institutions and elsewhere belonged to the Regency Period, immortalised by Jane Austen in her novels, where there exists many references to Indian muslins. The beautiful white dresses that ladies in her novels wear represent the quintessential regency fashion.

The Regency period in fashion is said to have been preceded and influence by the Empire Style in ladies fashion, which originated in the aftermath of the French revolution and was popularised by Mary Antoinette. Regency itself was named after Britain's Prince Regent who ran the country when his father, King George III, became mentally ill and unable to perform his duties. Prince Regent became king in 1830. The Regency period is also known as the Romantic era which influenced writers such as Lord Byron and Sir Walter Scott.

Jane Austen's novels are a good source of information about how people used muslin, the status of the fabric and how much people using the fabrics knew about it. There are many references to muslin in Austen's novels. In some of the films that have been made, based on her novels, one can clearly see, from the recreated dresses, how Regency fashion looked on ladies.

The following references to muslin in Northanger Abbey provide an insight into the historical influence of muslin:

They were interrupted by Mrs. Allen: -- "My dear Catherine," said she, "do take this pin out of my sleeve; I am afraid it has torn a hole already; I shall be quite sorry if it has, for this is a favorite gown, though it cost but nine shillings a yard."

"She is tolerable"

[Copyright 1894 by George Allen.]

"That is exactly what I should have guessed it, madam," said Mr. Tilney, looking at the muslin.

"Do you understand muslins, sir?"

"Particularly well; I always buy my own cravats, and am allowed to be an excellent judge; and my sister has often trusted me in the choice of a gown. I bought one for her the other day, and it was pronounced to be a prodigious bargain by every lady who saw it. I gave but five shillings a yard for it, and a true Indian muslin."

In the *Novel And Tasteful Fashion For August* (1821) article sited above, in addition to providing details of the role played by Indian muslin in dinner party dresses, it also mentions scarves and walking dresses. Although more and more inroads were made by English imitation muslins during that time, Indian muslins were still very popular and used for a variety of purposes. It is said that the 'basic seaside dress in Jane Austen's time was 'a white muslin dress comfortable for a breach stroll... or dress up with accessories for a promenade'. There are many paintings and sketches of ladies wearing white muslin strolling on British seaside resorts. In Austen's novels she mentioned several such resorts, including Brighton, Scarborough, Cromer, Lyme and Sandy Ton, which she created as a fictional seaside resort.

10

The Muslin Disease and other disadvantages

There were also a number of disadvantages in wearing muslin fabrics during the Regency period. One was the British weather. As the fabric was very fine and translucent it meant that in many situations when the temperature was rather low there was very little protection for fashionable ladies. Modesty was also an issue. These were addressed by putting on Kashmir shawls and coats. Nevertheless, the fashionable wearing of white muslin caused many young ladies to catch influenza and pneumonia which came to be known among certain circles as 'muslin disease'. In addition, many in society identified other disadvantages associated with the wearing muslin, often expressed in cartoon like caricatures. Two examples are provided below.

The shawls that were introduced as a source of protection from the British weather were made from a variety of materials, particularly wool that came from the Himalayan Mountains. Muslin shawls with elaborate embroidery designs were also popular. As the Regency period progressed the white muslin dress was complemented with shawls that became larger and larger.

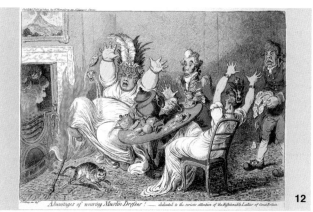

(10): Illustrations from Pride and Prejudice by Hugh Thomson
(11): "The Graces in a High Wind", a satirical engraving (1810) by James Gillray
(12): In Advantages of wearing Muslin Dresses ! — dedicated to the serious attention of the Fashionable Ladies of Great Britain (1802) by James Gillray.

European influences

The popularity of wearing white muslin dress increased with the discovery of the ruins of Pompeii and Lord Elgin's transfer of the Parthenon sculpture in the first decade of 1800 from Greece to London. The white marble sculptures, where white fabrics draped well, giving a naked look, made people in the Regency era of fashion experience a little bit of ancient Greece. The trend toward Regency fashion and the use of white muslin with such popularity can be traced back to the development of love admiration for classical Greece and Rome.

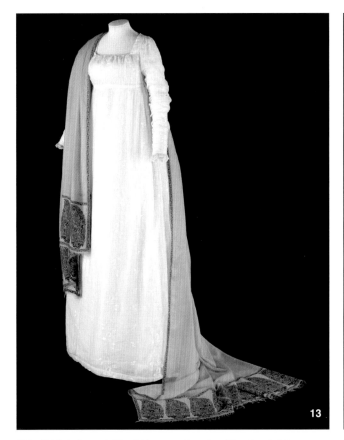

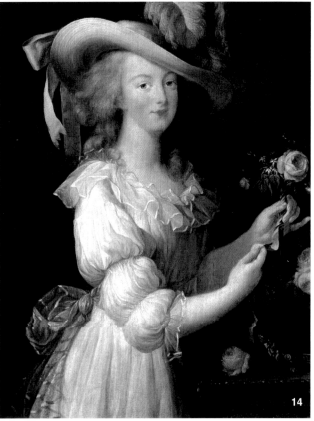

13

14

(13): © Victoria and Albert Museum, London. 'Empire style' unstructured muslin gown embroidered with cotton thread, made from Bengal muslin around 1800, stored at Victoria and Albert Museum. 'Inspired in part by the statuary of ancient Greece and Rome, the new fashion was epitomised by light cotton gowns falling around the body in an unstructured way, held around the high waist with a simple sash and accompanied by a soft shawl draped around exposed shoulders. This style was ideal for the Indian imports like Kashmiri shawls and Bengali muslin, as used in this embroidered gown.'

(14): Marie Antoinette en chemise, portrait of the queen in a "muslin" dress, by Élisabeth Vigée-Lebrun (1783). This controversial portrait was viewed by her critics to be improper for a queen because of her choice of clothing.

The French Revolution led to the discarding of the elaborate dresses that men and women traditionally wore. They were replaced by more simple garments. Mary Antoinette scandalised the French court by wearing muslin dresses, as they were so sheer they looked like underwear. The high society of France did not consider muslin to be appropriate for a French queen. Individuals in England began to imitate French Empire style, which culminated in the English Regency style ladies fashion era. This consisted of high waistline dresses called chemises, which again looked like undergarments.

Many visitors from England started to visit Italy and Greece from the middle of the 18th century and came back with items and painted images of Greek statues,

buildings and architecture. The statues of Greek ladies from the classical times wearing white dresses that draped their bodies well became examples of purity and perfection. Bengal muslin was the choice fabric that allowed English ladies aspiring to attain the purity of the looks seen in Greek statues. The soft white muslin draped well around women's bodies, showing their figures and making them look like pure and unspoilt.

(15): The Parthenon Marbles, also known as the Elgin Marbles.
© Trustees of the British Museum

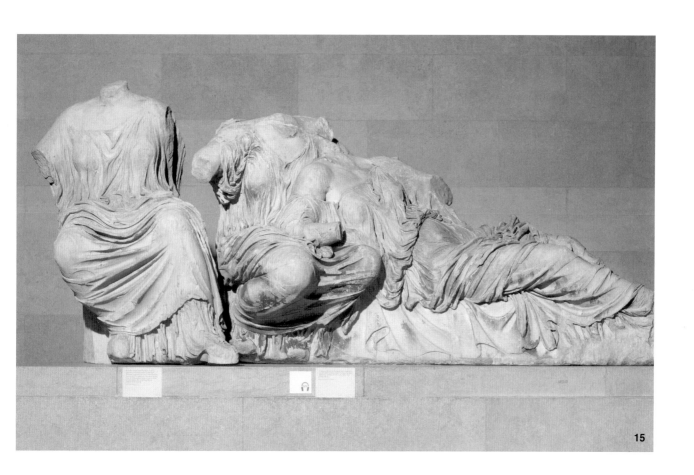

Muslin and the Mughals

Fathema Wahid

Getting involved with the project

I grew up with textiles such as Muslin and Jamdani around my home in England and I currently work as a printed textiles designer/maker from home. At the launch evening for this project, I felt it reflected the passion I have for textiles and fashion; particularly the textile heritage of different cultures, which needs to be acknowledged, in order for the new generation to appreciate their history.

What made it even more exciting was the prospect of researching and finding out about how the British used and maintained these luxurious textiles in a cold climate, and being a notorious reader of Jane Austin's books (who dressed her heroines in muslin), it all seemed too irresistible to resist.

Research stages

The museum visits were a fantastic source of information, regarding the great British love affair of importing goods into England from abroad. Seeing and handling actual historic garments and in some cases the precious pieces that remained, was a wonderful experience as it solidified the appreciation we should have for the exquisiteness of the muslin plant, and its origin.

(1): Me at work in my studio
(2): One of my own creations being modelled

Choosing my dress

It didn't take me long to decide what type of garment I wanted to re-create. The overall style I chose was that of a neo-classical regency dress, with white embroidery and a train (1800-1810), that I found on the internet. However I wanted to add a little glamour to the simplicity of the dress to turn it into the kind the heroines of Jane Austin's books would have worn. To achieve this I adapted the white work embroidery that was on the original dress.

During our visit to the Museum of London, I saw a floral pattern on a muslin dress given to the museum in 1970 by The Victoria and Albert Museum, dating 1821-25. I loved its simplicity and used it as inspiration to have flower motifs woven into my

3

4

5

muslin material. I thought the floral pattern was very simple yet powerful in its continuous repetition on the delicate woven muslin background; I wanted to emphasis this delicacy further, which is why I had the design woven rather than embroidered onto the muslin itself.

Working with muslin

There was such an exciting buzz when we met to hand over our images and design instructions for the weavers in Bangladesh. Initially like others I was apprehensive; what if the instructions get lost in translation? However it was an amazing feeling to see the final woven muslin cloth when it came back; the weavers had done an amazing job.

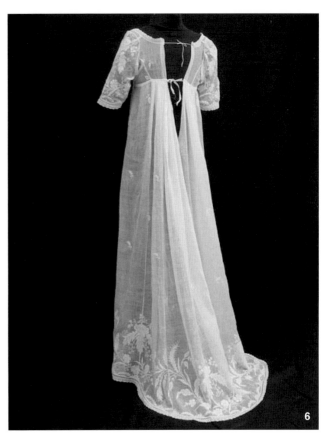

6

The washing and preparing of the muslin went fairly smoothly. However, the thought of pattern cutting a historical garment was pretty daunting. Our tutors Alice and Lewis were fantastic. With their knowledge and experience, I learnt a lot about the pattern cutting process. The hardest part of putting the garment together was keeping the weave intact while hand stitching. The open and delicate weave of muslin made it very challenging though it also became clear why the British and Jane Austin's heroines had such a passionate love affair for their muslin garments; they were just so beautiful and exquisite.

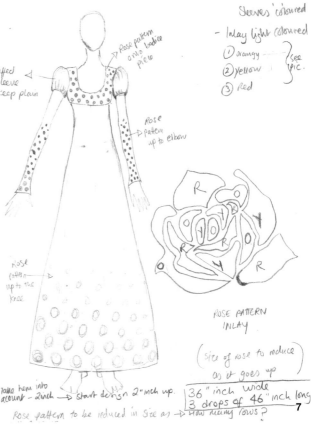

7

(35): Dresses from the archives at The Museum Of London
(6): The 19th century dress that inspired me
(7): Drawings of my own floral design for the creative piece

Although I made changes to the style of the garment and how the floral pattern was applied onto the muslin, I feel that the actual weaving of the cloth and the making of the dress by hand stitching has been as true to the period as possible.

Overall the project for me was especially challenging in regards to time management; I gave birth to my baby boy in November, during the project, and have been busy balancing life being a new mum, and doing what I love most, which is being creative.

Creative piece

For my second piece I looked at the similarities between the Mughal era and the muslin garments worn by the British. The Mughals kept muslin and other luxurious clothes such as silk to themselves. Anyone below royalty was not allowed to purchase highly valued cloth; in this case muslin.

Other similarities shared were the style of the garment; small bodices, full skirt, with fitted long sleeves. There were also differences, but very slightly, such as short, puffy sleeves and the long fitted trousers under the dresses worn by both the Mughal ladies and gentlemen.

I decided to choose a dress with a simple, colourful rose (the British link) motif embroidered onto it, in order to add a modern twist to the cloth, with an

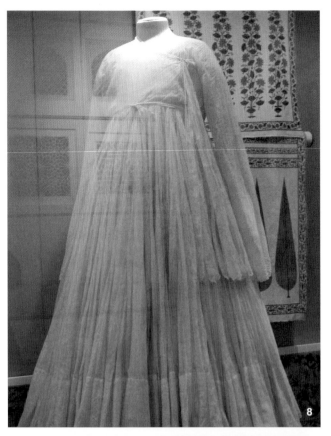

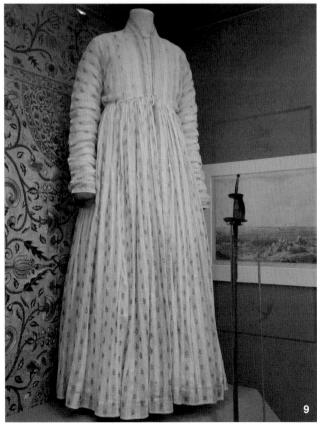

(8, 9): Mughal garments from The Victoria and Albert Museum displays
(10, 11): The Bangladeshi weavers had interpretted my floral rose design as colourful cicular motifs

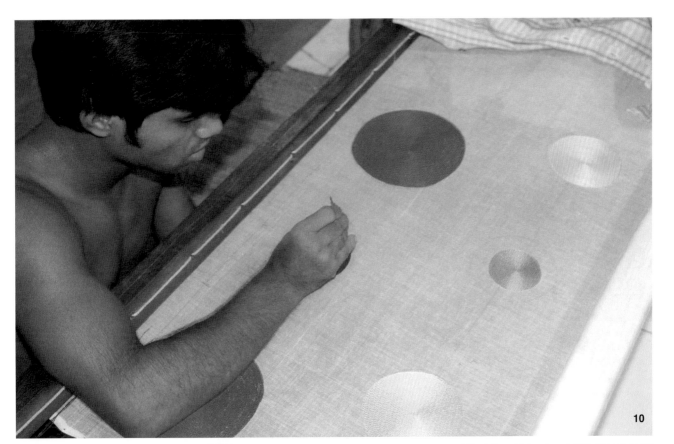

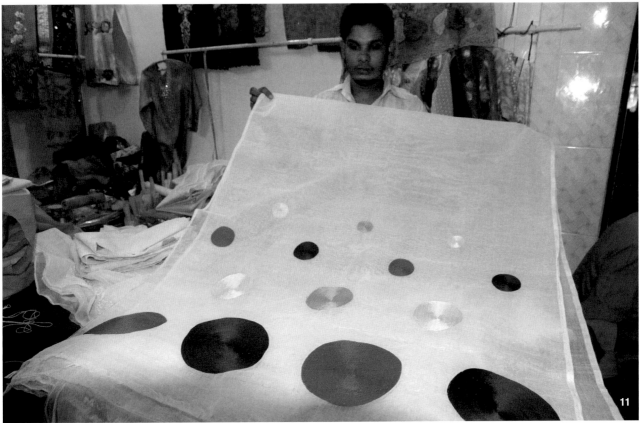

opening down the middle, and a full length skirt worn under it. However the Bangladeshi embroiderers turned it into circles instead of roses – I didn't mind, as the circles still gave the cloth a modern twist and looked very bold, dramatic and energetic. Due to having time constraints with a baby of eight months, I had to make a decision. It was not possible for me to realistically finish making my creative piece in time for the exhibition at Maritime Museum. Therefore I decided to have a muslin shawl made with the circle motif. The finished piece has a lot of impact – it celebrates the simplicity of British fashion with the creativity and colour of Bangladesh. I hope to still make my creative piece, when I have a little more time at hand.

(12, 13): Weavers in Bangladesh applying my designs into the muslin
(14-17): Me hard at work during the fortnightly sessions
Overleaf: My final historic dress alongside the creative piece

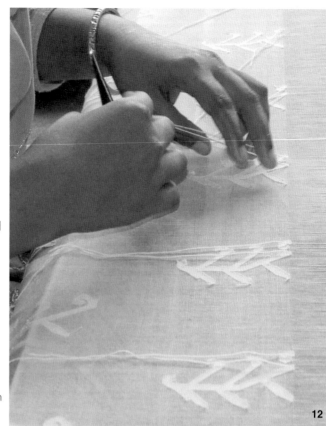

12

13

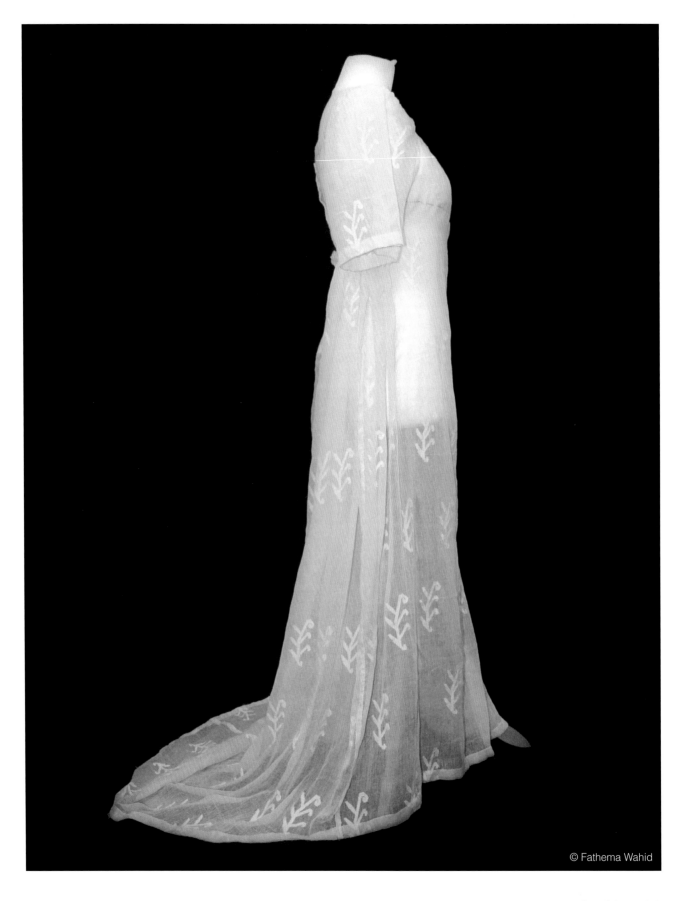

© Fathema Wahid

Muslin and the Mughals

© Fathema Wahid

Remembering a forgotten fashion trade

Sima Rahman-Huang

Going Back to My Roots

I grew up in London. My parents are in their late
40s and are of Bangladeshi origin. I had very
little knowledge about the textiles trade between
Bangladesh and England before I joined this project.
Fortunately I a friend introduced me to the project and
I made an application to participate. Reading through
the project details and course activity provoked a lot
of interest and intrigue in me at the thought of being
involved in such an opportunity. I had not heard of
the Bangladesh Heritage Project. I spent a lot of time
filling in my application making sure I had covered all
areas of my fashion background, knowing I would be
a perfect candidate to contribute to this project.

Growing up I tended to steer away from Bangladeshi
culture. I very rarely go back to visit Bangladesh and I
would describe myself more British than Bangladeshi.
On a personal level it was the creative side that
connected me to this project.

My mother who is also a designer would stitch and
design matching dresses for my sisters and I during
childhood. She would use a industrial machine which
she still has today to make her own clothes with and
style her own wardrobe. This is something which has
intrinsically stayed with me; being creative.

(1): Me at work during the sewing workshops
(2): Inside Moon Doll Boutique

Moving on from my childhood in to adulthood I studied marketing and worked in several property companies on marketing campaigns and events whilst working full time I moved into the fashion industry by becoming a part time freelance Make-up Artist, working on catwalk shows and photo shoots. I built a substantial network of contacts within this industry which helped me to launch my own fashion label and brand in London Fashion Week 2010. What started off as an online business, has now evolved into a retail unit in Hampstead, London which has now been open for over a year. I design and stock my own collections as well as source vintage fashion and accessories ranging from the 50s all the way to the late 80s. My marketing and events background has helped me launch my own business and market my own brand. A collection of summer dresses I designed and subsequently launched in 2010 was heavily influenced by prints from my cultural background, I used a lot of fabric from Bangladeshi silk vintage sarees to produce the dresses.

Coming from a fashion background this project has been fascinating. I have learnt a lot about my heritage; about the connections Bangladesh holds in history with London and how the birthplace of my parents connect with my birthplace through textiles and trade. All of which from an era which has been forgotten about. I was hoping I would be able to re-engage with my culture by working on this project. I wanted to learn about the rich history of the textile

industry in Bangladesh and about past cultures to use as inspiration for my own work. Meeting people within my group and hearing their stories and working with them have in itself been a great experience too.

Choosing my Garment

For my design I took in to considerations my capabilities; I didn't want to recreate something difficult, but something that I would be able to complete, yet also push me to challenge myself. Taking deadlines in to consideration I had to be realistic. I had never worked with muslin before and hand stitching an entire garment would be challenging.

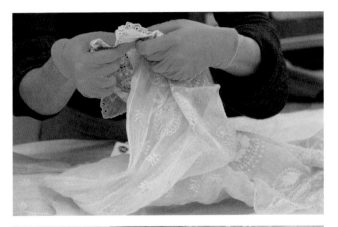

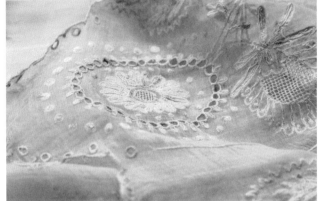

I decided to choose a garment which dates back 200 years, the actual dress which I got to examine and take pictures of is being held at The Museum of London which was given to them by The Victoria and Albert Museum in 1971. Unfortunately this was the only historical information they could provide. The dress had embroidery all over it but I decided to have a simpler version embellished onto my fabric, just along the bottom edge. I used images from pictures taken from the museum to recreate my sketch for the dress pattern, but as you can see it is quite different to the design I have ended up with, my interpretations of the dress had to change so that it was more true to the historical fashion that was out at the time that my chosen dress was worn.

(3): Creations from Moon Doll Boutique
(4): Dresses from Museum of London's archives

Working with Muslin

Muslin feels extremely soft and luxurious on the skin but is more suited to those living in warmer climates due to its sheerness; this also means that it needs to be treated with a lot of care and can be high maintenance. When I first received my fabric I hand-washed and dried it very carefully. I had to repeat the process several times until the starch it was treated with was washed out. The muslin is starched to allow it to stiffen up so it can be embroidered on, but once it's washed out, it becomes the soft muslin that is suitable for wearing, that women in the 18th and 19th century enjoyed wearing muslin a great deal. Muslin was seen as a sign of wealth to wear such a fabric which was imported over from Asia.

When sewing you have to take care not to damage the fabric. Also with its sheerness a lot of the stitches have to be reinforced so your garment doesn't fall apart. Some pieces are even doubled up to create a thicker fabric. Needless to say we all had a lot of hand stitching to do.

Constructing My Dress

Every time I made progress on my garment I felt as though I had overestimated how hard the process would be. Hand-stitching the entire garment was hard work but I found it very therapeutic and also really enjoyed it. Having guidance and assistance from our tutors, Alice and Lewis helped me massively in creating a garment that was true to the original design.

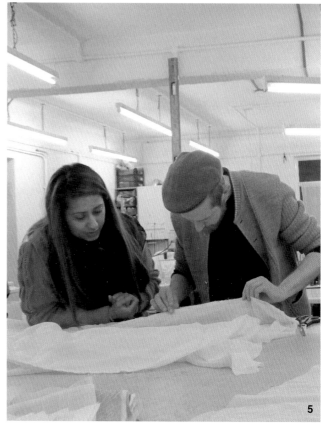

5

Running my own business full-time meant I couldn't attend all the group workshops, so instead I had some one-to-one sessions to keep me on track. This meant spending evenings and hours working on the garment in classrooms after a long day at work. During the process of translating my embroidery on to paper to scale and having it recreated in Bangladesh meant several of us had a few discrepancies in our patterns. The embroidery on my fabric was not placed far enough from the edges of the muslin for me to stitch the ends together to make my skirt which meant I had to use leftover ribbons of muslin to stitch my skirt together. This meant double the stitching time needed to complete my skirt.

(5): Getting advice at the workshops
(6): Original sketches and designs
(7): Mood board created during LCF sessions

6

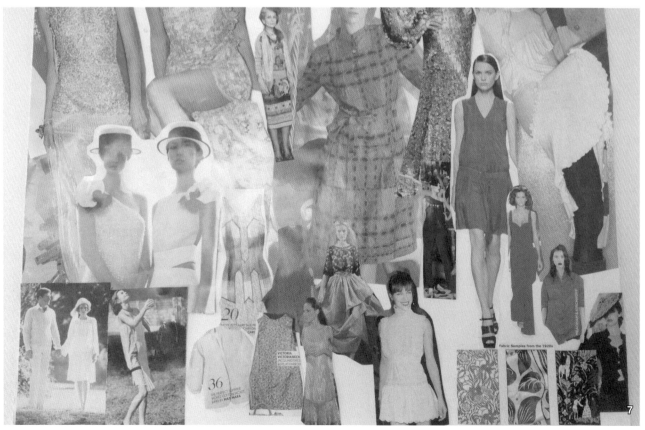

7

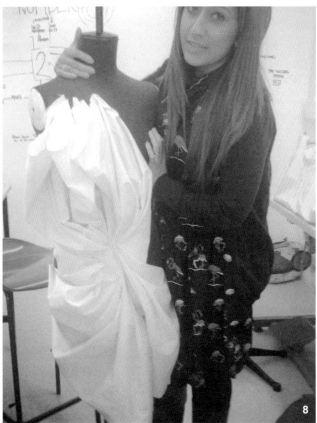

8

Remembering a forgotten fashion trade

The Finished Dress

I'm very pleased with the end results given the amount of time and effort I invested. I believe that the project has allowed me to get in touch with my heritage and inspired new and fresh directions in my business. Importantly, I learnt about a forgotten fashion trade, in a time of regal elegance and opulent lifestyles for the rich; living a life and wearing a cloth that told many stories.

From the moment my design was sent to Bangladesh for the fabric to be created and embroidered, it started a prccess, a woven process of a journey which resulted in the completion of my dress and a story to go with it. I feel privileged to be part of this project and have met some great people along the way, all of which I expect to keep in touch with.

(8): Conceptualising my designs at London College of Fashion
(9,10): Detail and side view of my final historic dress
Overleaf: The back and front of my final historic dress

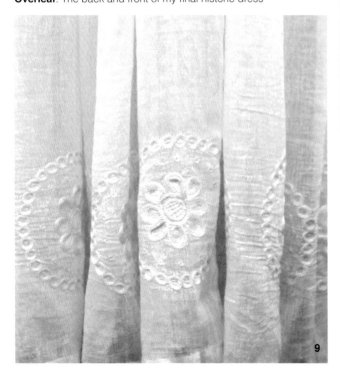

9

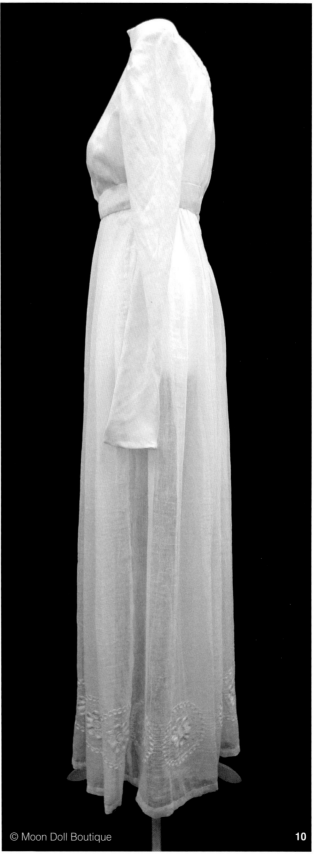

10

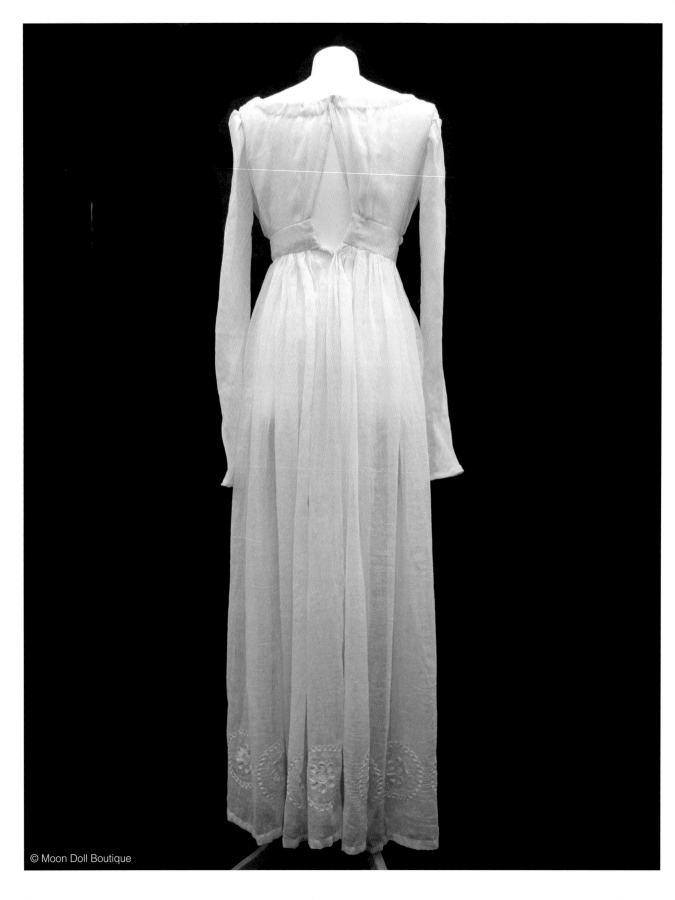

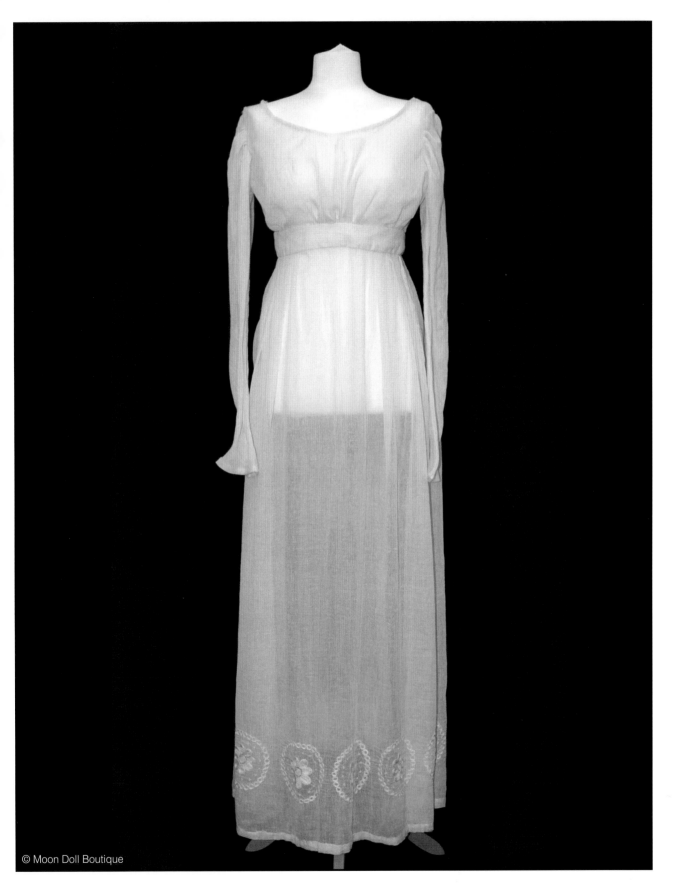

© Moon Doll Boutique

Weaving The Grid of a Present Past

Saif Osmani

Drawing inspiration

When applying brush strokes onto a surface I like the way the paint pigment soaks into loose cloth and embodies the fibres of the material. I find the traditional stretched canvas restricting and uninformative to the process of painting.

Prior to getting involved with this project I created some paintings based on the spaces inhabited by Mahatma Gandhi. By researching local archives I painted scenes from Bengal and London directly onto cotton. The significance of this material became increasingly important to the painting process and I began finding out more about Gandhi's symbiotic relationship with the cotton material and what it meant for the changes taking place in pre-partitioned India at the time.

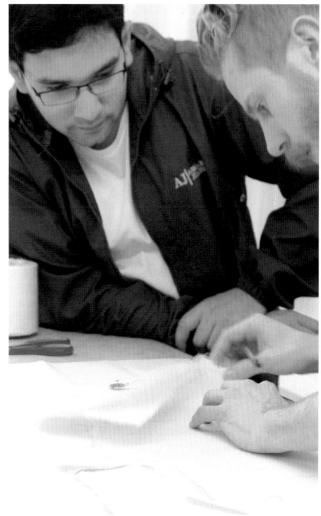

(1): Cityscape I: Gandhi in east London. Arcylic on natural cotton.
(2) Gandhi in situ (Arcylic on wooden veneer)
(3): Gandhi's loom (Acrylic on wooden veneer)
Part of 'Spaces Inhabited by Mahatma Gandhi' series

Soon after making these paintings I curated an cross-disciplinary group exhibition, showcasing 35 international practitioners; each project examined the unique way bamboo had been used. Bamboo is a grass which grows longitudinally across the globe and materially connects people across national boundaries. As part of my research I starting tracing over world maps and became fascinated by the cartographic representation of the globe and national boundaries. In process I questioned: *what if we were to view the world from another angle, how could the globe be re-imagined?*

The concepts for this muslin project came out of a mergence of both the paintings on cotton and the idea of re-configuring of the world map.

The muslin route

Coming from an art/ architecture background I was aware of stories about designers and architects refining a building design to such a degree that they were able to determine the clothes the inhabitants would be wearing, long before the building was even built.

Previously I've encountered muslin whilst constructing stage sets for theatre plays and recall conversations with theatre practitioners and set designers who told to me that the grade of muslin we were using could

4

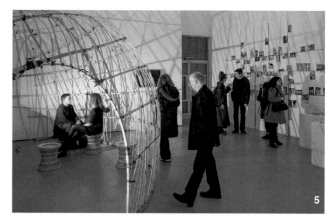

5

6

(4): Bambusoideae World Map (Source: Baasher Ghor/ Bamboo House)
(5): 'Parallel Horizons' exhibition exploring bamboo usage. Shown at Stephen Lawrence Gallery (Photograph: Warwick Sweeney)
(6): Early conceptual drawing of a building block extrapolated from a traditional Bangladeshi Jamdani design

not be called muslin at all. At the time I couldn't understand why anyone would need cloth as fine as this or what it would be used for; it seemed like an unnecessary luxury.

Before embarking on this journey I had to recall my two taster days of fashion design during my foundation course at Central St. Martin's College of Art & Design. I was initially unsure if I was able to work such a specialised project with little practical experience, however like the other participants I was fascinated by this material from antiquity and the opportunity to delve into historical archives.

Shifting perspectives

The lectures held on muslin were interesting insights into some aspects of muslin in Europe, although they were not balanced enough between the history of trade with Bengal and wider India. I put this down to a lot of the world's archive not being a paper-based, where expert knowledge still remains in the minds of community members.

In my own time I carried out research at the Whitechapel Art Gallery archives, finding out about the 1988 exhibition titled 'Woven Air: The Muslin and Kantha Tradition of Bangladesh'. By coincidence a few days later I met Ruby Ghuznavi who was involved with setting up the original exhibition at the Whitechapel. At the inauguration of the Muslin Trust, a charity being set up by one of the other fashion

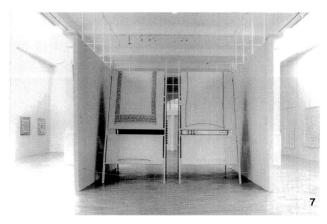

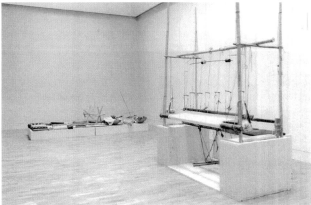

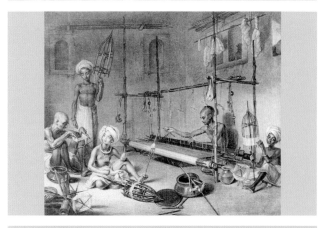

onder den Vyand weinig fchade doen.
MOUSSELINE, een fyn dun zoort van Katoenen-Lywaat, 'twelk een Donsachtig Haaïr op deszelfs Oppervlakte heeft. Er zyn verfcheiden zoorten van *Mouffelinen*, die in de *Ooft-Indiën* gemaakt, en tot Ons overgebracht worden, en byzonderlyk uit *Bengalen*; zodaanig als *Doreaffen, Betilles, Mallemolens, Tansjeebs,* enz.

(7): Images and photographs from 'Woven Air' exhibition held at Whitechapel Art Gallery in 1988 (Source: Whitechapel Art Gallery archives)
(8): Extract from records at The National Archives of the Netherlands

recreators on the project, Ruby told us that muslin patterns and weaving techniques had been destroyed as late as 1971, during the Pakistan-Bangladesh conflict. She explained that the distinct geometric weaving pattern, commonly seen in Jamdani saris was what deferentiated Bengal's regional aesthetic from the rest of India. Other Indian regions did produce different types of muslins, however the Dhaka muslins were known to be the finest grade of all the quality muslins.

Steep learning curve

At The Museum of London I asked the archivist how she knew from just handling the cotton garments that one was Indian and the other European. She replied: '… there's just something different about it. It's the

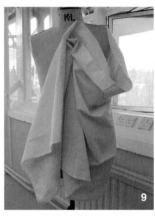

9

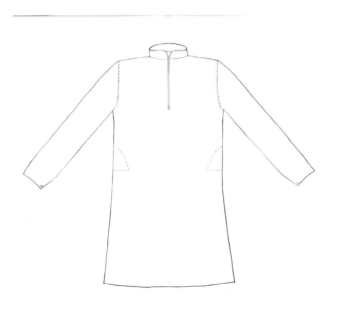

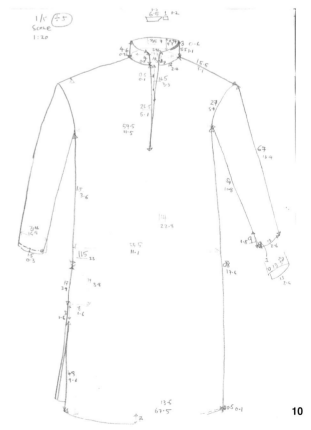

10

feel, the way it falls, the hold and the weight. It's more uneven. It's got character'.

The practical drawing sessions with Zarida Zaman at London College of Fashion were useful in realising the potential outcomes of our designs and the different directions we could take our projects. Early studies were free-flowing and I quickly worked out designs based on Asian clothing details like 'Nehru jacket' collars, the Bengali *lunghi* (loin cloth), *gamcha* (neck cloth) and *toppi* (Muslim cap) as well as the Somali *ma'awiis* (loin cloth). All of these aspects of dress held nautical relevance and would have been seen on lascars or sailors and were also examples of

(9): Forming ideas using a mannequin and calico
(10): Detailed measurements and scaled drawings
(11): Drawings of men's garments (Series 1-9 of 12)

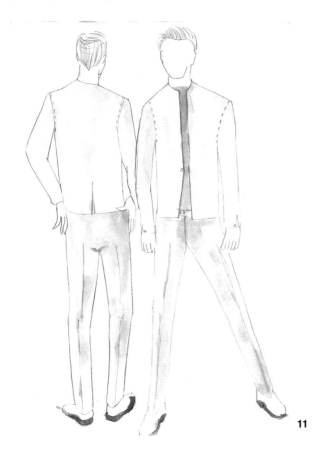

11

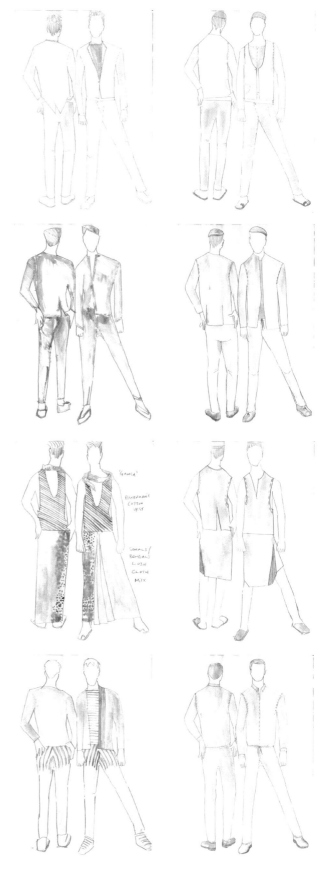

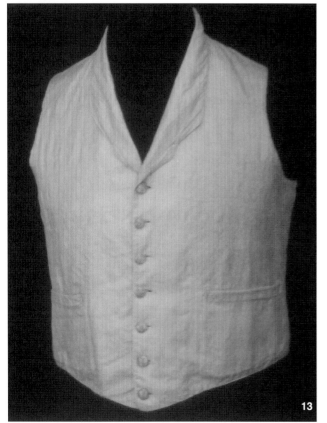

13

everyday clothes worn by foreign merchants making trips to England.

Concretising the design

The ideas that I kept being drawn to were of the sea, trade routes patterns and a grid-like structure created by the weave and weft of the loom. I was also particularly taken by a 1792 painting by Franz Balthazar Solvyns of a river boat, the Charlotte which travelled on the Hoogli River in Chittagong (4).

Creative construction

Whilst growing up I vehemently rebelled against wearing a suit and had not owned a waistcoat and now I was faced with the prospect of making my own one (!) To begin with I started reading about the

waistcoats worn during the French Revolution (1789), which were laced with symbolism, messages and quotes embedded within the waistcoats themselves. Soon after I booked a session with archivist Hilary Davidson at the Museum of London (Barbican) to view men's garments. She located some worn by young adults, eccentric individuals or older leisurely upper-middle class gentry. I was drawn to a simple checkered or *charkona* ('four corner') weave.

At this point a setting started formulating in my imagination, of an captain's evening walk on a ship. Soon afterwards I found a waistcoat which fit this setting, worn leisurely and subtle in appearance (2). I decide to fuse the checkered weave of the youngster's waistcoat ontop of this evening waistcoat.

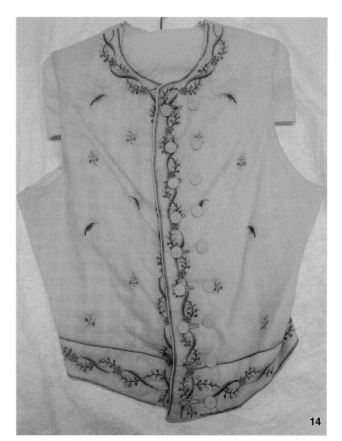

Lost in translation

As part of the project we were to have our patterns woven in Bangladesh and Muhammad, the project coordinator went there to oversee our orders. I requested a series of simple weaves and sewing to be added to the muslin. However, the drawings were mis-read and my diagonal stitches returned as an eleborately over-woven angles. The cloth was beautifully hand-made and added a new dimension to the project but these had to became shawls in their own right, too delicate to cut.

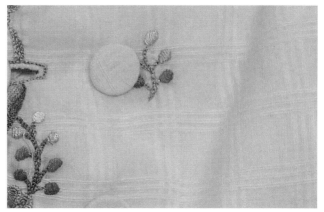

(12): Mood board of ideas for my modern garment
(13): 1830's waistcoat, East India Company (Source: 'Dressed to Kill', Amy Miller)
(14): 1786-1795, young male waistcoat with checkered or *charkona* weave (Source: The Museum Of London archives)
(15): Charlotte of Hoogli river boat in a Franz Balthazar Solvyns painting (Source: National Maritime Museum)

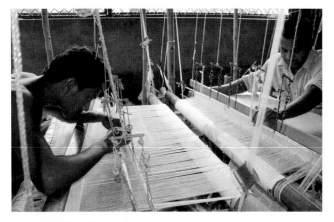

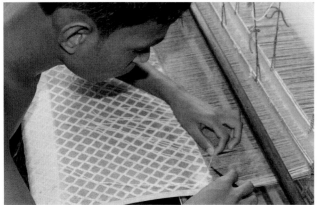

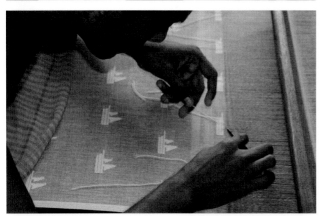

My drawing of a boat design, modelled on the Charlotte of Hoogli River (Chittagong) had been simplified to ensure it would be easy for the weavers to understand but I received a frantic call from Muhammad in Bangladesh telling me that the weave would be 'too difficult' for the weavers to undertake and the design had to change. So the front end of the boat motif was levelled off.

This small encounter was also an insight into how muslin had embodied the changing nature of the different tribes of people who settled in and in turn influenced Bengal. There was a dynamic differences between older muslin of the pre-Islamic era of South Asia and the Bangladeshi muslin of today; the older type was able to incorporate more curves and organic shapes, whilst the Bangladeshi patterns of today are more geometric in shape – sometimes the leaves on a tree appeared to resemble the wings of a spaceship.

This linear shift offered new shapes and patterns to emerge and probably brought about renewed interest into the industry at the time.

The weavers created my checkered pattern accurately although I felt the plain patterns which might excite the Europeans buyer, was probably quite tiresome to re-create compared to the eleborate designs they are use to.

Toils of a tiny spider

Sometimes in the course of endless needle pricks, watching the thread fall out from the needle's eye for

the fifth time, following a stitch by the millimetre and then realising I had stitched the wrong side again, I wondered why on earth anybody would want a hand-made tailored waistcoat? The overlay of muslin was an added difficulty which at times really did feel like you were weaving the clouds in the air!

The waistcoats we are accustomed to today appear easy to wear and ready-made however a 'proper' waistcoat is a lot harder to make. I soon learnt that patience was key, and my fascination with the history of the material was the drive to find out about something that links my ancestry, my birthplace and my present occupation. Luckily there was an endless supply of Bengali *channa chur* (snacks), glasses of mango Rubicon drink and green tea throughout the often gruelling and slow workshops. The process was arduous at times, delicate to a point of frustration but I felt it was rewarding and would be more so at the end.

The last time I saw this kind of toil and diligence in workmanship was in Bangladesh, where farmers plant young rice shots in perfect lines. After harvest, cows are directed into the fields to step over and break the shells of the individual raw rice grains; careful considerations we don't often see nor appreciate in our fast metropolitan lives.

17

... my grandmother just says
how the muslins of today
seem so coarse and that only

in autumn, should one wake up
at dawn to pray, can one feel that
same texture again.

One morning, she says, the air
was dew-starched: she pulled
it absently through her ring.

Extract from Agha Shahid Ali's *Half Inch Himalayas* (Wesleyan U.P., 1987)

(16): Bangladeshi weavers re-interpretting my design
(17): Fitting for a made-to-measure waistcoat

The promenade

My final historic waistcoat has an underlay of raw Chinese silk with an *charkona* muslin weave overlay, which resembles the colonial waistcoat whilst embodying the story of the Islamic age of India where Muslim men, not allowed to wear silk (as prescribed by the Prophet Muhammad [SAW]) substituted it with fine cotton, which in turn became muslins. In due course muslin became more luxurious than silk itself and gave wind to the sails of the trading ships to and from England.

My final modern interpretations are a mixture of historic navy waistcoats worn by captains and commanders in a contemporary fashion which incorporates new designs with a fusion of Asian and European styles.

18

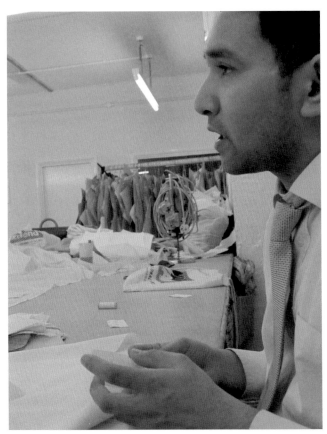

The s
the rui
machir
them t
them t
But
the h

The survivors were found in a room in the ruins, protected by large weaving machines that stopped rubble crushing them and created air pockets, allowing them to breathe.
But as the living emerged along with the bodies

19

These lead me to work with a London-based tailor George who lives and practices in north-east London. George incorporated my designs with a mixture of hand and machine sewing, introduced me to a variety of contemporary cuts and fittings. Originally from Cyprus he tells me that tailoring is a profitable trade but sadly a dying skill, recalling his beginning at 13 years of age and dressing the celebrities in Carnaby Street (London).

Sailing away

This journey has influenced my artistic practice in many ways and I've learnt that although history can be kept and recorded down in books it can also be easily destroyed once the knowledge leaves people's minds, if it isn't passed on through to younger generations. The project allowed me to think outside of high-street trends and question the

global impact of the fashion trade, just as muslin was once infamous for decades, its decline was just as fast as its rise. Native English tailors exchanged stitch ideas with Bengali tailors and weavers for centuries and we continue to share more through the material exchanges on daily basis.

On 24th April 2013 a clothing factory collapsed in Savar, a sub-district of Dhaka (Capital of Bangladesh). 1,129 died, mainly women. Bangladesh is the world's second-largest apparel exporter of western brands. This tragic event brought up debate within our sessions. We questioned the sustainability of clothing now and then, its impact on the global south and how the knowledge of the past can be best preserved and appreciated.

(18): The many stages of stitching
(19): Newspaper quote I kept from the Savar disaster
Overleaf: The historic waistcoat followed by the two modern design waistcoats and two shawls

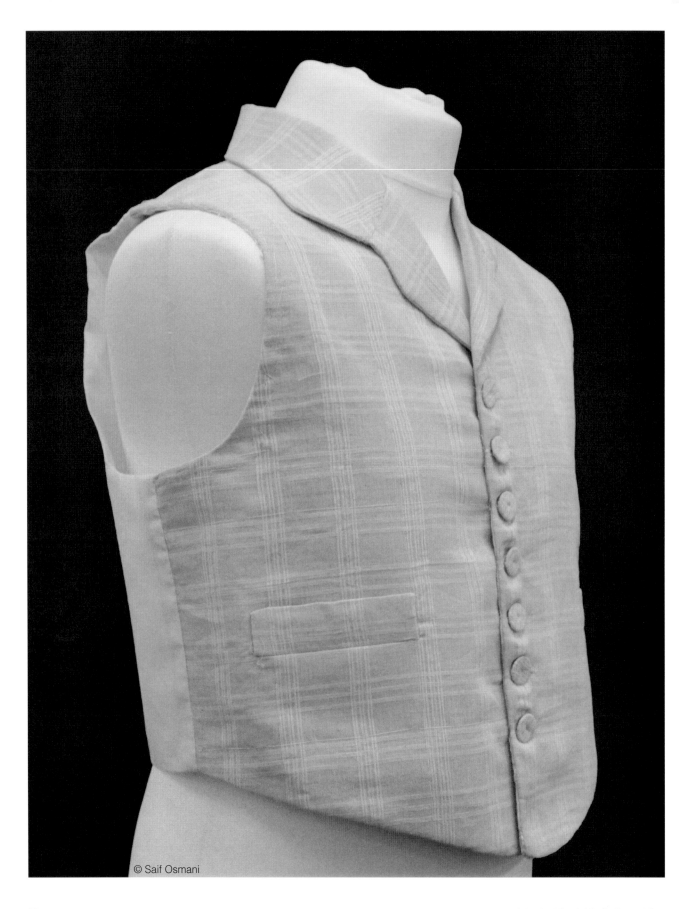
© Saif Osmani

Weaving The Grid of a Present Past

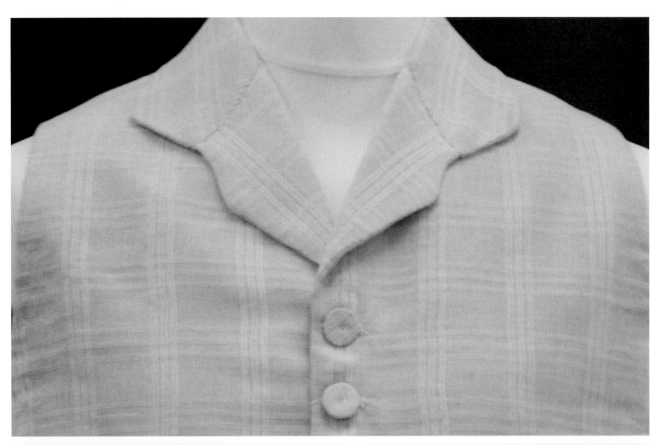

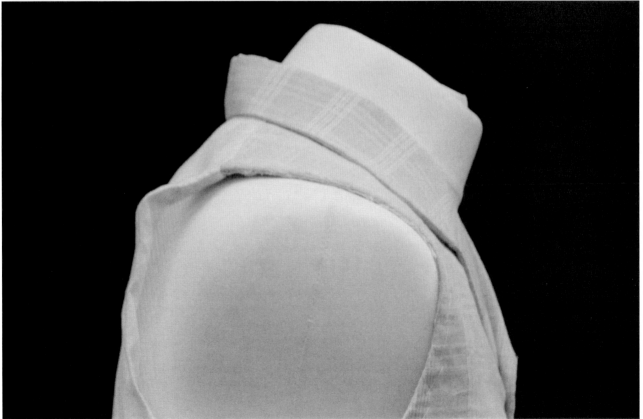

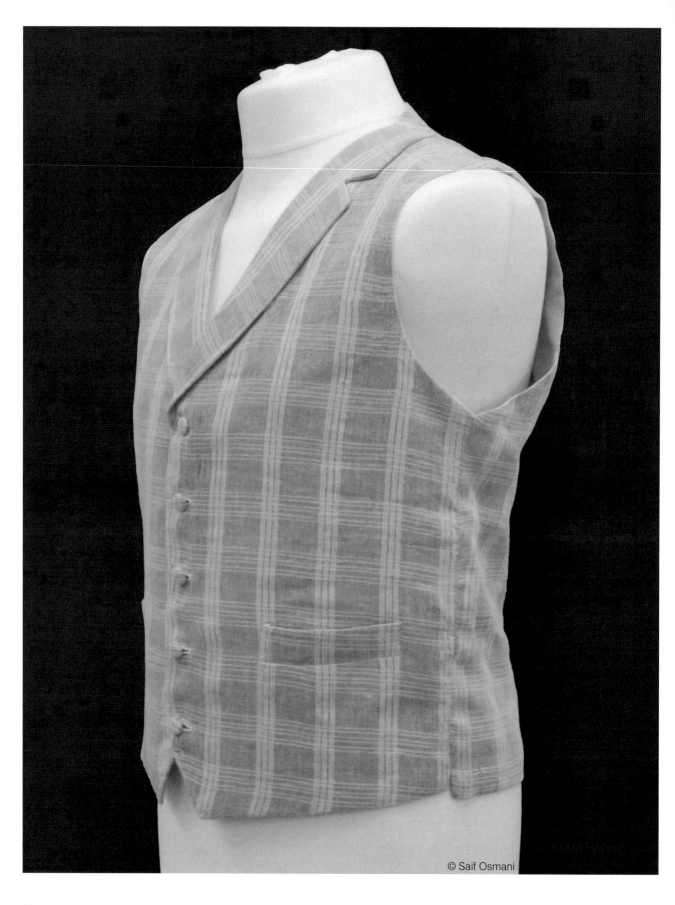

© Saif Osmani

Weaving The Grid of a Present Past

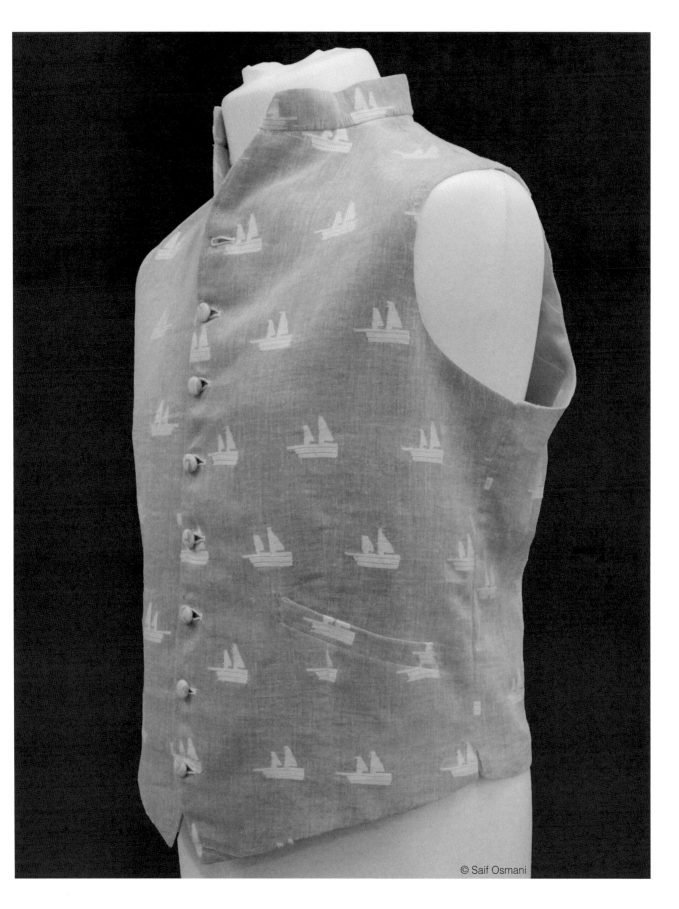

© Saif Osmani

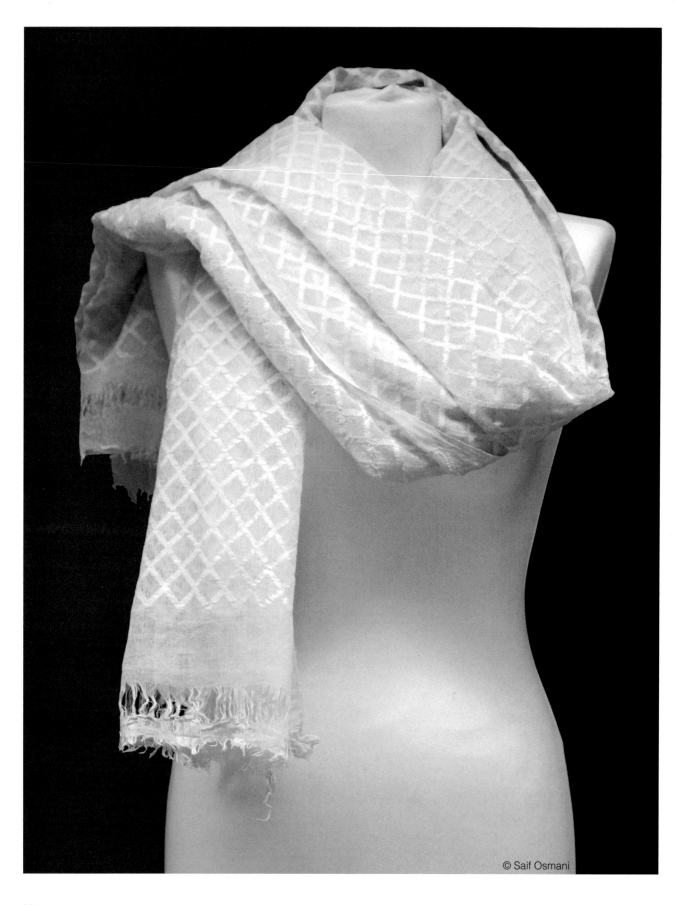

© Saif Osmani

Weaving The Grid of a Present Past

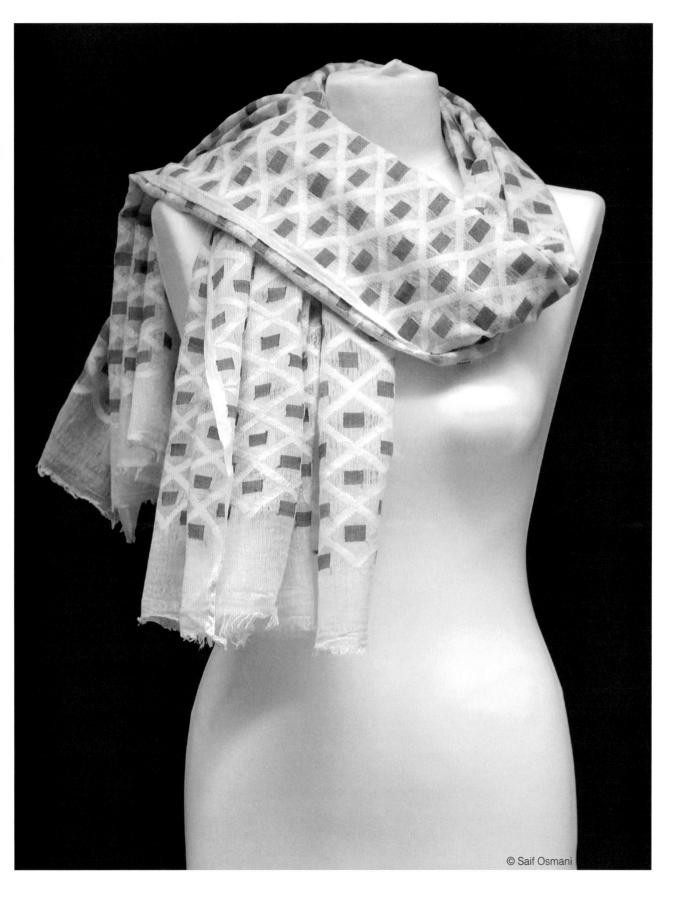

© Saif Osmani

The Empress' Clothes

Hilde Pollet

Josephine Bonaparte

I started my search for a reference dress with
the leading lady of the era. Empress Josephine
Bonaparte would have been the person French
society looked at to learn about the latest fashions.

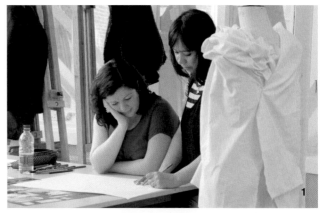

An image of a grand marble sculpture of Josephine
kept appearing during my research. When I stood
in front of it in The Victoria and Albert Museum
I was astonished by the detail worked into the
stone. Josephine's dress has a low-cut bodice with
honeysuckle decoration. The back was also cut much
lower than the dresses most women were wearing,
controversial but suitable for an empress. The sleeves
looked intriguing although I could not quite imagine
what they would look like in fabric.
Above all I fell in love with the way the shape of this
cold white marble exudes sensuality. The fabric
skimming over her bust and the majestic way the frill
on the neckline frames her face makes this sculpture
come to life.

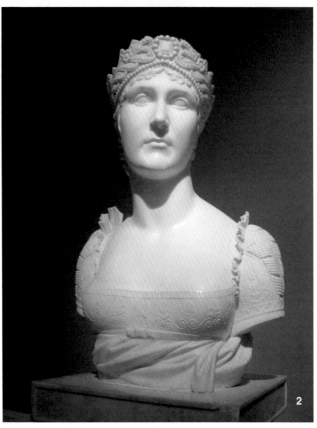

Choosing this sculpture as my reference was going
to need a lot of interpretation but that was what I was
looking for. I was going to be able to design a skirt

combining different elements of the many dresses we had studied during our research. In the Museum of London a dress with a pattern of pleats had grabbed my attention. The effect of light and dark was mesmerising.

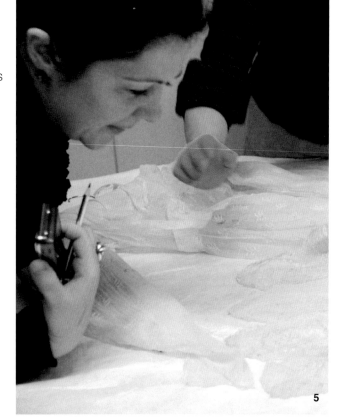

(**1**): Figuring out my design with Zarida Zaman from The London College of Fashion
(**2**): Bust of Josephine, wife of Napoleon Bonaparte, by Joseph Chinard, made c. 1808 (Source: V&A)
(**3**): Detail of the dress showing the honeysuckle motif
(**4**): Structured embellishment on the sleeve
(**5**): Undertaking research at The Museum Of London archives
(**6**): Low cut of the back panels
(**7**): Pleat detail on muslin dress at The Museum Of London
(**8**): My early drawings of the dress I wanted to recreate

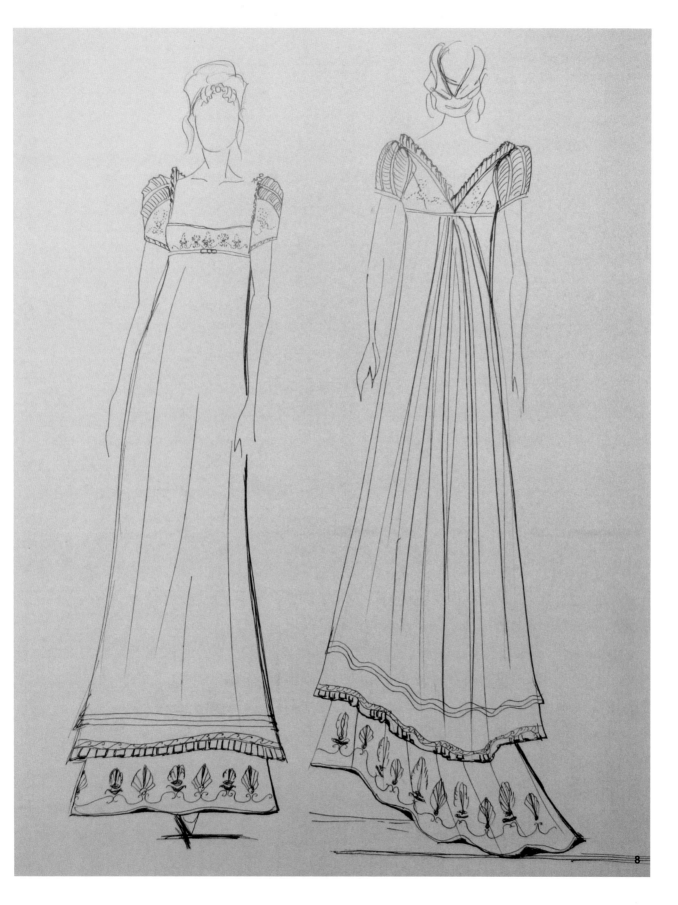

Dress design

I intended to perfect my handsewing skills with this project. My preference was to have the majority of the decoration to be sewn, manipulations of the fabric to create lines and textures and to use the lightness of the fabric to play with light.

From the research I found the lower part of the skirts was often heavily decorated, embroidered or in textured fabric. As this was an empress' dress no expense would be spared. Choosing two layers in the skirt would create depth.

I decided to stay true to the embroidery on the bust, as it was a popular motif at the time. There are two different embroidery designs; the honeysuckle on the bust, and a trim to be worked in the structure section of the sleeve.

For the skirt I decided to use a combination of pleats and frills. I designed a large pattern to be woven into the fabric to form the base of the underskirt based on the honeysuckle design. Two more woven trims were chosen to finish off the skirt design and for the neckline.

At the design stage I was still unsure on how to make the sleeve embellishment. Cording or tucks were the main options but I was concerned the muslin was

(9): Scrapbook of skirt designs
(10): Embroidery and weaving designs in development
(11): Finished patterns ready for production
(12): Detail of the embellishments, bust by Joseph Chinard (Source: V&A)
(13): Hem decorations on the skirt in two layers

going to be too light to carry this. I left this part of the design undecided when I started sewing.

The making of the dress

Receiving the fabrics was extremely exciting. The quality was exceptional. The embroidery was fine, true to the pattern and looked worthy of an empress' dress. The woven trims looked fine in finish but robust to work with.

I was really keen to get started on the skirt, I expected the sewing to take many hours. Because the design includes a train, and with the added fullness in the back, one circumference of sewing is at least 2.85m long. Six circumference seams had to be sewn.

I first hemmed the large woven trim for the underskirt and then attached it with a running stitch and finished by encasing the seam allowance.

The embellishment of the upper skirt was made separately before joining it to the top skirt. The pleats were made by running stitches. I prepared the frill by tacking pleats first. The seam allowance of the frill was encased between the skirt itself and the wave design trim.

Working with the muslin proved quite a challenge because the fineness of the fabric. After handling the fabrics a few times the fibres would start separating. I reduced the pleats from two to three to avoid too much handling and damaging the muslin.

13

The bodice is made up of three layers of fabric; linen as the base layer to support the construction, a plain layer of muslin and the outer muslin with the decoration. Matching the design of the embroidery to the shape of the bodice was the first step of the construction. I used the two different designs on the back to emphasise V-shape of the low cut back. The top edge of the front panel has a channel to allow for a handmade string to shape the bodice.

I constructed the sleeve in three pieces; I decided not to use an embroidered piece on the side panels to avoid the sleeve to becoming too heavy with embroidery; for the central piece I first pinned pleats onto the paper pattern and tacked them in place. With the embroidered trim I further secured them in place. The same trim also is used to finish the hem of the sleeve.

The Empress' dress

This is how I imagined Josephine's dress to be. The texture of the fabric and the sheen on the embroidery create the sensuality on the upper body that the sculpture hinted at. The ruffle on the neckline creates a playfulness and draws the attention to the back.

(14): Hemming of the underskirt trim
(15): Frill of the top skirt is being inserted in between skirt and wave trim
(16): Finished patterns ready for production
(17): Encasing the seam allowance after joining the trim to the skirt

The difference between Chinard's sculpture and the real dress is the way light plays between the different layers of the fabric. The shadows show the space between the threads and make this so light. The movement is a nice surprise too. The design of the skirt has turned out better than I imagined, the different layers in the train really work well, I can imagine the empress gliding past in it.

With every of the many hundreds of stitches I have gained more respect for the seamstresses of the past, who did this for a living, with very little tools. Re-creating this dress has been an eye-opener to

(18): Embroidered trim being sewn onto the pleated sleeve
(19): Preparing the different layers of each bodice panel
(20): Channel on the top of the front piece before it was closed
(21): The sleeve pattern was separated into 3 pieces
(22): Securing the pleats of the central sleeve piece

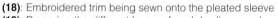

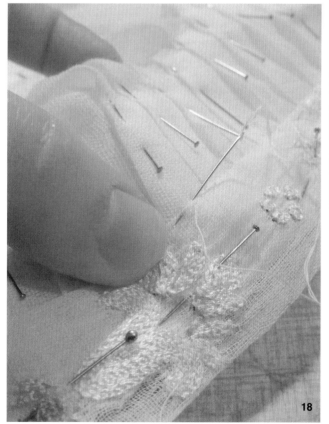

the effort it would have taken to dress ladies in this fashion style, whether they were trying to impress in an English village or on the European political stage.

Creative project

The lightness and transparency of the fabric is what has fascinated me the most. Even though it is light the cotton is strong and can take quite a lot of strain.

This fabric caused scandal when it first appeared on the London scene. The hint of seeing a leg through the fabric was shocking. This showing and not showing, combined with how the light plays in the fabric is my starting point for the creative piece.
I am working on pieces that are a combination of sewing, painting and possibly 3 dimensional work.

(23-26): Josephine Bonaparte's complete dress
(27, 28): My creative sculptural piece

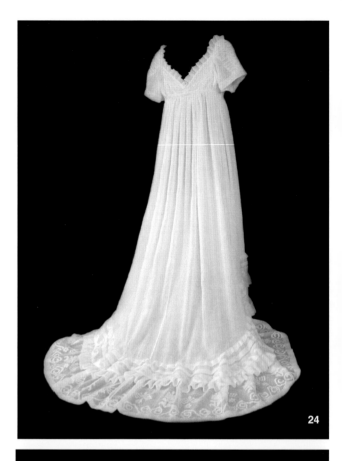
24

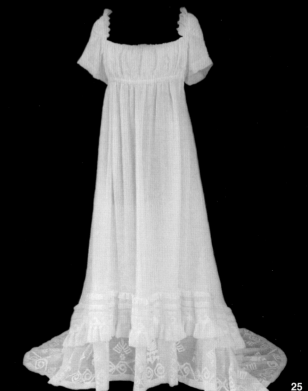
25

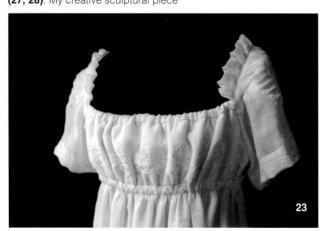
23

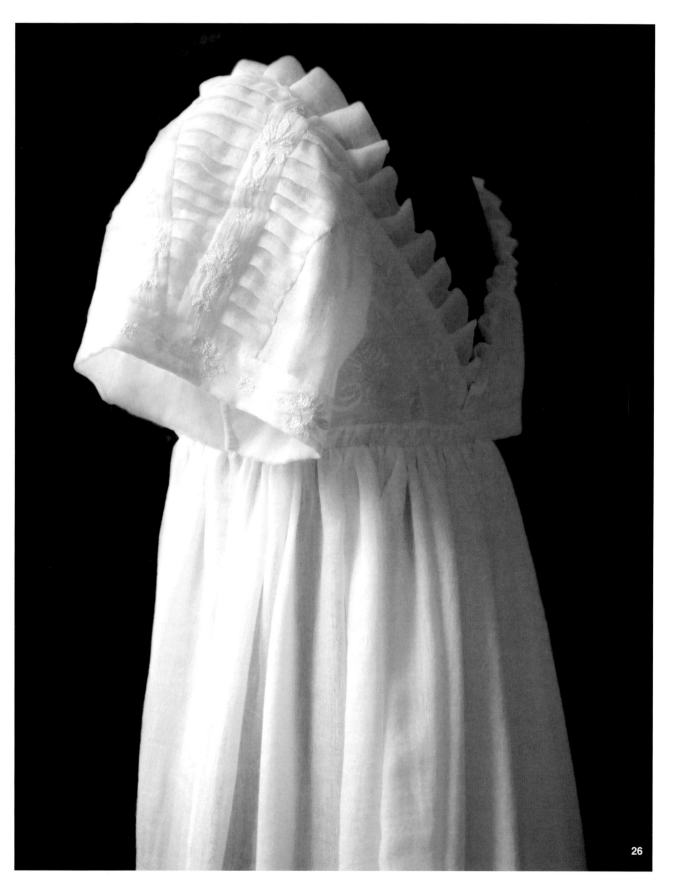

The Empress' Clothes

The beauty and influence of Jamdani

Rifat Wahhab

I became interested in the Heritage Project because I was really interested in the history of Bangladeshi muslin and how, why and who among the British wore it. The Project addressed these my areas of interest.

My initial expectations

I thought the project would be a series of talks on the history of muslin, which suited me well because I wanted to learn about the history of Bangladeshi muslin and how it dressed English women. I was very nervous when I found out that we also had to create a historical piece and a contemporary design. I did not see myself as someone who has sewing skills and was worried that I might not meet the required standard for the project. After meeting the two experienced tutors who would be assisting us, I felt assured they would help and guide me through all the stages of making the dress.

The knowledge I brought with me

I knew something about muslin before the project started. I am Bangladeshi British. From childhood, my parents and many Bangladeshis passed onto me the knowledge the mythical status of muslin. I was so fascinated and inspired by what I was told that I started to look for older relatives who may still have

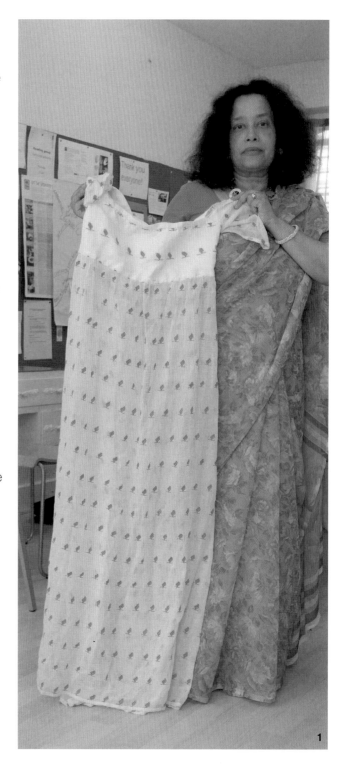

1

Dhaka muslin saris. It was a futile search, many never possessed muslin. The saddest of all was that my maternal grandmother did own muslin saris but they were all destroyed in a terrible flood.

Her muslin saris were carefully packed, along with her wedding sari, in a suitcase and when the storms hit her house she saw the suitcase flowing down the tidal paths.

My grandmother was the first person to tell me about how the best muslin saris woven just outside Dhaka were so fine that they could be passed through a gold wedding ring, I was enchanted from there on. I have since learnt that this knowledge is rooted in a historical account by a Middle Eastern traveller named Sulaiman from the 9th century who saw the fine cotton Dhaka muslin (Rahmi) and wrote that it was so fine that a dress made of this material can be passed through a cygnet ring.

I have been a fan of Jane Austen since my teenage years and I love her heroines because they all – especially Elizabeth Bennett- teach us how to be good. Austen's craft of portraying a character involved writing about the type of clothes she wore. Austen's heroines wore understated, discreet clothes that displayed good taste; the fabrics were not silk but grades of cotton. Apart from Emma and Jane Austen herself, most of Austen's heroines came from modest income families. Regardless, Austen's heroines wore

(1): My dress nearing completion
(2): Examples of Jamdani sari patterns (Source: Muslin Trust)
(3): Gathering research from The Museum Of London
(4): Examples of 19th century sari material (Source: V&A)

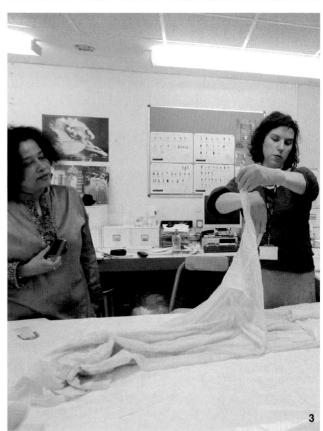

The beauty and influence of Jamdani

clothes which displayed good taste and heroines often wore muslin, thus reinforcing the idea that muslin was worn by good poeple. *Northanger Abbey* refers to muslin in detail. Jane Austen herself wore muslin and in her house in Chowton, there is a muslin shawl on which she added her own embroidery. There is also a painting of Jane Austen wearing a muslin gown (The Rice Portrait by Ozias Humphry, c.1792-3). In many ways, Jane was like her own characters – she lived in modesty, she was never wealthy and upgraded her clothes through her sewing techniques. Neither she or her sister Cassandra could afford to have all their garments fully made by tailors.

This project confirmed for me that even today's Bangladeshis do not own the historical muslin

because it was only sold and exported to the Mughal courts and rich European buyers.

Jamdani

Jamdani, the inheritor to muslin- has always been a constant interest and presence in my life and in the lives of millions of Bangladeshi women. I am lucky enough to have been given Jamdani saris by relatives. Thousands if not millions of Bangladeshis own or aspire to own Jamdani saris, it has and will always be a very much loved garment by Bangladeshis that goes back centuries.

A very close friend of our family (also my mentor) has dressed me in Jamdani saris from my early teens.

4

I used to sit with Taleya Rehman and wonder with awe at the creation and design of Jamdani saris; the wonder of it all was also that this beautiful sari was created in Bangaldesh. Taleya Rehman taught me that Jamdani is one of the many reasons to being proud of being a Bangladeshi. This was important because Bangladeshis in British society have always been seen and treated in a negative light and there have always been obvious and covert attempts at making Bangladeshis feel ashamed of being Bangladeshi. The good side of Bangladesh and Bangladeshis are rarely mentioned. Wearing and promoting Jamdani is our counter message because it is a major reason for being proud for being Bangladeshi, the Jamdani sari continues to draw attraction and admiration from all quarters. I continue to wear Jamdani saris on both formal and informal occasions and in doing so I often am asked about my sari by people who have never seen Jamdani- it is always my pleasure to say that it is the much loved and traditional sari from Bangladesh.

Getting Involved

My technical knowledge of muslin expanded and exploded when I joined the project. I went to the launch of the Project on a cold February evening in 2012 and I was blown away with what I had learnt from Muhammad Ahmedullah and Sonia Ashmore. The following day my family and I flew out to Bangladesh. Whilst there, I was lucky to secure a meeting with Ruby Ghuznavi, a leading international

5

6

(5, 6): Jamdani saris from The Victoria and Albert Museum archives
(7-10): Bangladeshi weavers recreating historic patterns

knowledge holder of muslin, natural dyes and Jamdani. Ms Ghuznavi not only gave me a fantastic talk on muslin and Jamdanis but also kindly arranged for a manager from her organisation Aranya to take us to two Jamdani weaving villages just outside Dhaka so that we can see how the Jamdani sari is woven. I was amazed by the craftsmanship of the weavers; they were designing outstanding Jamdani saris with intricate detail – most without paper patterns but by memory. I was inspired and felt that the whole world ought to know about this genius craftsmanship.

Developing our knowledge of muslin

When I came back, I attended all the talks given by Muhammad on muslin as well as the visits to The Museum of London, The British Library and The Victoria and Albert Museum. I learnt a lot about the social and economic history of muslin. It was special and a privilege to see the records of bales of muslin ordered and delivered to England. I also enjoyed learning about which social classes wore muslin and finding the link between muslin which was created just outside the town where I was born and I also learnt about the people who wore it.

I learnt from Heritage Project about who wore muslin – Princess Charlotte, Marie Antoinette, Jane Austen, Mughal emperors and their families . A major turning point for me was visiting the Victoria & Albert Museum- the curators allowed us to touch their muslin

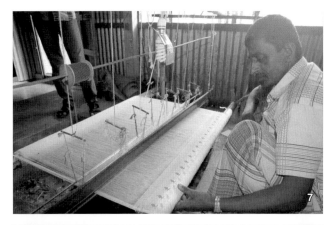

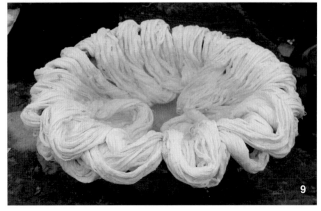

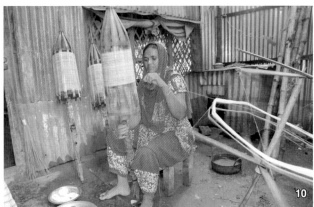

collection. This made all the difference because I have never touched such a fabric before, I can now see why it has its mythical status.

Choosing my garment

Whilst at The Victoria and Albert Museum, we were met by Rosemary Crill and Sonia Ashmore where the two curators showed us their muslin collection. There were many muslin garments which were exquisite, ornate and detailed but my eyes were attracted to early Jamdani designs on muslin. The choice was between a lovely red dot embroiderd fabric and an unusual Jamdani motif, I chose the latter. (please add Muhammad's photo no.1082, mine is attached) The design is not ornate and is actually simple which I think has a lasting appeal. Some ornate designs look dated but my view is that clean, simple designs will always quietly attract attention.

I chose the pattern because I love the combination of the muslin and Jamdani.

I found out at a very late stage that the fabric is from Hyderabad and dates back to 1855. My initial re-action was shock because I had assumed that the combination of Jamdani design on muslin was from Dhaka. I talked to experts about this and the response was interesting. The fabric is dated 1855. By this time the outside world had found out about Dhaka Jamdani and started to re-create it in their weaving villages. I imagine that this could have been the case in Hyderabad.

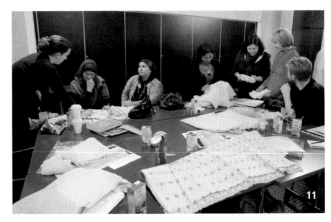

(11-14): The woven muslin arrives from Bangladesh after which work begins to transform the cloth into a dress

Design of my garment

The dress I chose to recreate is based on a photograph of two muslin dresses in a small book titled *Fashion in the time of Jane Austen* (p.40). There is no information on who wore the dresses but I liked the fact that the dresses allowed more fabric for the bodice, it is more flattering and easier for larger sized women to wear.

Most of the images of muslin dresses of that era do not allow much fabric for the bodice which in turn leads to very low necklines. I liked the femininity and simplicity of these dresses, they would flatter both the slim and the fuller figure. I think the beauty of muslin can be spoilt if the design is over fussy; I have seen many images of European muslin dresses that are over worked and in my view, this takes away the beauty of muslin.

The book gives no further information about the two dresses other than they were created around 1800-1810.

The creation of my fabric

I felt very humbled to have a design of my choice to have been woven in Bangladesh by a Bangladeshi weaver just so that I can create a historical dress. In England, it is rare to start a costume where the fabric has been woven for you. Dressmakers usually start by buying an off the shelf fabric – very few have the privilege of having a fabric woven for them. And so it was very special to have the fabric of my choice woven for me. I have shown family members and friends the photo of the weaver weaving my fabric. I would like to show the final product to the weaver.

It also felt special because by touching it, you are a part of the link between muslin and the English dress of the 1800s.

Preparing the fabric

I was brought up with the knowledge that Jamdani and cotton saris must never be washed; if really necessary, they can be sent to specialist dry cleaners in Bangladesh who will clean them using a special technique called "katta". So I was shocked when we were advised to wash the fabric by soaking it with a special fabric bleach, at a tepid temperature and washing them in our bath tubs! I was convinced I was ruining the fabric. I did not obey all the instructions – I took the washed fabric outside to dry in the fresh air. The first wash did not wash out all the starch, it was still stiff, so a second wash and dry was necessary. After I washed the fabric a second time, all the starch left the fabric and what was left was a much softer fabric that actually smelt like cotton .

Since then, I have taken the brave step of handwashing a few of my cotton Jamdanis. The risk was worth while, the starch has almost gone and the Jamdani saris are much easier to wear as a result.

Pattern cutting and work with Jamdani

When I found out that we were expected to create period pieces, I bought a paper pattern of dresses likely to have worn by Jane Austen's heroines in *Sense and Sensibility*. I showed the patterns to our tutors (Alice and Lewis), they examined the patterns closely and the sewing instructions and told me that neither patterns were true to historical detail. They explained to me how and why they did not reflect correct historical detail. I reflected on Alice and Lewis' feedback and decided to drop the pattern I had bought and go for a pattern that was true to historical detail after all, it was a once in a lifetime chance to create a dress under the guidance of historical costumiers and I thoroughly enjoyed the methodical steps the tutors took to create the pattern for my dress. Lewis cut out the pieces which involved a lot of calculation and Alice taught me all the steps it would take to place the paper onto the fabric and cut around it.

I made every effort to do my fabric justice by cutting it properly and then sewing it properly. I was very nervous at the beginning about my sewing ability and it was a giant step to go from sewing simple hemlines to sewing a dress according to historical instructions and design. My tutors were excellent, more often than not they had to explain their instructions several times before I understood what I had to do. I really appreciated their patience, this improved my

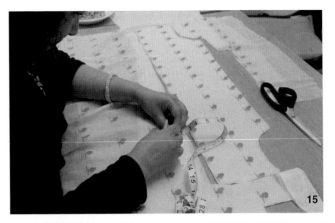

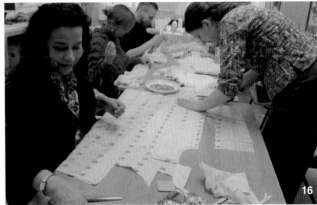

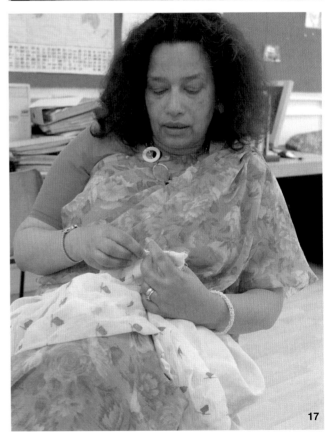

(15 - 17): Pattern-cutting and sewing at the fortnightly workshops

confidence in sewing to the extent that I hand sewed by creative piece using historical sewing techniques without resorting to my tutors for guidance.

Once I started to develop the technique of historical sewing, I could understand why women and children are preferred for sewing; I have wide fingers which makes sewing difficult and I now understand why the nimble fingers of women and children are preferred. Historical sewing requires sewing very small stitches, and this puts pressure on the eyes. Fortunately I could put on my reading glasses and switch on extra lights but sadly children in poorer countries do not have access to these and suffer eye damage at an early age.

Learning the different historical handstiching techniques

I learnt how to sew very small double stitches to keep the pieces strong. I also learnt how to whipstitch so that the full extent of the sewing is not shown on the right side of the fabric. Alice taught me how to pull a thread from the fabric to follow a perfect line. But the technique I am most proud of learning is the fell seam, it is a seam that involved several steps but the result is a neater seam than the flat seams seen nowadays. I made so many mistakes at the beginning and Lewis patiently repeated the instructions until I sewed it properly and with confidence.

To hand sew a whole garment is a painstakingly long experience – but a very satisfying one. You really feel that you 'own' the garment when you have hand sewn it.

I had never been confident in sewing and this was a very challenging piece of work and one that I wanted to do well. As a part of my learning experience, I was constantly asking Lewis the reasons behind his instructions so that I could have a better understanding behind the creation of my dress.

The dress was made both at home and at Heba. Here, Alice and Lewis set out the instructions for the next phase in creating my dress and I spent the rest of the afternoon following their sewing instructions, most times I was keen to continue the work at home so I would ask Lewis for instructions for my homework.

I felt a great amount of responsibility and commitment to my dress. I approached my sewing with a spirit to do it right and give it my best shot. I think everyone else in the project had the same approach – we gave it our best. The combination of having our chosen fabric and design created for us and the special privilege of having two experts like Alice and Lewis inspired us all to make the most of our sewing. I personally really enjoyed talking to everyone while we were sewing. I think there is something about sewing in a group that brings about good conversations!

Everyone supported each other in the sewing and we

also supported each other outside the project. One member of the project is an artist and so we supported him by attending his exhibitions. During the project, I set up a new charity – The Muslin Trust. Some members supported the charity by attending our first seminar and I have invited some project members to become trustees of the Muslin Trust. I hope that we will continue to be in touch and support each other in our work after the project has finished.

My creative piece

My creative piece mixed the old and the new. Using the same fabric, I created a very simple top. Sewing the creative piece was challenging because the fabric count was 80. This meant that I could not use my sewing machine because the stitches would be too tight and heavy for the very fine material. I had to hand sew the garment.

Initally I used the normal stitching we use today to sew but I saw that this was not strong enough to keep the pieces together. The seams edges were too frayed and it looked untidy. I decided to unstitch the whole garment and sew it using the same historical sewing techniques: fell seams, whipstiching, double stitching and re-inforcement stitching. It felt strange but good to create a modern garment using historical sewing techniques – but it worked.
The garment was updated by using sequins and beads and other embellishments.

I chose the garment to be size 16 because the average size of an English woman today is size 16. This was an important factor because the bodices for the historical pieces had to be for a smaller woman, the best of fashion seems to have been created only for smaller women who furthermore had to show low necklines. There was no room for fuller figured women who wanted to wear muslin. The cartoons by Gillray, especially The Graces in a Storm, re-infornces the idea that larger women looked foolish in muslin – especially when the wind blows in their direction!

By creating a size 16 top I am making a statement that larger women have a right to wear muslin as much as smaller women – and they can look equally as good. The English feminist movement's achievements include moving fashion away from dresses that made women wear body damaging corsets, show low necklines and wear robes with ultra long lengths that restricted free movement.

In many ways the ideas that follow fashion from past days have not moved. Whilst we are appalled by corsets from the 18th and 19th century that deformed the liver and internal organs just so that women can appear to have minute waistlines, in the 21st century we can link this to today's women who are made to feel that their current body is not good enough and the only way to assert their femininity is by reducing their size to size 10 and below, wear garments that are transparent, tight and show large amounts of flesh and by wearing heals that damage their bone structure.

My garment is a protest against this mind set. It's by far from perfect but the message is there: the average size of British women today is size 16 and they too have a right to wear lovely clothes without having to resort to crash diets and restrictive clothing.

I would like to dedicate this dress to my husband, Derek Perry. I fell ill during the period of making this dress and was almost immobile for three months. Derek knew that I was dedicated to making this dress and so for several months he drove me to the sewing venues and brought me back with a dedication I shall never forget."

(18): Detail of the pattern on the sleeve
(19): Side view of my historic dress
(20): Back of my historic dress
Overleaf: My completed historic dress alongside my creative piece

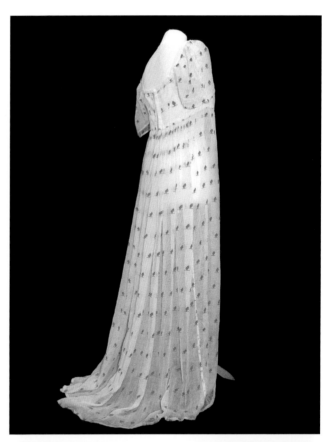

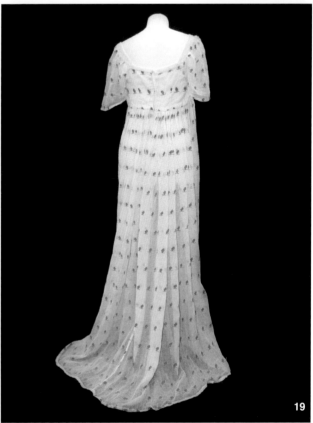

18

19

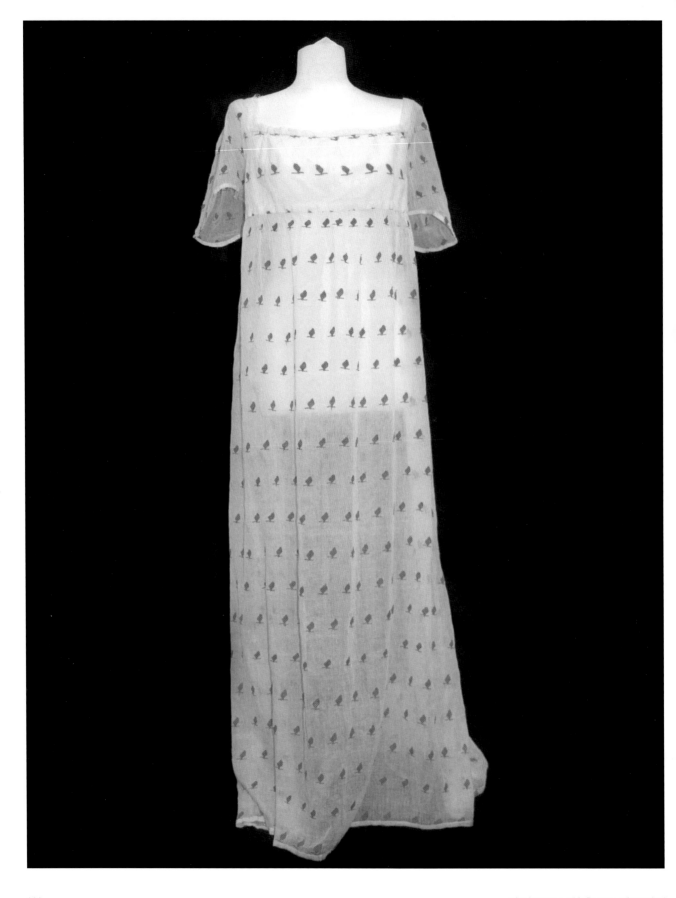

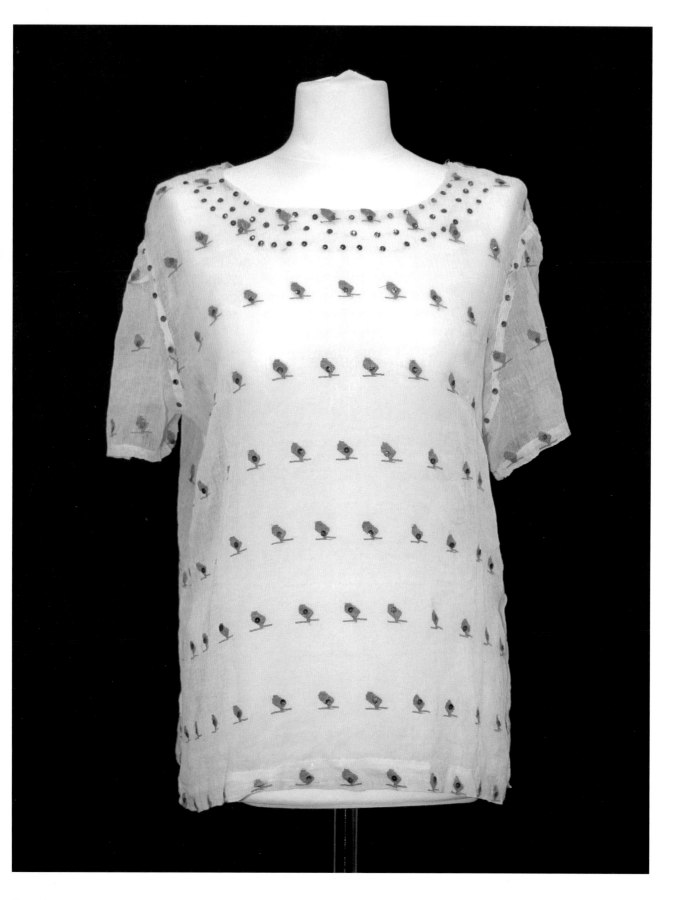

Collective Discovery

Heba Women's Project
Anjum Ishtiaq, Lindsay Dupler and Rehana Latif

Getting involved

I am the production manager and sewing tutor at Heba. In 2012 we heard about the project which involved reproducing dresses that were made from muslin. I am originally from Pakistan where I used to make and wear muslin dresses but I didn't know much about the history behind it.

At Heba we work with women from diverse backgrounds who have a variety of skills and interests linked to sewing, dressmaking and fabrics. We met together to discuss the muslin project and explored ways that we could be involved. Although the project was for individuals, we decided to work as a Heba team and put our joint efforts towards the project.

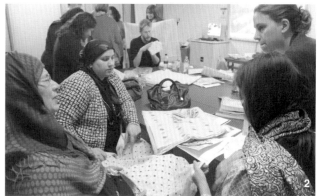

Team Heba

Our Heba team consisted of three individuals: myself Anjum Ishtiaq, Lindsey Dupler and Rehana Latif. Each one of us has our own different life stories, which explain why we decided to join the project. Within our team we divided the work between us and undertook tasks jointly and separately.

Lindsey joined Heba quite recently to learn sewing and utilised the centre's crèche facilities for childcare. After a

(1) L-R: Rehana, Lindsay and myself Anjum
(2): A collaborative process right from the beginning

few classes I introduced the idea of this project to her and suggested she consider participating. Lindsey liked the idea of being part of a team and working as a collective.

Rehana has been with Heba for many years and the idea of joining the project was of particular interest to her. She saw this as an opportunity to learn more about the design process, especially as the London College of Fashion were going to run a short course on fashion design.

The task in hand

We thought the dressmaking would take place during weekly sessions. However, this turned out not to be the case. We were required to work outside the workshops, at home or wherever was convenient; the accompanying workshops were designed for us to get help and expertise from our two tutors Alice Gordon and Lewis Westing.

When we learnt that the project would involve hand-sewing we were slightly disappointed as the process was going to be time-consuming, laborious and hard work. However, on the other hand, we also thought that this would give us an opportunity to develop a better appreciation of historical sewing methods and experience the hard working skilled weavers, embroiderers and dressmakers go through to produce these beautiful garments.

I had seen hand-sewing undertaken by poor people in Pakistan and felt that this project would help us appreciate and identify with the emotional sides of the work; how people undertake hard work all day, month after month and year after year. It is a common scenario - poor people do

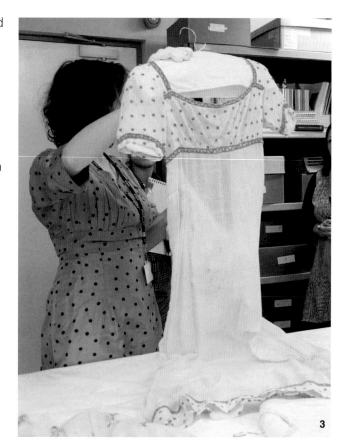

3

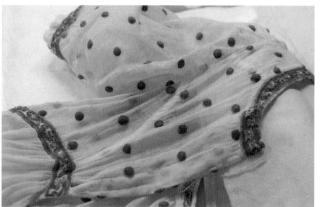

all the labouring while the rich enjoy the beautiful creations of the former's hard toil. Our participation in the project has helped us develop a better appreciation of this and other issues.

We also learnt a great deal from the visits to The Victoria and Albert Museum and Museum of London. We saw many examples of muslin fabrics and dresses made from Bengal textiles several centuries ago. At The British Library we were able to look at records of the East India Company's exports of Indian textiles into Britain. At The National Maritime Museum in Greenwich we learnt about the transportation of these materials. The displays also explained how textiles from the East revolutionised fashion and textiles usage in Britain.

(3): The original dress at The Museum of London archives
(4): Hand-stitching the dress with care

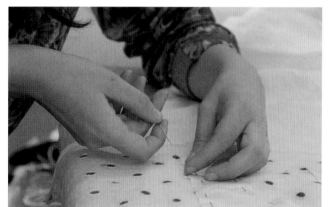

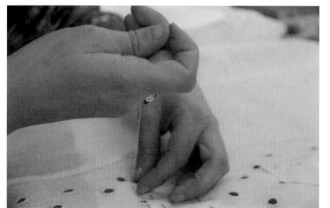

4

Our dress

Our historical recreation was an attempt to make a replica of a dress stored at The Museum of London. It was worn by Catherine Lucy, an author and wife of Philip Henry 4th Earl of Stanhope and sister-in-law of Lady Hester Stanhope, a famous English adventurer and traveller. We chose this particular dress after a group discussion; the fact that it had bright colours - red and yellow - was particularly attractive.

It was donated to the Museum of London by Catherine's great-granddaughter. We tried to undertake internet research on her background but found very little information. Her husband Philip Henry, 4th Earl Stanhope however was more well known, and a great deal of information was readily available on his life such as the fact he followed his father's footsteps with an interest in science and served as an active member of Medico-Botanical Society and Society of Arts.

Lady Hester Stanhope (1776-1839) was even more widely known. She was the granddaughter of William Pitt the elder and served as a private secretary under Prime Minster William Pitt the Younger. After his death Lady Hester went on adventurous foreign travels to Turkey, Egypt and the Middle East. She was received by rulers and ambassadors and even undertook archaeological expeditions to uncover lost treasure.

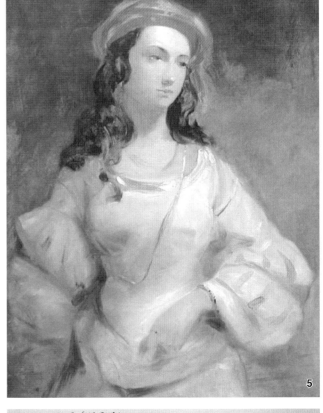

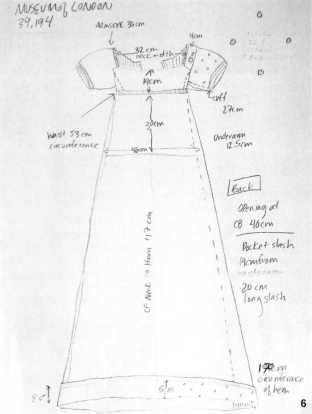

(5): A painting of Lady Hester Stanhope
(6): Detailed notes and drawings from the sessions
(7): Lindsay working on the dress

Lindsay's story

Lindsey was especially interested in finding out about the links between historical textiles of Bengal and the rest of the world, particularly African slavery. She is originally from America and her family has ancestral links with slavery. At the outset it was clear that the project had many potential dimensions to explore, which became more and more clear during the workshops.

For example, we learnt that there was a slavery connection with Bengal textiles. About a third of British textile imports from India were re-exported to Africa, primarily to purchase African slaves, and as the majority of Indian textiles were purchased from Bengal, the project allowed Lindsey and the team as a whole to engage with and explore this connection and we spent some time thinking about how to incorporate this dimension in our re-creation of historical dresses.

The historical slavery link with Bengal textiles was a very important discovery for Lindsey. She felt there are quite a few modern day equivalents that carry on this greed and exploitation.

She is a conscientious individual who is learning how to live more sustainably and ethically - preferring to upcycle, reuse and repurpose clothing. Lindsey also found the project very useful as it has allowed her to discover historical technology used in garment construction. For example during our visit to The

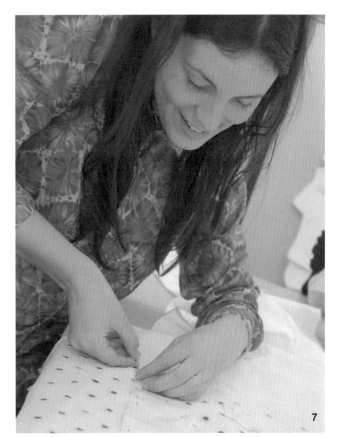

7

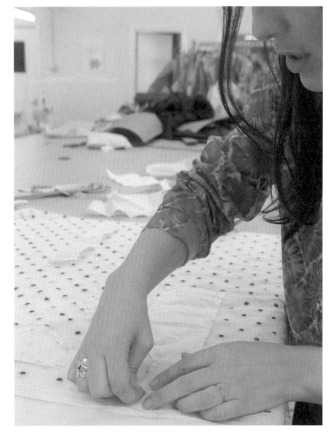

Museum of London we learnt about stays and corsets for women and how they were made.

Stays and their busks, carved with poetry and pictures by lovers, were a particularly amazing discovery. We also learnt that stays were also very different from the latter corsets, and were actually more comfortable to wear, helping women keep the correct posture.

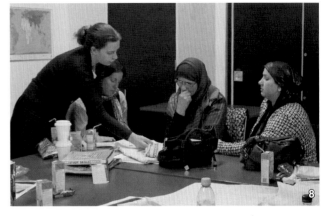

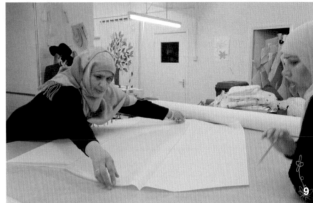

(8): Working out the overall approach
(9): Laying out, cutting and ironing the cloth
(10): We all contributed ideas to the mood boards which were created during sessions held at The London College of Fashion

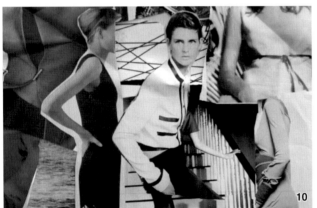

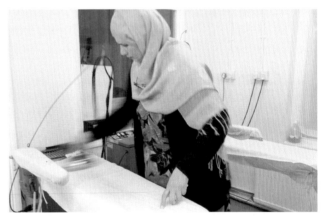

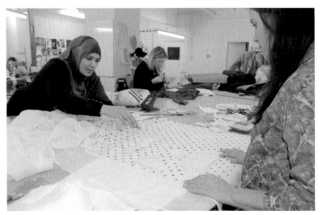

Rehana's story

Rehana's motivation for joining the project was to increase her knowledge of different types of fabrics. When she saw and touched the fabrics brought back from Bangladesh she thought they were beautiful and looked forward to working with them.

She found historical pattern cutting difficult because the types of measurement used then are different to what she's used to in her usual dressmaking. At first she also found it very hard to hand sew. However, the facilitators who are experts in historical costume making, provided guidance on the kind of threads and needle to use. Alice told her to use very thin thread soaked in water over night before stitching.

Rehana mostly worked on her part of the dress from home and managed to sew the whole skirt within four days. The hardest part was sewing the braid on the dress.

(11): A section of the boddice taking shape
(12): Rehana's contribution included delicate hand-sewing

My story

As for me, I have a background in the fashion sector and have developed considerable knowledge and skills in dressmaking and working with fabrics. This is one of the main reason why I got involved with this venture as it would enable me to share skills while involving the Heba Women's Centre with this project. Initially I wanted to encourage students from Heba to join the project to enable them to gain wider experiences and learn more. Prior to joining this project I had worked with muslin fabrics before but it was through machine sewing. This is the first time I have undertaken hand-sewing. The fabrics that they handmade from Bangladesh for us to work on in this project was however more fine and of a higher quality than the muslins that I had worked with previously. Thankfully the hand sewing turned out to be a pleasant experience.

Washing the fabric was a good experience too. It took me a long time to get all the starch off from the fabrics but the end product was very nice. One can experience the quality and softness of the fabrics when they are washed thoroughly. I had washed fabrics and clothes made in Pakistan before but the items from Bangladesh had more starch in them.

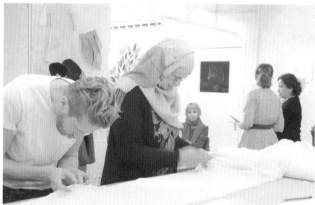

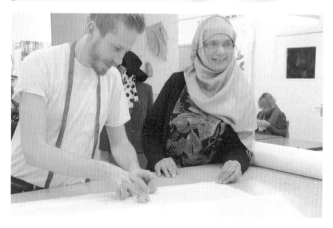

(13): During the fortnightly workshops
(14): Back of our final full length historic dress
(15): Hemline design on the historic dress
Overleaf: The final dresses pictured together

Creative piece

Each team or individual had to recreate a historical dress and then a second creative piece. Our exploration of how to incorporate the slavery dimension led us to a tear drop design in black and silver which we had embroidered onto the second garment.

We were very happy with the work done in Bangladesh for our historic piece but the actual woven design on the creative piece we requested was slightly different from the specifications we gave. However we used it to create a second dress and are extremely pleased with both garments.

Overall this was a unique experience to work on and it was also a pleasure to lend our Heba workshop space and sewing rooms to the rest of the group, giving everyone a regular place to meet up in and sew.

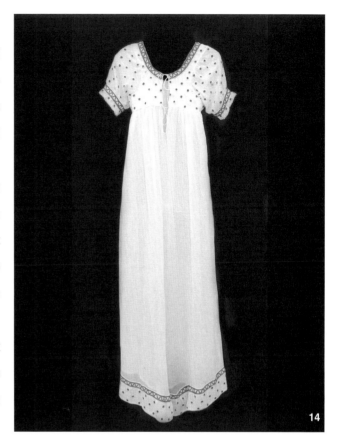

14

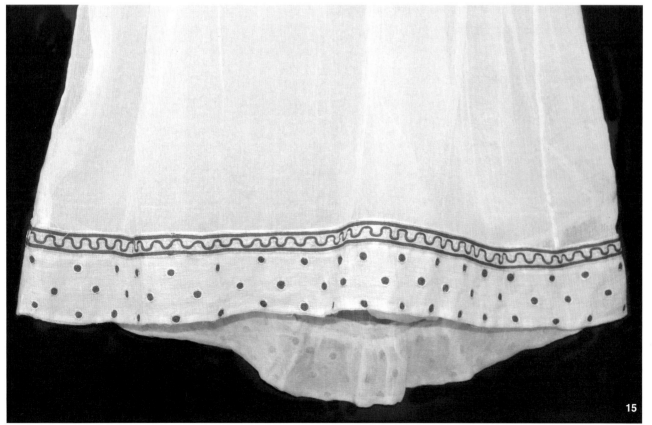

15

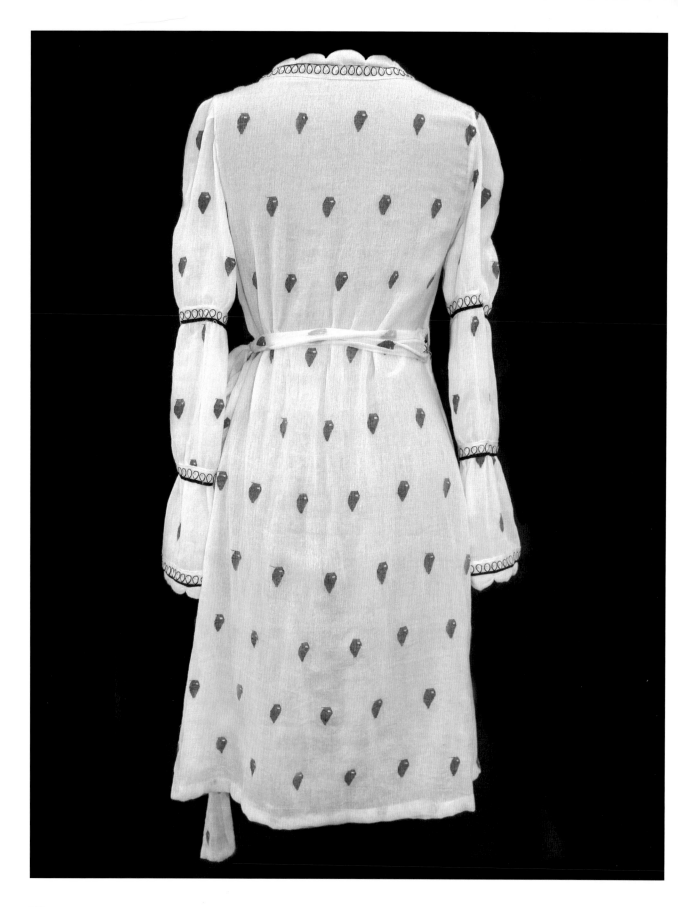

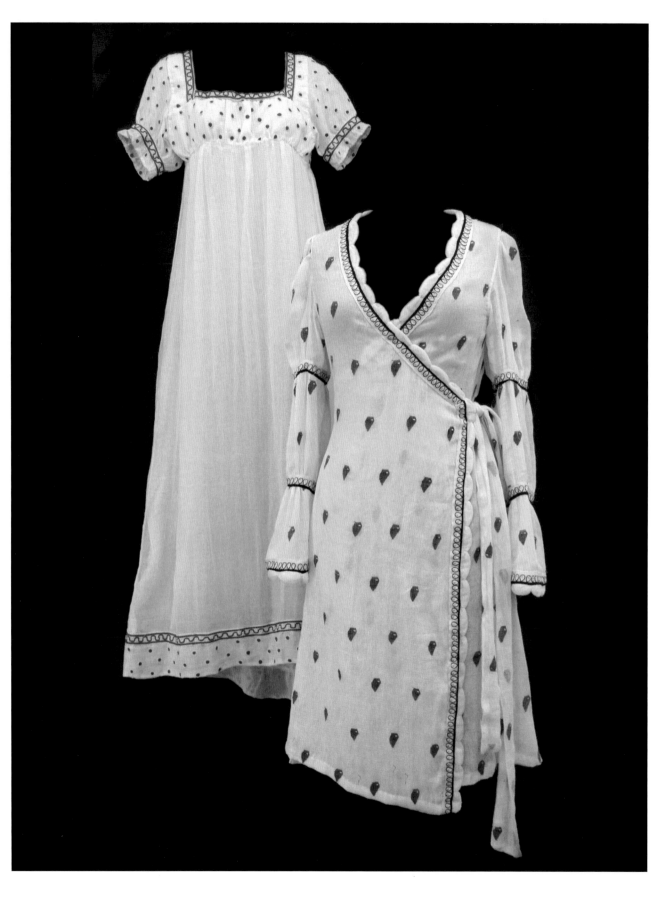

The Finer Details

Muhammad Ahmedullah

From research to re-creation

I am the co-ordinator of the project and worked on the initiative from the beginning. My first task was to generate publicity and recruit a dozen volunteer heritage fashion recreators to help us recreate historical costumes. The quality and diverse range of people that we managed to attract to the project was a pleasant surprise.

During the first stage of the project, which involved taking the group through a process of learning, attending the short course with London College Of Fashion and visiting heritage institutions and museums, I began to become more and more interested in the subject area.

I worked with the group, hired facilitators with expertise and knowledge on historical fashion, and took orders for fabrics to be hand woven and embroidered in Bangladesh. Supporting the group and observing how they and every individual involved with the project developed from the start to working on their chosen dresses were a very interesting experience. The whole process and how things progressed impressed me immensely.

Midway through the project I thought perhaps I should also try and produce some items and many ideas started to float in my mind. I discussed and explored my ideas with the group, facilitators and several friends. While the rest of the group made dresses, I decided to work on a number of smaller pieces, both historic and modern, designed to bring out additional heritage dimension to the project. It really is amazing how quickly ideas can be turned into concrete reality. In this section I provide details of four pieces that I worked on and a fifth item given as a present to the project by one of our helpers in Bangladesh, who became inspired by the project.

Jane Austen Regency Saree

A creative piece based on an imagined historical British cultural mix. I worked on developing a white Jamdani style saree but with less elaborate woven designs than normal Jamdanis, made from mix cotton and silk threads with embroidery based on an early 18th Century English flower drawing. I called it a Jane Austen Regency Saree.

The first idea that I explored when I decided to produce several items was based on an imagined late 18th and early 19th century hypothetical situation in England. I asked myself what if there were a sizeable Bangladeshi community living in London around the period when Jane Austen was born and writing her novels? Surely, the East India Company would have seen them as a potential market for goods that it imported into the UK from Bengal, India and Asia in general. The community would have wanted to consume goods, spices, etc. that originated in Bangladesh, just like they do now. My next question was what kind of textiles would they have ordered from Bangladesh.

If we consider most of the surviving dresses in various collections in the UK, made from Bengal fabrics, they are from the time when Jane Austen was living and writing her novels. This means that in addition to many items that London Bangladeshis would have wanted, they would have most likely also have ordered white muslin sarees, including those woven in Jamdani designs. Further, some of them would have incorporated English and western themes into the saree designs, just as western and British fashion senses and demand lead to order specifications for East India Company's commissioning of textile production in Bengal. Many of the fabrics manufactured in Bengal and other places in Asia were undertaken based on British designs and specifications sent out during East India Company's ordering cycles. An example from an order sent to Bengal is as follows:

'Mullmulls with fine needle work flowers wrought with white ye flowers to be about 3 or 4 Inches asunder and neate ye peices to be 11/8 yd wide at least and Better if ell, and 21 yards Long'. (Dispatches from England, 1680-1682).

This led me to think about working on a saree that would be white, incorporate Jamdani designs and British elements, which would be able to compete with British and European ladies fashion of the day, in terms of elegance, beautify and sophistication. At first I thought perhaps I should order a mixed cotton and silk white saree to be hand woven based on certain Jamdani style design specifications with empty spaces across the whole saree for embroidering traditional British flowers, like the rose. This idea was not very popular among my colleagues when I requested feedback. Later I thought of embroidering the Bangladesh national flower, Shapla (water lily), however, it was pointed out that the water lily was not a unique Bangladeshi flower and that I should think of something else that would be more appropriate in linking Britain with Bengal.

Idea of embroidering a mango or other traditional Bangladeshi fruits came up for consideration. This stretched my mind for a while until one of our workshop facilitators suggested that I could look at English flower drawings from the relevant period and choose one that I liked to be embroidered on the saree. It was pointed out that during different times people drew things differently so flower drawings of the 18th century, for example, would be different from another period.

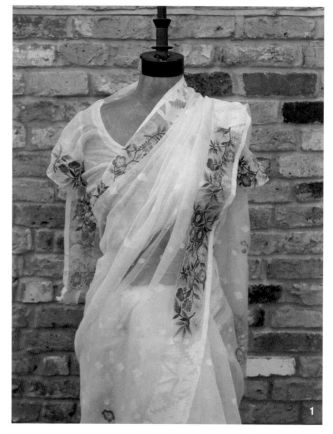

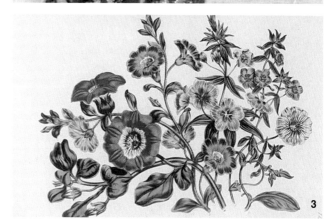

(1, 2): My idea of Jane Austen's Regency saree and cloe up detail
(3): Jane Loudon (1807-1858), 'The Ladies' Flower-Garden of Ornamental Annuals'

This sounded just right so I started to look into this option. After carrying out some research on the internet I found several beautiful flower drawings at the Victoria and Albert Museum website. The one I chose was from drawings (published 1842) by Jane Loudon, an 'English author and early pioneer of science fiction', who 'created the first popular gardening manuals'. Rather than embroidering exactly the whole drawing I gave the embroiderers in Bangladesh freedom to incorporate part or whole design or be a little creative. The result of the effort can be seen below. In addition, I had a rumal (handkerchief) made with same flower embroidery. In the case of the rumal it was embroidered on a piece of hand woven white cotton fabrics.

I sent my design specifications to Bangladesh by email and followed up by telephone conversation and clarification. The saree was hand woven by Abu Mia Jamdani in Rupganj, which was then taken to be embroidered at the 'Idea Boutiques and Taylors' at Taltola Market, Kilhgaon, Dhaka. However, against clear instruction to undertake the embroidery work strictly by hand they used modern machine technology instead to complete the order. Seeing the machine based embroidery, at first, I was naturally very disappointed at the mistake or deliberate decision to work contrary to specifications. However, this experience helped me better appreciate the East India Company's textile trade with Asia. In the Company records there are many references to discrepancies between items ordered from London

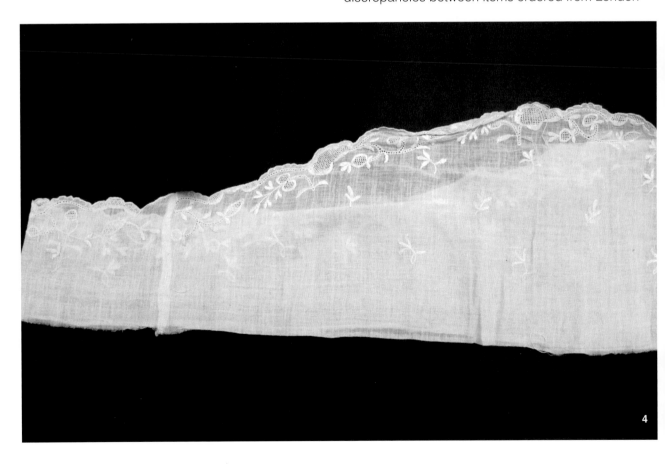

4

and the qualities and quantities that came back to the UK, procured by its agents in Bengal. There are also other records and sources of information which show many instances of bullying and oppression carried out by East India Company agents against local textile suppliers in Bengal.

These images of fichus are archived at Worthing Museum and Art Gallery and dates back to the 1760s. They were worn by ladies around the neck to observe modesty and came in many shapes, sizes and designs. Some of the designs on the fichus were woven in during the weaving process while others included embroidery work, undertaken on woven fabrics. The fichus were used to fill in the neckline and add to the fashion and style to dresses worn.

They are said to have been 'indispensable necessities for any regency wardrobe'. It is said that fichus were first worn by lower class ladies before 1700 but then from early 18th century it started to become more fashionable among upper echelons of society.

Although this looks very simple I found it quite difficult to hand sew the semi-circular outer part of the fichu. This was also my first attempt at historical sewing. Prior to this my experience of hand sewing extended to sewing buttons on shirts and shortening trousers. The fact that I was working on a half silk material made it even harder to produce thinly turned and

(4, 5): Fichu - a recreation based on items at Worthing Museum.
© Worthing Museum and Art Gallery

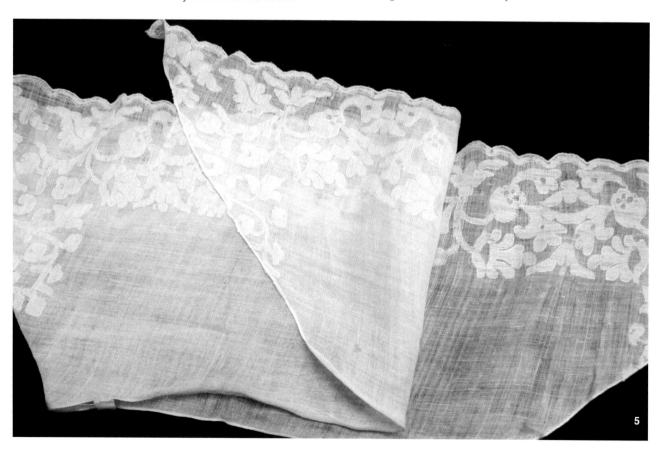

5

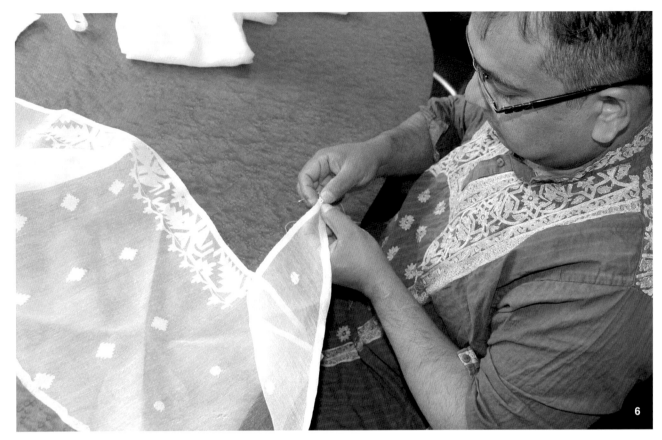

6

uniformly smooth edges around the semi circular part of the item.

I used spray starch to make the material harder in order to iron a smooth edge, before placing pins in to hold it section by section of the whole area needed for sewing. One of our facilitators helped with the pattern cutting and I learnt much from observing how other were working on their dresses. The final piece looks very beautiful, although based on a slightly different design than what I was trying to recreate.

A recreation of a rumal in the Victoria and Albert Museum's collection

This Bengal rumal (handkerchief) was produced in late 19th century in West Bengal. This kind of design and the method utilised is called 'chikan embroidery'. According to The Victoria and Albert Museum, after the decline of the muslin textile industry in Dhaka during the 19th century, many people with skills moved to places like Kolkata, where they produced items similar to this rumal for the British.

This Bengal rumal (handkerchief) was produced in late 19th century in West Bengal. This kind of design and the method utilised is called 'chikan embroidery'.

According to The Victoria and Albert Museum, after the decline of the muslin textile industry in Dhaka during the 19th century, many people with skills moved to places like Kolkata, where they produced items similar to this rumal for the British.

During previous centuries handkerchiefs were ordered in large numbers by the British from Bengal and often the items ordered had to be designed based on British specifications. In recreating the rumal I tried to follow a process similar to how orders were placed by the East India Company. I sent out details of the rumal to Bangladesh, including photographs of the V&A rumal (East India Company would send drawings and samples in some cases) and specific instructions, in terms of the size and how it should look as near as original as possible. However, as the people chosen for the work were not experts on chikan embroidery they were given flexibility and scope for creativity, but had to complete the work on a very tight time schedule. The plain white cotton fabrics used was hand woven by Jamdani weavers and the material was then taken to be embroidered. The recreated rumal shows that today people in the region still possess a range of skills similar to what their ancestors were able to produce in the past.

(6): Working on aspects of my fichu
(7): Original piece at The Victoria and Albert Museum
(8): Recent recreation in Bangladesh

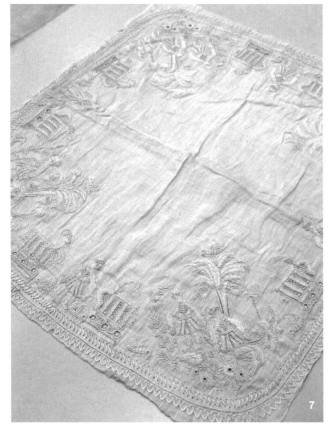

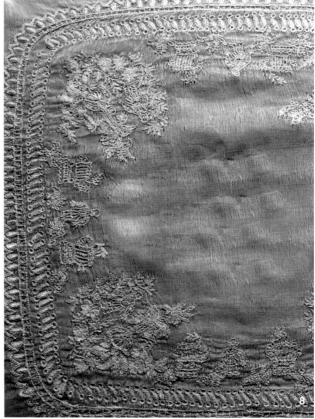

Princess Charlotte's Shawl – a creative interpretation based on a dress in the Museum of London

I fell in love with the beauty of a small section of a dress shown at the Museum of London, thought to have belonged to Princess Charlotte. This dress was embellished with embroidery and where there was no embroidery, texturally it looked like a soft tissue. Of course it was not a tissue and therefore not as fragile. But it was very delicate; they must have utilised the best muslin produced in Bengal to make that dress.

The heavy embroidery would have strengthened the structure of the material and made it more durable. The museum did not have the full dress so it was not possible to recreate the whole garment. This led me to think about what else could be done as I didn'tt want to lose the opportunity to include images and information on this item in our project. I undertook some internet research on Princess Charlotte and found out that she died at the age of 21 during childbirth, which was an incredibly sad thing to discover. The following quotation is from Wikipedia:

Princess Charlotte of Wales (Charlotte Augusta; 7 January 1796 – 6 November 1817) was the only child of George, Prince of Wales (later to become King George IV) and Caroline of Brunswick. Had she outlived her father and her grandfather, King George III, she would have become Queen of the United Kingdom, but she died following childbirth at the age of 21.

First Interview of the Princess Charlotte with Prince Leopold at the Pulteney Hotel.

9

Charlotte's parents disliked each other from before their pre-arranged marriage and soon separated. Prince George left most of Charlotte's care to governesses and servants, but only allowed her limited contact with Princess Caroline, who eventually left the country. As Charlotte grew to adulthood, her father pressured her to marry William, Hereditary Prince of Orange (later King of the Netherlands), but after initially accepting him, Charlotte soon broke off the match. This resulted in an extended contest of wills between her and her father, and finally the Prince of Wales permitted her to marry Prince Leopold of Saxe-Coburg-Saalfeld (later King of the Belgians). After a year and a half of happy marriage, Charlotte died after giving birth to a stillborn son.

Charlotte's death set off tremendous mourning among the British, who had seen her as a sign of hope and a contrast both to her unpopular father and to her grandfather, whom they deemed mad. As she had been King George III's only legitimate grandchild, there was considerable pressure on the King's unwed sons to marry. King George III's fourth son, Edward, Duke of Kent, fathered the eventual heir, Queen Victoria.

I decided to produce a shawl incorporating various designs from the section of Princes Charlotte's dress at the museum. Shawls were very popular items imported from India and often worn with white muslin based dresses. Although the most popular shawls imported were made from Kashmir wool, many shawls were also made from textiles that came from Bengal, including muslin. With this knowledge I decided to produce a white muslin shawl with elements of Princess Charlotte's embroidery designs. I took the small motifs scattered around the piece and had them embroidered on a 100% hand woven cotton fabric, two metres by one metre in size, and then at both ends the main flower design repeated three times each.

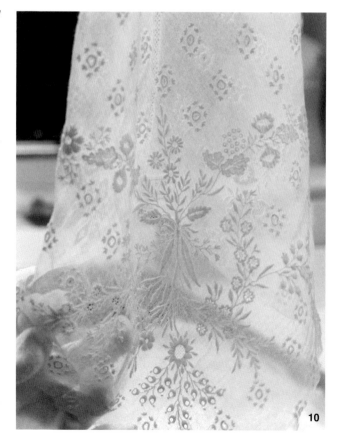

(9): Artist's impression of the first meeting between Princess Charlotte of Wales and Prince Leopold during his visit to England in June 1814
(10): By Kind permission of the Museum of London

10

Creative Piece

I enjoyed the process of recreating the fishu by myself through hand sewing and developing orders for producing some recreations and creative pieces. I followed a similar process of how things were ordered from London and then how they were made in Bengal and then imported back into Britain.

Although I am the project co-ordinator of the project and my job was to assist and support the heritage fashion recreators to work on recreating historical dresses I could not resist the growing desire in me, during the delivery of the project, to also undertake some of the recreations myself. As we visited various heritage institutions and undertook detailed work on identifying which dresses to recreate and drawing specifications to commission weaving and embroidery work I became more and more familiar with and fascinated by the story of the role played by villages and towns in Bengal in ladies fashion in Britain. This created in me a desire to use my hand to undertake some work myself as a way of developing a deeper understanding and appreciation of the whole process. I was very pleased with what I managed to produce.

A Muslin Fatua - a traditional men's half shirt worn in Bangladesh

In Bangladesh no one wears fatua made from this kind of muslin look a like materials. The thought of experimenting with this idea came from Imtiazul Haque (freelance photographer / cinematographer) who took responsibility for the Bangladesh element of the project. While working on orders for our project he got inspired and created a number of items and one of them was this fatua. This was made from a hand woven mixed cotton and silk material with gold coloured designs and the sewing was undertaken by machine. Imtiaz gave this fatua as a gift to the project and I have included it as a creative piece.

(11, 12): Detail and completed Fatua, male top garment made of muslin
(13): Princess Charlotte's shawl
(14, 15): The completed Fichu
(16): The final handkerchief
(17): Jane Austen's Regency saree

11

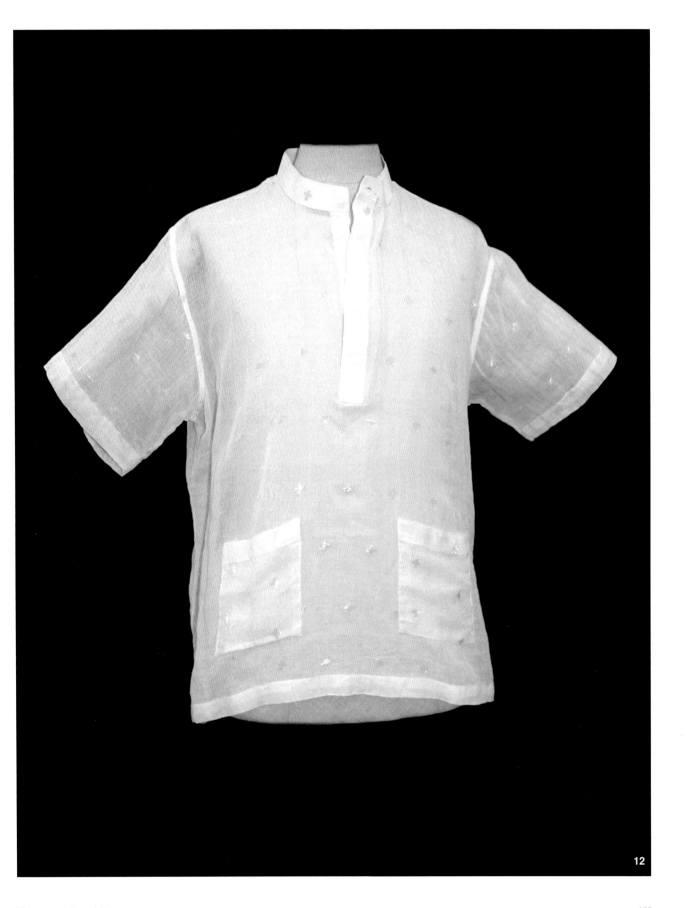

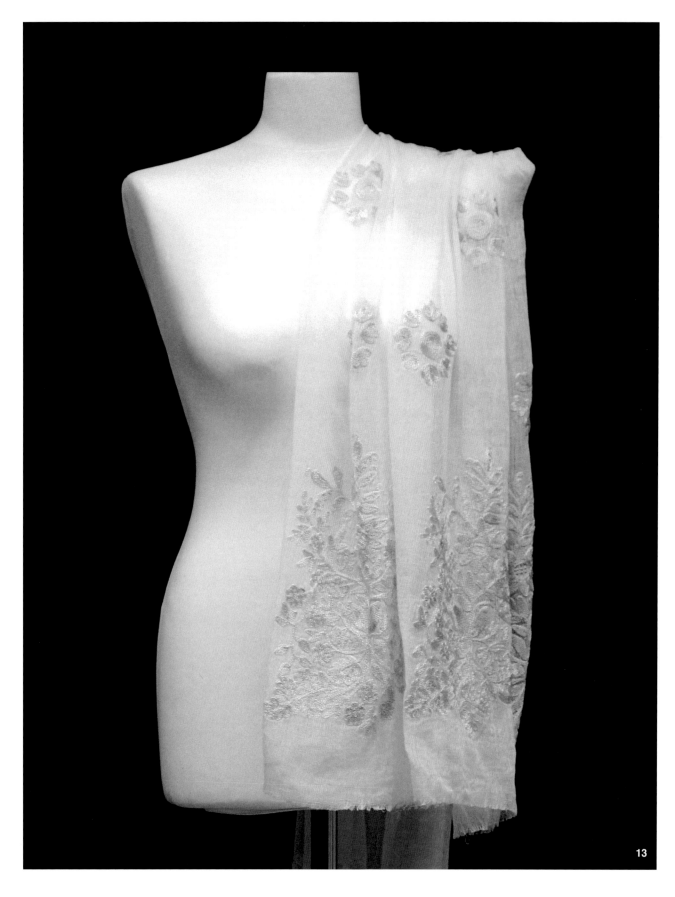

13

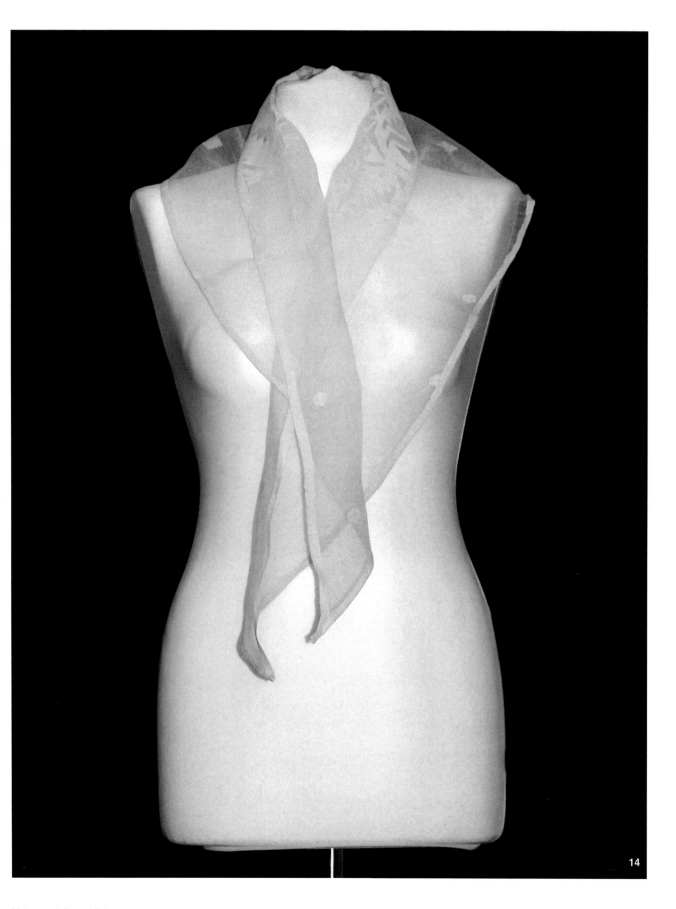

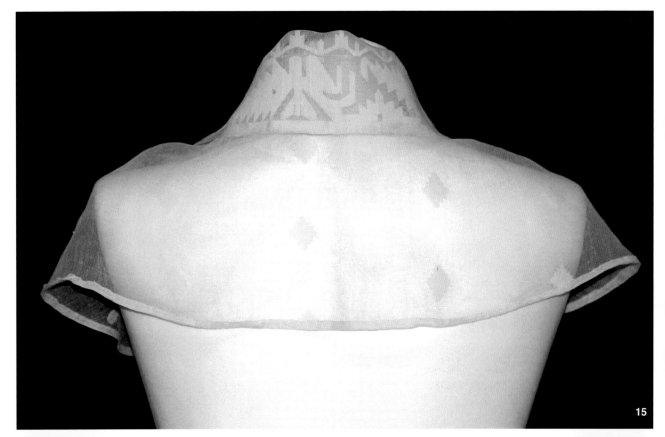

15

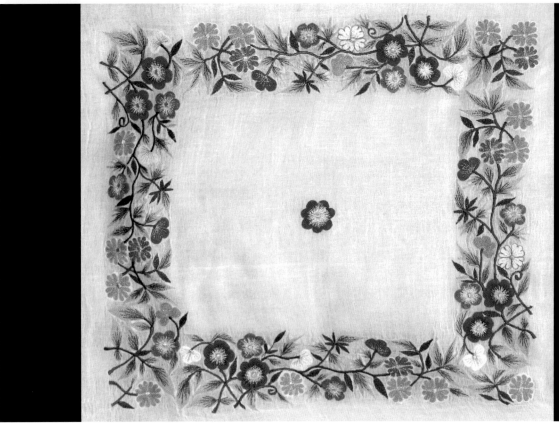

16

The Finer Details

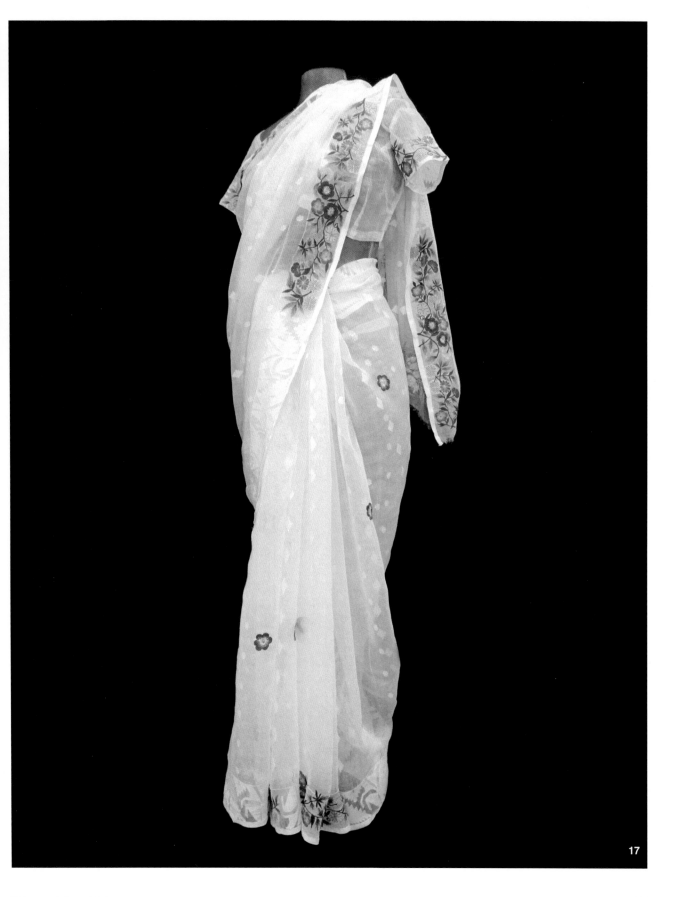

Re-discovering my creative self

Lucky Hossain

It has been a long time since I have done something creative. I came into the project with no experience of muslin but learnt a lot through the lessons from The London College of Fashion, visiting London museums, and the sewing workshops I attended.

I best express myself through poetry and the following is my journey.

Setting sail...

This has been an exciting, creative journey through heritage, textile and skill. London Fashion of College, Victoria and Albert and the Maritime Museums; all hold London's high fashion garments and shipping history, spurring my interest in 17th-19th century England.

East and West meeting across the high seas, fighting scurvy, pirates and rations to buy and barter cloth and produce, to see who would be the greatest conquerors of the land. Muslin was my mission, and garments made from muslin I had to seek. Muslin made in Bangladesh and dresses made to be worn

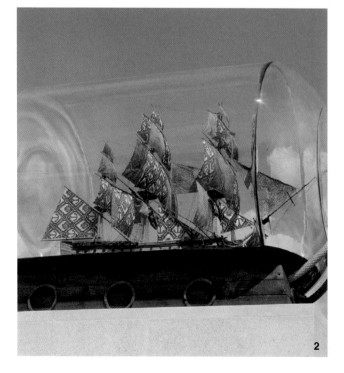

(1): Choosing the garment I wanted to reproduce
(2): Artist Yinka Shonibare's 'Nelson's Ship in a Bottle' (Location: grounds of National Maritime Museum)

by ladies of London; ah Jane Austin you showcased muslin so finely.

So many garments, what to choose? Dilemma dilemma; in the end I go for a garment that is both beautiful and elegant; one worn in the 18th century, 1795 to be precise; a dress made of muslin, displayed at The Victoria and Albert Museum.

The delicate soft muslin, how it drapes, shapes and falls to the feet. Its bridal trail and striking intricate embroidery made from golden silk thread and tambour stitch is what attracted me.

Muhammad the co-ordinator of the project is to steer the ship, Alice the seamstress is to navigate and Lewis the tailor, the taskmaster with the whip; I'm on my way, my journey to complete my beautiful muslin dress.

Sailing through treacherous waters...

Pencils, measurements, cubic metrics; oh my god, it's maths all over again!

This angle that angle, scaling skirt, bodice and sleeves; drawings, enlarging, rubbing and re-doing until I am pleased.

Yards of muslin and instructions so precise; people of Bangladesh weave your magic and send it back to me. Beautiful hand craftsmanship produced the

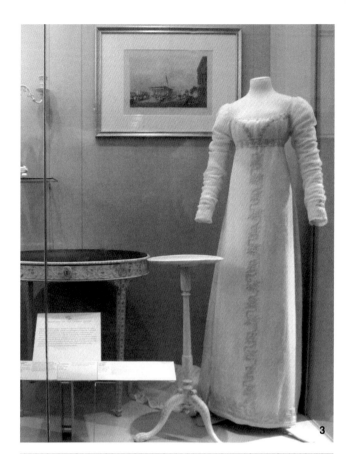

3

WAIST LINE

4

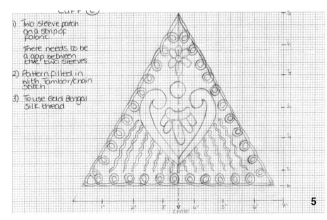

5

weave of muslin fabric; yards and yards of the airless soft clouds of fabrics with beautiful embroidery has flown back to me.

No machines in the 18th century, so by hand I will sew. Tiny, tiny little stitches, a straight line followed by a fell stitch; all this to create a seam and hem - cloth so fine it takes some time, but practice, practice, to make it alive.

Oh what excitement, the muslin has arrived and now washing it is applied. Tentatively and gently I bathe the pieces of the fabric and then lay them to dry; I watch after pressing how light the muslin flies. I am happy and this is a surprise.

Dress patterns galore, tacking and margins, shaping and cutting. I thought the seams were tough but the skirt hem showed trouble was ahead. Stitch by stitch, fumbling over, capturing of tiny weave and weft threads, avoiding going off the beaten track and learning the art of camouflaging such as holes and other damages, all in the aid of ensuring only a straight seam hem was visible to the naked eye. Before I could take a breath of relieve, another intrigue was to come into sight.

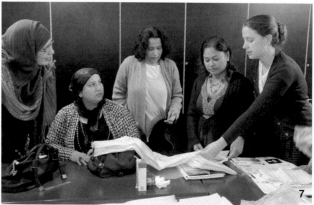

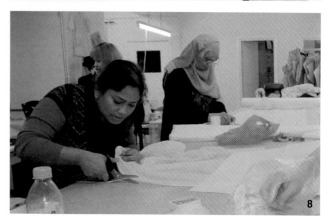

(3): Woman's cotton muslin dress and belt embroidered with tussar silk thread, embroidered in Bengal, made in England, ca1795 (V&A)
(4, 5): Technical drawings sent to Bangladesh to be worked on
(6): Fell stitching the skirt
(7): Receiving muslin fabric with tambour embroidery from Bangladesh
(8): Carefully cutting the length of the skirt
(9): Joining of the embroidered pieces of fabric together

Attaching the embroidered piece to the skirt hemline was definitely a challenge as special techniques were necessary to modify the dress. I joined two embroidery pieces to make one long continuous strip, I had to join pattern on pattern to make this happen, but it also meant some clever gathering had to be done along the curve of the trail of the hem; a tricky task but by jove I got it and proud I am.

Hours of labour, moving one stitch at a time, fingers stiff and cramped, pricked and pinned careful not to bleed on the sheer creamy cloth; rough fingers inflected by the needle, followed by a few swear words to express the ache; straightening the back, stretching the shoulders and flexing the neck, it's pain stakingly slow; bed time calls but I persevere, and one more stitch I try to make.

Tick-tock the pressure is on; making the bodice is no easy feat. Mechanical manoeuvres hidden inside the dress, which no one would have seen. Technical genius the tailors of the past, the bodice alone would need one or two staff to help the lady in waiting to don it on! Tiny framed small and dainty, certainly not the shape of today's modern lady.

Tired and exhausted, I must go on...cutting the bodice required two layers of the muslin and a backing of linen

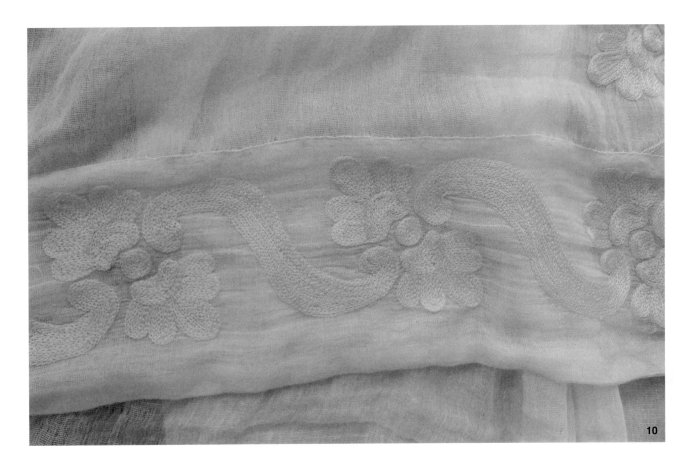

10

Back piece, side-pieces, shoulder bits, front bib piece, other bits of strips and straps, front, back, er Lewis...Help!

Oh did I mention I had to re-cut the bodice pieces again and did I mention I had to do the tacking for the second time round? Half past eight on a mid-week night after work.

The bodice required a running stitch, backstitch, fell stitch...er which stitch? Oh hey and careful to only catch the linen at the back, so that most of these stitches are invisible to the front of the bodice. Iron and press, and keep on pressing instructs Alice.

I then had to unpick a couple of lines of back stitch and fell stitch as they were sewn on the wrong section of the bodice; I look at Lewis as if he is an alien from another planet, I see his lips moving but really do not understand what he is saying...it seems like an eternity, but I resign myself to doing as I'm told. Never mind my blurry eyes from trying to find and unpick the blasted tiny stitch without slicing into the muslin, or was that weeping into the muslin? I've lost the plot.

Using selvage from the left over muslin cloth, I had to make piping for the bodice to create a drawstring

(10): The hem joined to the skirt
(11): Cutting and tacking the bodice pieces together
(12): Working out the construction of the bodice
(13): Working on the front bib or 'milking bib' as known in the 18th Century
(14): Preparing the embroidered strips to be stitched on top of the front bib

to shape the lady's bosom. To hide all of these wondrous mechanisms, a front embroidered bib is needed to go on top of the bodice. Inch- by-inch I strategically lay and pin the separate golden embroidered strips which I fell stitched onto the bib; the embroidered strip follows the curve of the bust line and is smoothly flattened and pressed. Ah finally a moment of beauty.

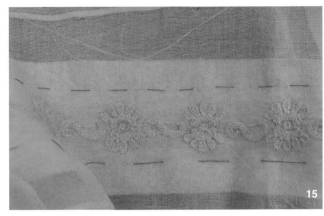

Coming into port...

Working hard and fast I put the sleeve pieces together; again two pieces of muslin are cut but this time on the bias to create the drape of the sleeve; tacking and markings are aligned before the sleeve

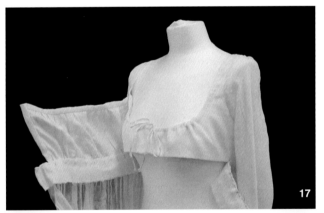

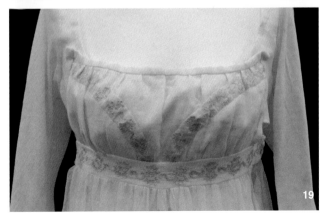

embroidery piece is fell stitched and the sleeve eased and sewn into the arm hole of the bodice.

The pleasure of seeing my muslin dress forming and shaping is a sight for sore eyes.

Nearing the moment of truth…gathering of the skirt must happen before I can contemplate attaching the bodice to the skirt and sewing it together. A sense of total euphoria washes over me as I look at the finished garment. At this moment there are no further words to describe what is felt, it is simply complete.

On land...

A journey on the high waters is no plain sailing. There were rough seas to battle and conquer dealing with the different challenges that I faced in trying to make my garment. Overcoming technical difficulties, tiredness and finding time to labour over my garment. Weather beaten, but I have come out of it more enlightened about the heritage of muslin, textiles, making a garment and strength in myself.

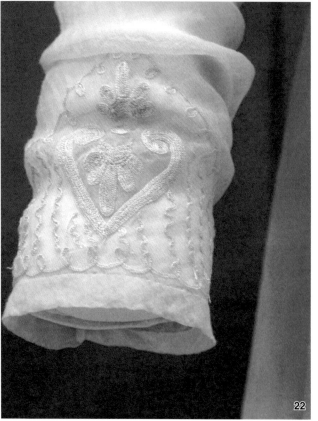

(15): Tacking the lines along the bib
(16): Tacking the bodice together
(17): Finished bodice with draw string to shape the bust
(18): Joining the waist band with the bodice and gathered shirt
(19): Final front bib of my dress
(20): Panelling inside the dress to hide the raw seam edges of the bodice, waist band and gathered skirt
(21): Embroidered cuff sewn with selvage edge
(23): Cuff of dress at The Victoria and Albert Museum
(24): Cuff embrodered in Bangladesh 2012

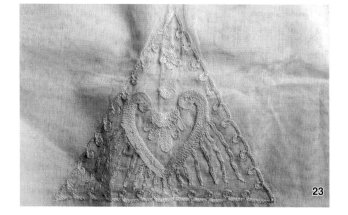

Finishing touches

I was unable to find out about the lady who originally wore the dress as there was little or no information available, however it was worn during the Regency era. Women wore dresses with empire waistlines; this style of dress allowed women to discard the previously popular undergarments such as traditional waist narrowing corsets, panniers, and bustles.

I imagine my dress with its gold embroidery would have been worn with some form of stays or corset with a chemise underneath it and maybe drawers or pantaloons on the legs. They would have had an under dress or petticoat or perhaps both, although due to the train on the dress it suggests more of an evening dress, worn to a ball with an under dress to puff out the skirt. The wearer's shoes would have been slippers with a very low kitten heel and pointed toe and be accompanied by a cashmere shawl.

My journey

This project has reminded me of the creative person I am; I feel alive again and not just living. Just knowing this is an accomplishment, but I am also proud of the dress I have re-created. It means I can continue to apply my knowledge and textiles skills and explore other avenues that will give me meaning and fulfilment in my life after the project is over.

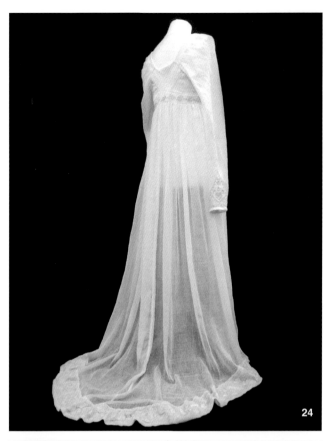

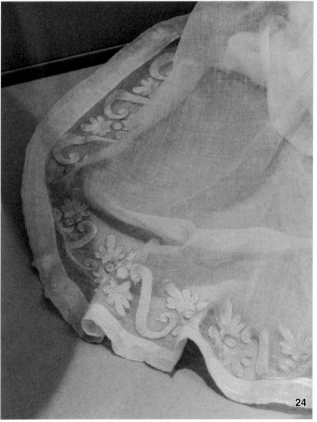

(24): Details of my dress
(25): The complete final dress

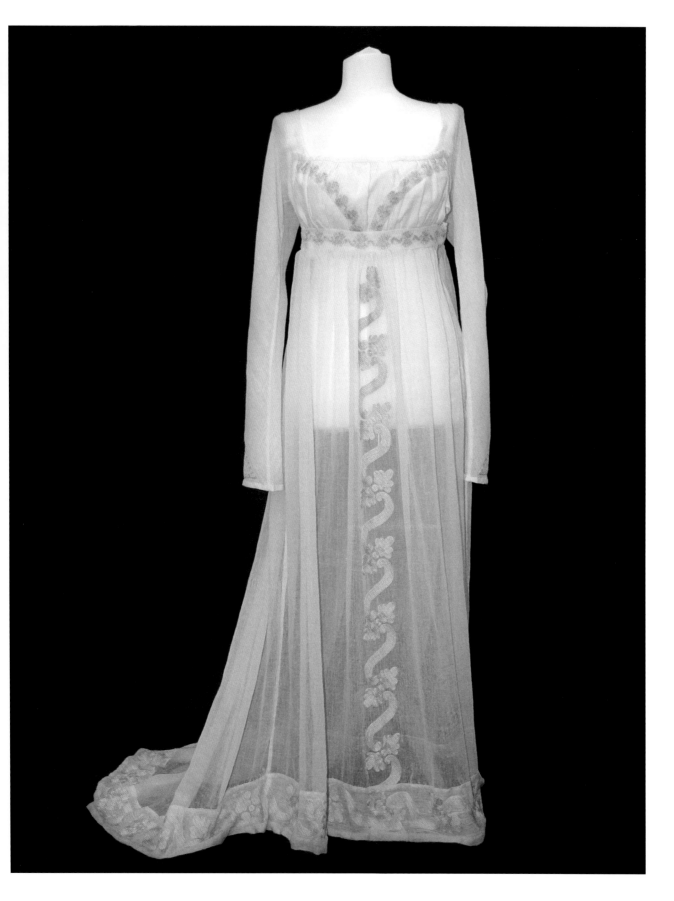

A Handmade Tale

Momtaz Begum-Hossain

Getting involved

When I was 11 my form tutor at secondary school gave me a copy of Jane Austen's *Pride and Prejudice.* While my friends were reading pre-teen fiction by Judy Blume about kissing, I was grappling with the concept of adulthood and trying to understand the complex love story between a young intelligent woman, Jane, and the older, wealthy gentleman Mr Darcy.

Maybe that explains why I have such romantic notions of life. Half the time I find myself living in a dream world, wondering what it would be like to be someone else in another place and another time. I'm not a big fan of period costume dramas but I certainly enjoy the escapist fantasises they evoke.

In my day job I'm a journalist while my hobbies centre around crafts. I love moulding, cutting, sticking, rolling, gluing, coating, spreading, glittering, stitching, sculpting, carving, printing, shaping, collaging…if it involved my hands and is creative then I'm in.

That's what drew me to this project. I had grown up around sewing machines. My mum was a seamstress.

1

(1): Getting to grips with pattern-cutting

She was one of the Bangladeshi women who sewed clothes for the British high street and got paid cash-in-hand, 25p a garment. Through her sewing she made enough money to send funds back home to her siblings to ensure their children were fed and clothed just as we were.

Understanding the power and significance that the sewing machine had and what could be achieved with it, I set about acquiring my own. While I was studying for my A'levels I got a Sunday job and with my earnings bought my own sewing machine. I wasn't particularly good at sewing. I dabbled in making a few dresses, textiles and fixing things – it was more knowing it was the most expensive thing I owned that gave me the greatest pleasure.

Fast forward 15 years and here we are amidst a sewing revolution. The make do mend, thrifty, DIY ethos has penetrated into all aspects of popular culture from TV shows to the high-street. Everyone wants to know how to sew. And that was partially why this project caught my attention. While the masses are trying to figure out how to use a sewing machine, I had an opportunity to go back to a time when such technologies didn't exist - where clothes were handmade one stitch at a time.

(2): Me aged 17 in a handmade dress
(3): My decorated sewing machine
(4): The original muslin dress (1816-1818). © Royal Pavilion and Museums, Brighton & Hove
(5): Brighton Museum and Art Gallery (Photo: www.megalithic.co.uk)

Setting the scene: white is alright

I have this rule whereby I don't wear black or white clothes. I live in a technicolour world and have no interest in monotone. I would never wear white socks and don't even own any white underwear – the only white bra I did have, I dyed beige with a teabag. Naturally white clothes don't speak to me so in the early stages of project research when we looked into historic garments and embarked on visiting museums I was rather deflated that perhaps I would never find a dress I would like enough to recreate.

The muslin dresses and accessories we discovered were all beautiful in their own right but none of them drew me in or intrigued me. I found some accounts that coloured muslin did exist but it was hard to get evidence and part of me didn't feel comfortable choosing a coloured piece knowing that the majority of the cloth was white.

Then one day it happened. While Googling for muslin dresses I stumbled upon a dress and as clichéd as it sounds, it was love at first sight. This was the only dress I wanted to make.

Located in the storerooms of Brighton Museum and Art Gallery, the dress originated from 1816-1818, the latter period of muslin dress wearing. According to the online records it was usually on show but currently in storage.

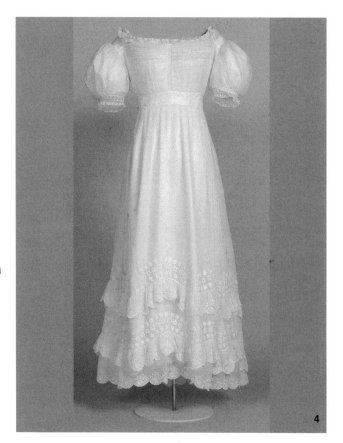

When I phoned up to enquire about coming to see it, my request was turned down. All I had was one photograph of the front of the dress. The image was of low resolution making it impossible to see the motifs clearly enough to draw them accurately.

As such, when my fabric arrived back in the UK, the embroideries had been adapted but they still looked delicate and intricate enough to resemble traditional white work.

The tragic script

When it comes to love some things don't change. There are infinite tales of women who give up their lives for men, who in turn let them down. The owner of my dress was sadly one of these victims. Though the museum records can't prove the complete accuracy, it is believed the piece was part of a trousseau of beautiful hand-made dresses commissioned by an English woman for her wedding.

She fell in love with a merchant who invited her to leave Britain behind to move to India to be with him. Clouded by romance and fantasy, she set sail with a trunk full of dresses and optimism.

Upon arrival the man who claimed he would give her a new life, was in fact a fraud who had no intention marrying her.

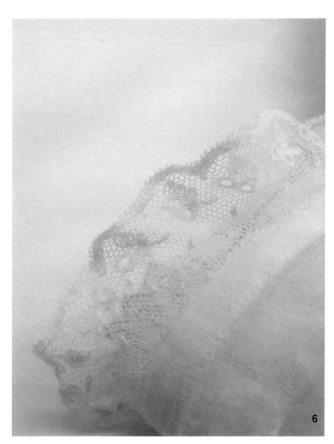

6

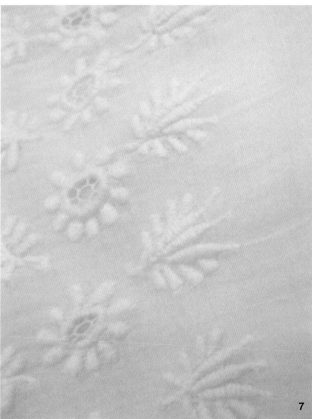

7

(6, 7): Detail of embroidery pattern on the dress
(8, 9): The dress I found in the Brighton Museum and Gallery collection

She returned to England with her dresses and spent her remaining life as a spinster living with her sister, who also never found a partner.

Instead of getting wed, the pair got their pleasures through other means; both were keen shoppers hoarding beautiful clothes, jewellery, accessories and ornaments. After they passed away it was discovered that their home was like a museum; a homage to the styles and fashions of the 19th century.

One of the people who was involved in clearing the house was a distant aunt of a young women who acquired the dress as a gift many years later. When she was 15 the new owner wore it to a party where someone stepped on it, making it rip. The dress was hand mended, as it would have been done originally, the rip becoming a feature at the back of the dress. In 1993 Mrs J Browne as she had become, donated the dress to Brighton Museum.

I was astounded by the story, how a modern teenager actually wore the dress to a party, just as it had been intended to be worn a hundred years earlier. I tried but failed to get in contact with Mrs J Browne. All I had was her name. I would have loved to discover whether she was still alive and if so to find out more about her relationship with the dress and of course how much she knew about the original owner.

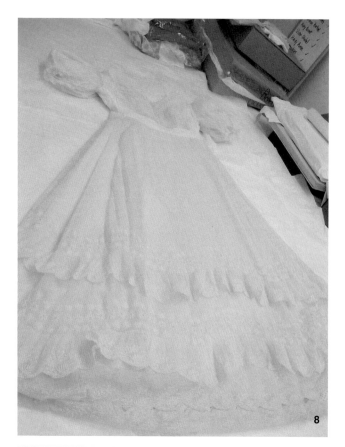

8

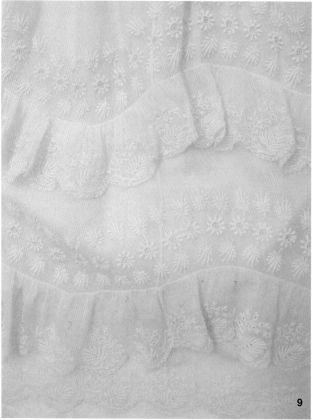

9

The drama unfolds

Six months after discovering the dress of my dreams I was finally given access to it with a visit to the archives at Brighton Museum. I couldn't believe that after getting to know every millimetre of the dress in a photograph, here I was in its presence. I was nervous and nauseous as it felt like one of the most precious items I had ever touched.

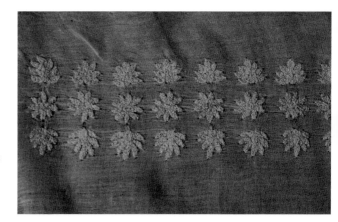

The dress was laid out on protective paper and the museum's curator Martin gave me a pair of gloves that allowed me to handle and measure the dress. With so many layers and sections there was a lot to pay attention to – measuring the gap between frills, the drop down between curves, the circumference of the puff of the sleeves, width of the lace etc. I wanted the dress to be as accurate as possible so I measured, re-measured and triple checked the numbers.

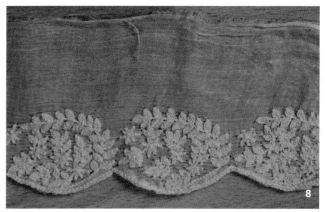

While inspecting the dress I found some initials stitched on it, a detail that wasn't in the museum's description and had not been noted by Martin or his team. He explained this was an unusual discovery but as it was so difficult to decipher the letters, we couldn't be sure whether it was done for the original owner or was one of the later modifications. As a homage to it, I decided to add my own initials onto my version of the dress.

(8): The modified embroidery
(9): Discovery of unidentified initials on the muslin dress
(10): During the dressmaking workshops at HEBA Women's Project

Sewing began shortly before Christmas and my first task was to prepare each of the frills at the bottom of the dress. Most of it was done on the top deck of the bus as I travelled to and from my sister's house in the absence of tube trains during a national holiday. I was conscious that perhaps I wasn't giving it my complete undivided attention. Most of my sewing was done in the classroom but out side of our group sessions I stitched on trains and even on a deckchair in the park. I also watched countless movies.

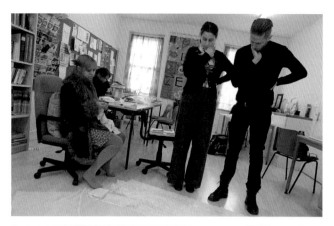

This probably detracts from the fact this was supposed to be a project about appreciating hand-sewing. I'm a multi-tasker by nature. Sewing in isolation may give time to reflect and appreciate, but in reality doing it whilst travelling or watching TV meant I didn't feel as guilty as I was achieving two things at once.

One of the highlights of making the dress was going to the home of one of the other students on a Saturday afternoon. We had a sewing circle away from the class. There was only women present and I felt sewing, talking and eating in this context was closer to the experience of making a muslin dress than any of the class room sessions. We chatted more openly about ourselves and had a good gossip.

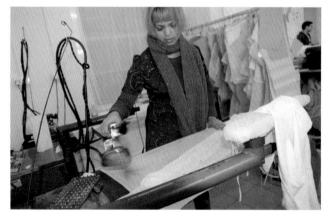

The curtain falls

It took me eight months to sew my dress. The result feels like a work in progress. I have a dress that's very pretty which eludes to the dress it is based on but the replica

10

is not as exact as it could be. I took some short cuts and made some modifications, which in hindsight given the brief of the project was not the best decision. I can't justify them either, other than, the challenge begun as a hobby but turned into a mammoth task that had to be managed alongside a full-time job and other commitments which in some respects took some of the pleasure away.

The accuracy and commitment required for historical recreation is not for everyone. Although I will continue to make repairs by hand (like sewing on missing buttons and patching up holes), I don't think I will ever hand-sew another garment.

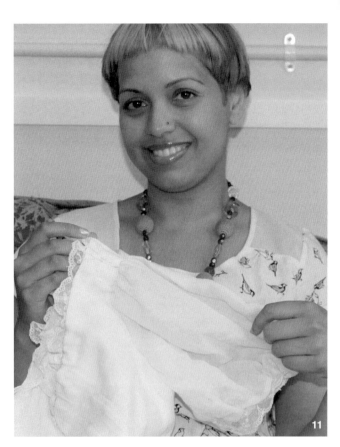

Looking at my dress it also reminds me of Mrs Carter, the teacher who gave me *Pride and Prejudice* when I was 11. I think she would have been proud of my final piece, or at least I hope she would be.

It also feels like I have come to a point in my life where I have actually experienced a sewing journey. Over the years I've attempted to make my own clothes, gifted sewn items to others, sold stitched creations at craft markets and even taught newbies how to sew, but stepping back in time and learning professional hand-sewing has given me an appreciation of garment manufacturing. In these fast 'disposable' fashion times where clothes are cheaper than they've ever been, knowing how to hand sew is a rare and privileged skill and one that I have added to my repertoire with pride.

(11, 12): Adding the final touches
(13): Details of my finished dress
Overleaf: Back and front of my historic handmade dress

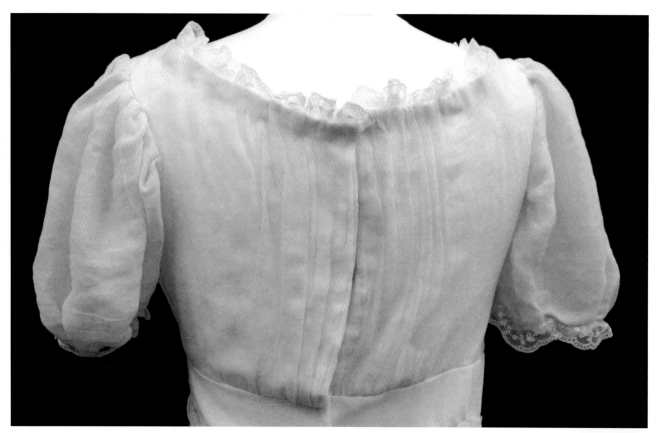

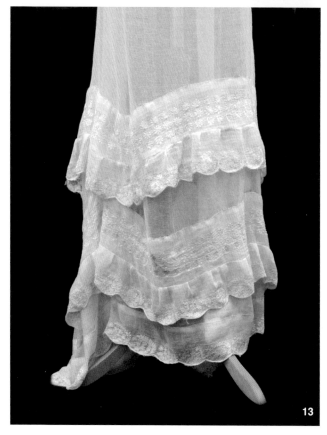

13

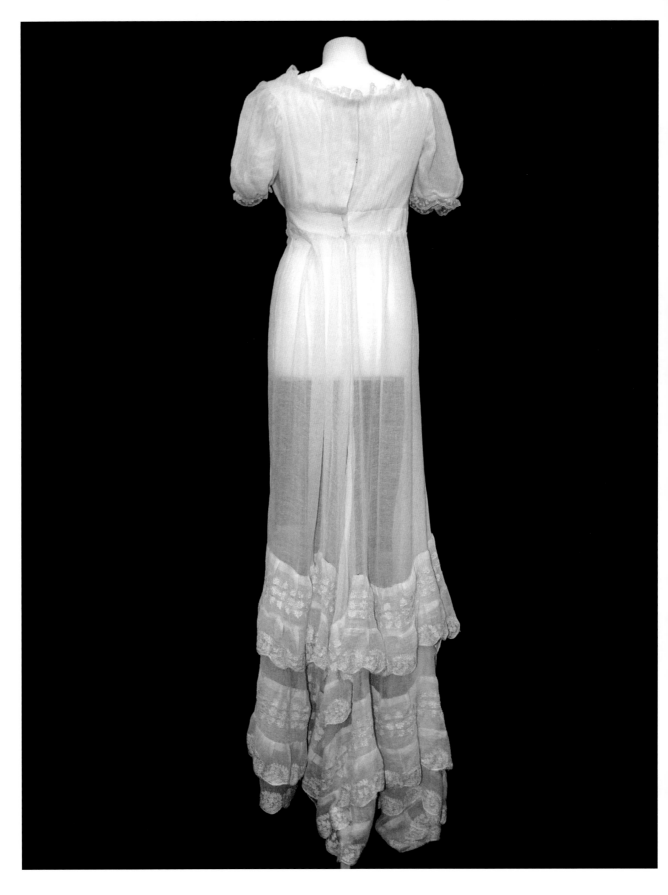

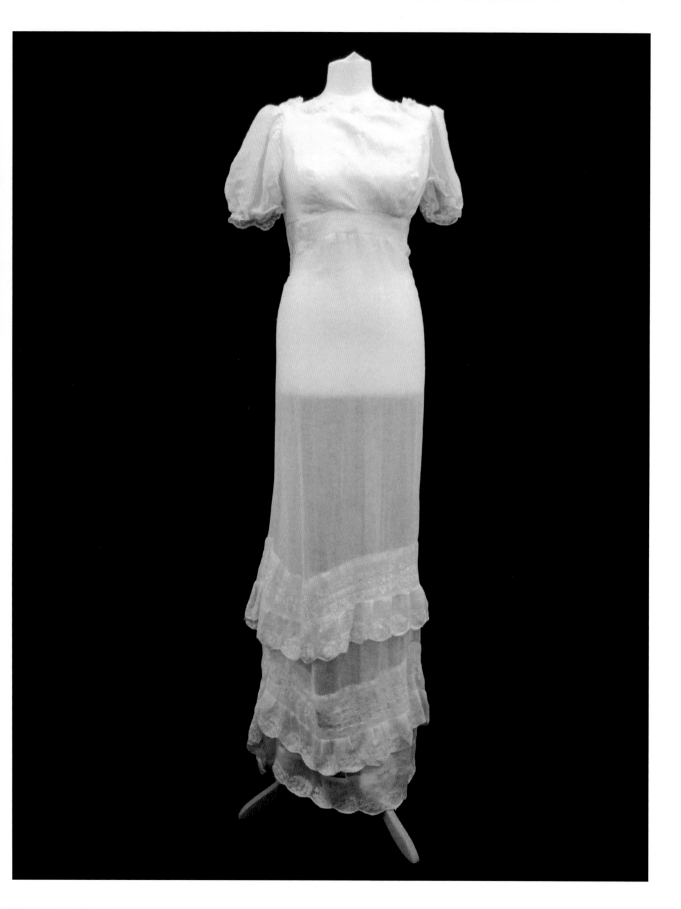

A 'worked muslin gown' for Lydia Bennett

Eppie Evans

'I shall send for my clothes when I get to Longbourn; but I wish you would tell Sally to mend a slit in my worked muslin gown before they are backed up.' [1]

Lydia Bennet in *Pride and Prejudice*

Muslin has become synonymous with fashion from the Regency period however, this thin and delicate fabric first originated in the hot and humid climates of the Middle East dating as far back as the 9th Century. It was only imported into Britain from India in the seventeenth century.[2] This project has explored the history of a distinct type of muslin, that from Bengal in India, which was once the finest in the world. The biggest impact which drove the rise in wearing muslin gowns was the French Revolution (1789), where a simpler, more natural way of dressing was required. This was a stark contrast to the flamboyant and extravagant silks and brocades, ornate embellishment and embroidery typical of earlier in the period. The entire shape and silhouette of women's dress altered dramatically, the waist line gradually rose which was known as the empire line, and with that, heel height on shoes lowered evoking

1 J. Austen, *Pride and Prejudice* Penguin, (London1996 Ed.), p.277
2 http://janeaustensworld.wordpress.com/2011/09/08/muslin-muslin-versa-tile-cloth-for-regency-fashion/

the image of natural, unadorned beauty. Underwear also had to adapt. Corsets became very short and were structured so that the dress would fall straight down from the shoulders as it was seen as highly unfashionable to show the arch of one's back. For the first time, women started wearing cotton drawers, as previous fashions with their many layers of petticoats had not required this[3].

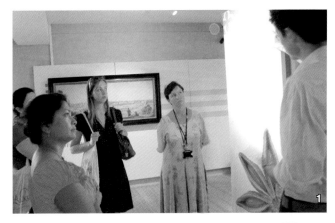

The muslin from the seventeenth, eighteenth and even the early nineteenth centuries was much finer than what is produced today, and its ability to drape was a much valued quality reflecting the garments of the ancient Greek and Roman statues. According to Amanda Forman, Georgiana the Duchess of Devonshire 'introduced the muslin gown to English fashion', undoubtedly provoked by her friend Marie Antoinette who first popularised the style in France in the 1780s.[4] This style of dress was known as *la chemise a la reine*, it was exceedingly simple, almost like a shift, with a drawstring neck and a plain ribbon to tie around the middle.' [5] The colour white was a mark of high class and status, it was especially difficult to keep clean and so it became a conspicuous form of displaying ones exemption from any type of physical labour. Despite this, the fashion was not completely anti-functional, and it was far easier for the lower classes to imitate than the robes and mantua's constructed in rich silks and

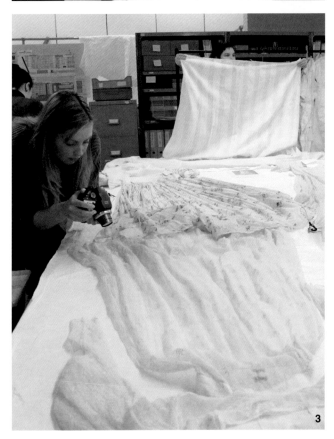

3 http://www.metmuseum.org/toah/works-of-art/1998.222.1

4 http://www.metmuseum.org/toah/works-of-art/1998.222.1

5 A. Foreman, *Georgiana The Duchess of Devonshire* London, (London, 1998), p.176

A 'worked muslin gown' for Lydia Bennett

damasks which were incredibly expensive and almost impossible to keep clean and neat; thus cotton (often a mix of cotton and linen) provided the lower classes with a suitable alternative, it could be bought cheaply and was far easier to maintain.

Embroidery became a way of embellishing muslin gowns, transforming them into garments suitable for eveningwear. In Jane Austen's *Pride and Prejudice* Lydia Bennett, in her letter to Harriet Forster, asks Sally to mend her "worked muslin gown".[6] White work embroidery (white thread on a white ground) was most commonly used; many examples of this work are incredibly intricate, remarkable considering how the embroiderers would have been entirely reliant on natural light. Other colours as well as metal threads was often used, such as gold and silver plate, spangles and threads like bright check, pearl purl and smooth passing, created a beautiful effect catching the candle light in the evening.

When I started the project I was in my final year at university where I was specialising in the study of eighteenth century textiles at The Royal School of Needlework. My main focus was on recreating historic embroidery in order to gain an understanding of the original techniques, I believe that only with this

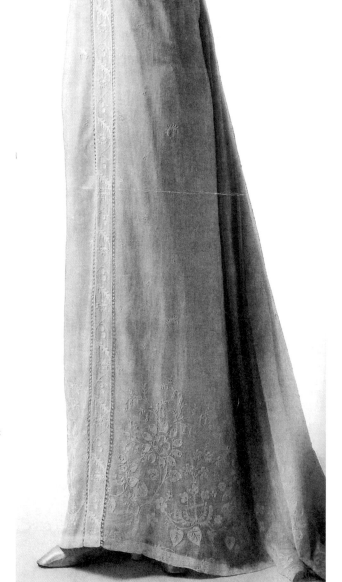

4

6 J. Austen, Pride and Prejudice Penguin, (London1996 Ed.), p.277

(1): On tour at National Maritime Museum
(2, 3): Researching dress details from The Museum of London archives
(4): My dress was inspired by this 1802 white cotton dress (Source: 'Fashion : The Collection of the Kyoto Costume Institute' by Fukai, Akiko)

in-depth knowledge can you fully comprehend its context and meaning. Initially, the research began with the study of extant garments and textiles in the Museum of London and the Victoria and Albert Museum. This was a great opportunity to see what was hidden amongst the museum's collections and out of view from the main gallery spaces.

From the offset I was determined to construct my dress in accordance with historical methodology by incorporating the exact same processes and techniques. I was initially inspired by a dress that demonstrated a simple design with striking embroidery and which featured the heavy use of bullion knots (similar to a French knot but when the thread is wrapped around the needle several times). The fabric for this project was woven in Bangladesh and so our design needed to be planned well in advance, for me this meant I would need plain fabric, as I would add the embroidery myself. However, when I received the muslin I was surprised by how open the weave of the muslin was in comparison to examples we had seen in the museum archives, which were much finer. Furthermore, once the muslin was washed it became even softer after the starch had been removed. It felt extremely fragile and held no structure - the worst possible ground for delicate white work embroidery. The weave was so open it was almost impossible to embroider, white work often carries the thread over just a few threads at a time, but with this muslin the stitches became lost, making the bullion knots almost impossible to work as they slipped through the weave

5

A 'worked muslin gown' for Lydia Bennett

as there was no structure to hold them in place. My initial intention to hand embroider my garment utilising the unique skills I had acquired during my degree soon faded, and as the project developed the true reality of how much time is needed to achieve such intricate work became all too apparent, with working full time and studying for a Masters Degree, my spare time was rapidly consumed. I therefore needed an alternative solution. Historically, dresses were often made up before being embroidered and so I decided that this is what I would do.

The second design I chose demonstrated a much finer use of embroidery and one, which for me epitomised early nineteenth century women's dress; made from white cotton muslin the dress is simple and elegant, embroidered with tambour work and with an empire line waist, short sleeves and train. Having constructed the skirt I then drew my design onto the muslin freehand with a water-soluble pen so that the talented makers in Bangladesh could embroider it with tambour work. Tambour embroidery was used historically and can be found on many garments and textiles from this period. The word Tambour comes from the French term for drum, this is because the fabric is held tight in a frame (usually circular), another expression embroiderers use is to call a framed piece of fabric 'drum tight' owing to the sound it makes when you tap your fingers on it. Using a tambour hook to pierce through the fabric collecting the thread on the other side it creates a chain

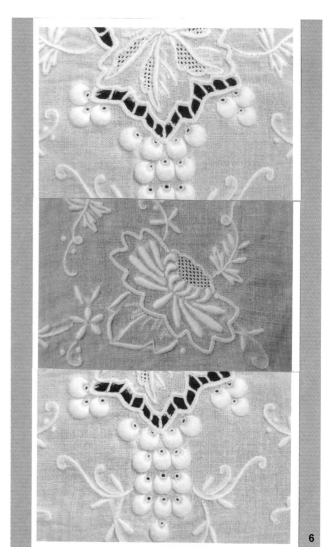

6

7

(5): Sewing details of the arms and dress train
(6): Tambour work produced by me
(7): Cutting out sections of the bodice from the muslin cloth

stitch effect and when done by experts can be an extremely fast technique, used most commonly today for applying beads and sequins to fabric. Unfortunately, as the muslin had been washed already it had become very soft, too soft to be embroidered, and so the makers in Bangladesh would have to apply starch to it before they could embroider it. They used a spray starch and as they applied it my design began to slowly vanish. No photographs or recordings had been made of it, I had drawn it free hand…

I was starting to regret my design especially when I saw everyone else's which had the design woven into it and how stunning they looked, yet another solution to another problem was needed. My only option was to sketch the design onto paper as best I could from memory providing the embroiderers with a general layout and then to make more detailed drawings of the all the different flowers and leaves, these were then sent off to Bangladesh to be incorporated as best as possible. I really didn't know what to expect. But when it finally arrived back I couldn't believe how stunning it looked, the embroiderers had done a fantastic job and despite having no direct contact with them, they had managed to achieve something very close to what I had originally planned.

With the skirt finished I was filled with enthusiasm to finish the rest, I got to work on the bodice. I enjoyed putting this together, many pieces were used to construct the bodice, pinning and tacking them together before using a mixture of running and backstitches on the seams and tiny pin stitches on the areas which would be visible. The

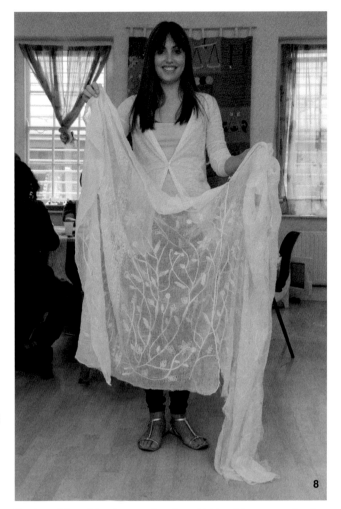

8

final problem I had was after the skirt had been washed the embroidery went a much darker beige than I wanted and due to how many times the skirt had been washed and starched the muslin went much paler than the bodice. I had to wash the bodice several times to lighten it and dip the skirt into water stained with tea to try and get a better match. In the end it all came together and it has been extremely rewarding. I feel a great sense of achievement having made something completely of my own design. This project has been a fantastic experience throughout which I have learnt a great deal and have met a wonderful group of talented people.

(8): The dress train nearing completion
(9,10): Embroider details from my historic recreation
Overleaf: Lydia Bennett's dress and my creative piece

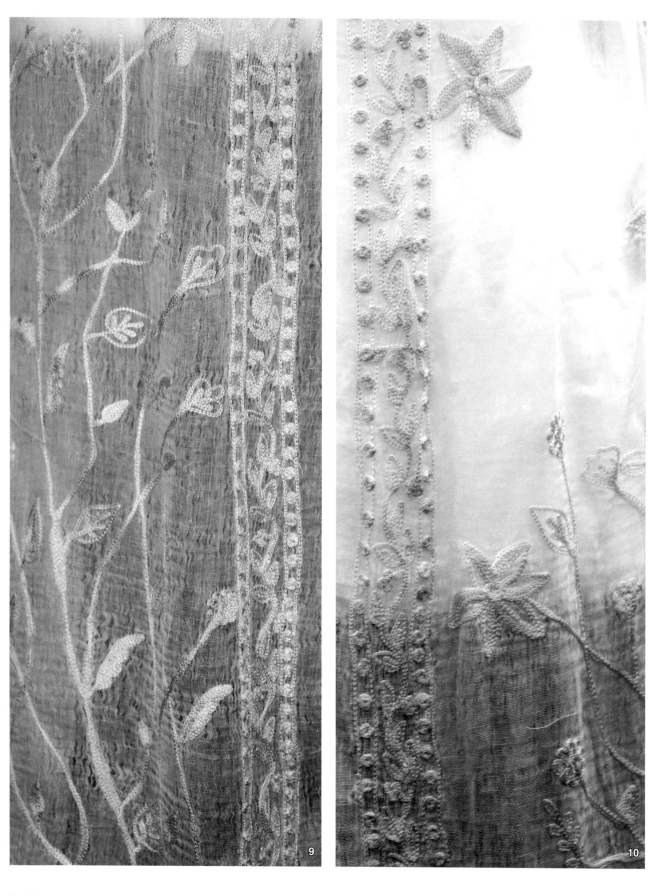

9

10

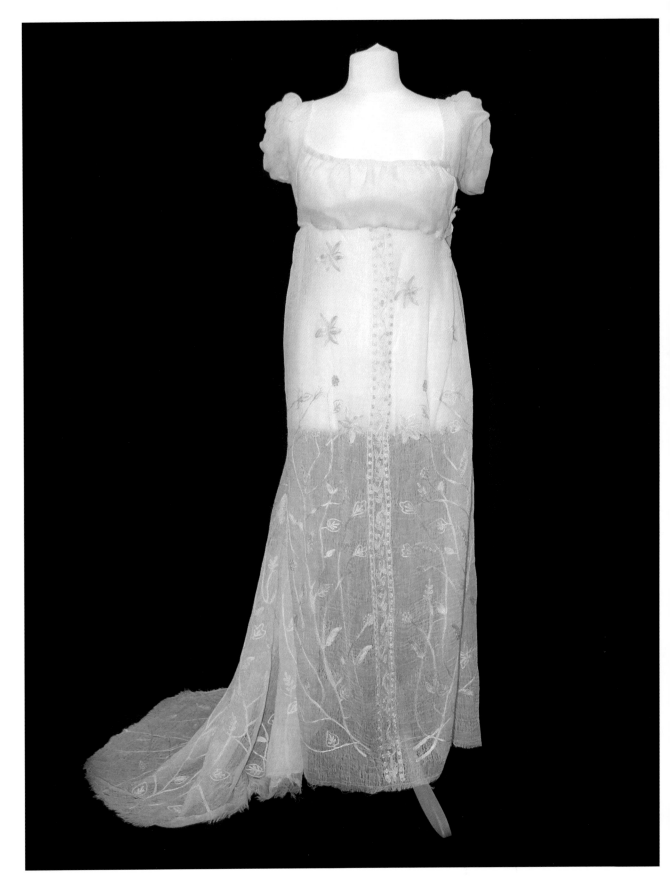

A 'worked muslin gown' for Lydia Bennett

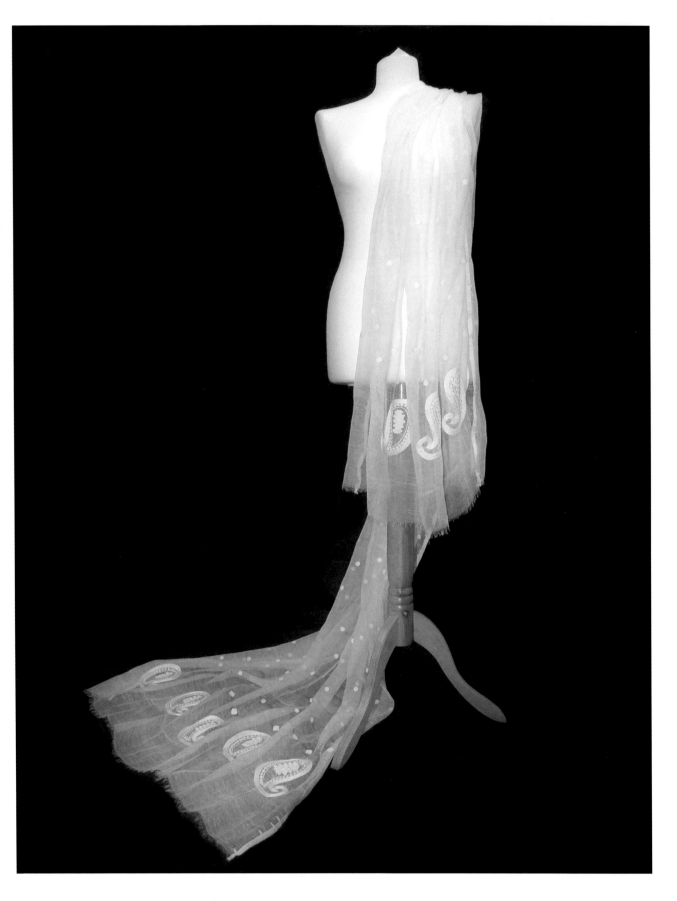

Biographies

Photo: Steven Lawson

Fathema Wahid
Printed Textiles Designer/ Maker
Fathema specialises in printed textile design for fashion and soft furnishing. She has been exhibiting and selling her work privately as well as running workshops for the last ten years, whilst working full time as a secondary school Art and Design teacher.
Her work is predominantly inspired by natural forms and objects with a delicate structure, such as shells, leaves and fresh produce.

Saif Osmani
Visual Artist & Spatial Designer
Saif's art and design practice examines gaps in historical events encountered through displacement. It examines migration routes and explores how new communities and cultures formulate and the consequent effects on the spatial environment.

This year he has curated a cross-disciplinary exhibition at Stephen Lawrence Gallery and held solo exhibitions at Rich Mix Arts Centre and Barbican Centre, London.

www.saatchionline.com/saifosmani

Sima Rahman-Huang
Moon Doll Boutique
Sima is a vintage fashion entrepreneur of Bangladeshi origin. She has recently started up an online retail fashion business where she sells handmade, vintage and ethnic textiles and clothing.

www.moondoll.co.uk

Rifat Wahhab
Rifat was born in Bangladesh and came to live in the UK with her family in 1964 when she was eight years old. Her education and working life has been in London and she currently works in the NHS. Throughout her adult life she has been active in charities and is currently Company Secretary of Consortium of Bengali Associations and Acting Chair of the Muslin Trust.

Hilde Pollet
Product Developer
After studying Industrial design in Antwerp, Belgium, Hilde moved to the UK to obtain a Masters in Design, Strategy and Innovation at Brunel University.

Hilde's been making clothes from a very young age after pursuing her childhood dream to set up a couture studio to make bespoke wedding dresses.

Muhammad Ahmedullah
Muhammad has worked in major inner city regeneration programmes in the UK since 1989 and completed his PhD in 1998 on the Relationship between Epistemology and Political Theory from Kent University. Between May 2005 and June 2010 he delivered a unique exhibition on Dhaka City around the UK and is also the Secretary of Brick Lane Circle, a voluntary organisation working to help transform the intellectual landscape of the Bangladeshi community in the UK through knowledge generation / dissemination, seminars, conferences and networking.

Lucky Hossain
Lucky works in the NHS and is currently a Commissioning Manager for Dental and Optometry Contracts. Over the last couple of years, Lucky has been discovering her creative side and is studying a Foundation in Counselling and Psychotherapy with the aim of challenging herself and to continue to develop.

Lucky's interest in textile has been revived by this project and she is looking forward to the next chapter of her journey.

Eppie Evans
Eppie achieved a first class (hons) in Hand Embroidery at The Royal School of Needlework. She is now studying a MA degree in historical research at the University of London. Her main interest is 18th century dress textiles.

Momtaz Begum-Hossain
Momtaz has been a journalist for over 10 years and began her career designing craft projects for the BBC, before becoming Editor of one of the biggest craft magazines in the UK. She is currently Digital Editor of Asian lifestyle website Asiana.TV and Editor of Ethnic Restaurant magazine.

The Heba Team consisted of **Rehana Latif, Lindsay Dupler and Anjum Ishtiaq**. Anjum teaches dressmaking classes at the Heba Women's Centre on Brick Lane in east London where she continues to make a wide variety of clothing.

A brief history of Stepney Community Trust (SCT)

A brief history of Stepney Community Trust (SCT) Stepney Community Trust is a community-led charity that has a long history of local action and supporting the community. The Trust was set up in 1982 as the St. Mary's Centre - a housing, welfare and resource project responding to the severe levels of housing and social deprivation experienced in the area, based in the former ward of St. Mary's in Tower Hamlets. The charity's aims were re to help address inequalities faced by local people, especially the Bangladeshi community, in accessing decent housing, appropriate welfare advice and good education.

Initially, the Trust's activities focused on campaigns to improve local housing stocks, bring regeneration into the area and provide better quality community and leisure facilities, including for the young. The organisation worked closely with the Greater London Council (GLC) and successfully persuaded the Department of the Environment to designate the Stepney locality as a Housing Action Area, which led to new investment in housing stocks and environmental improvements.

In 1984, the Trust acquired the freehold of their premises with assistance from the GLC, which enabled the property to be developed into a resource centre. An example of a major local contribution of the Trust was when it helped persuade the then Inner London Education Authority (ILEA) and London Borough of Tower Hamlets Council to develop the Settles Street Depot into a primacy school, known as Kobi Nazrul Primary School, to meet the shortages in primary and nursery education places in Tower Hamlets.

In 2002, following Boundary Commission changes to ward names and boundaries in Tower Hamlets, the Trust changed its name from St. Mary's Centre to the Stepney Community Trust. The geographical focus of the organisation's activities is the Whitechapel area, but it serves the wider London Borough of Tower Hamlets.

STEPNEY COMMUNITY TRUST
ESTABLISHED 1982